DYNAMIC FIGURE DRAWING

Burne Hogarth

DYNAMIC FIGURE DRAWING

Watson-Guptill Publications • New York

Copyright © 1970 by Burne Hogarth

Published 1970 in New York by Watson-Guptill Publications,
a division of Billboard Publications, Inc.,
1515 Broadway, New York, N.Y. 10036

Published 1973 in Great Britain by Pitman Publishing Ltd.,
39 Parker Street, London WC2B 5PB, England
ISBN 0-273-00492-1

Library of Congress Catalog Card Number 73-87324
ISBN 0-8230-1575-0

Manufactured in U.S.A.

First Printing, 1970
Second Printing, 1971
Third Printing, 1972
Fourth Printing, 1973
Fifth Printing, 1974
Sixth Printing, 1976
Seventh Printing, 1977
Eighth Printing, 1978
Ninth Printing, 1980

Edited by Margit Malmstrom
Designed by James Craig and Robert Fillie
Set in ten point Palatino

Contents

To my brother, Harvey, who in a real sense
inspired my first attempts to draw.

Introduction

Most art students — and too many professional artists — will do anything to avoid drawing the human figure in deep space. Walk through the life drawing classes of any art school and you'll discover that nearly every student is terrified of action poses with torsos tilting toward him or away from him, with arms and legs striding forward or plunging back into the distance; twisting and bending poses in which the forms of the figure overlap and seem to conceal one another; and worst of all, reclining poses, with the figure seen in perspective!

These are all problems in foreshortening, which really means drawing the figure so that it looks like a solid, three dimensional object which is moving through real space — not like a paper doll lying flat on a sheet of paper. Drawing the figure in deep space foreshortening is not a mere technical trick, not a mere problem to be solved; it's the essence of figure drawing as perfected by Leonardo, Michelangelo, Tintoretto, Rubens, and the other great masters of the Renaissance and Baroque eras.

But most art students would greatly prefer to draw the figure as if it were a soldier standing at attention, with the axes of the body and limbs parallel to the surface of the drawing paper, like a building in an architectural elevation. Well, no, they don't *really* prefer to draw it that way, but the dynamic, three dimensional, foreshortened figure is so forbidding that most students are inclined to give up and stick to wooden soldiers — though silently longing for some magic key to the secret of foreshortening.

Burne Hogarth's *Dynamic Figure Drawing* doesn't pretend to be a magic key-to-three-dimensional-figure-drawing-in-ten-easy-lessons, but it *is* a magical book. Here, for the first time, is a logical, complete system of drawing the figure in deep space, presented in step-by-step pictorial form. I've read every figure drawing book in print (it's my job) and I *know* that there's no book like it. The system and the teaching method have been perfected over the years in the author's classes at the School of Visual Arts in New York, where many of the dazzling drawings in this book — immense, life-size figures which the artist *invents* without a model — were created before the eyes of hundreds of awestruck students.

And surely the most stunning thing about *Dynamic Figure Drawing* is that Burne Hogarth teaches the *reader* to invent figures as the great masters did. After all, Michelangelo didn't ask his models to hang from the ceiling or hover in the air as he drew! He invented them — and this is what the author demonstrates in the carefully programmed series of drawings (with analytical text and captions) that sweep across these pages with the speed and graphic tempo of an animated film.

Dynamic Figure Drawing, in the author's own words, shows the artist "how to fool the eye, how to depress, bend, and warp the two dimensional plane" of the drawing paper so that a figure drawing springs from the page in the same way that the author's remarkable drawings bound from the pages of this book. He demonstrates how to create the illusion of roundness and depth by light and shade, by the overlapping of forms, by the transitions from one form to another, as well as by the accurate rendering of individual body forms. He explains how to visualize the figure from every conceivable angle of view, including the upviews and the downviews that baffle students and professionals alike. .

Particularly revealing are the multiphase drawings — like multiple exposure photographs — in which figure movement is dissected, broken down into a series of overlapping views of the body, "frozen" at various stages of movement, so that the reader can see how forms change at each critical phase. Learning to see movement as a *process*, the reader can draw the figure more convincingly because he knows what happens to body forms at each stage of the process. The reader ultimately finds that he can *project* the figure — from any viewpoint and in any stage of any action — as systematically as an architect projects a building in a perspective drawing.

Burne Hogarth's achievement in *Dynamic Figure Drawing* is the creation of a rational system which eliminates the guesswork that plagues every student of the figure. This system isn't a shortcut, a collection of tricks to memorize in order to produce stock solutions to drawing problems — for nothing can make figure drawing *that* easy. The human figure remains the most demanding of all subjects for the artist. What *Dynamic Figure Drawing* reveals is the inherent logic of the figure, and the author proposes a system of study that is built on this logic. The system takes time and patience and lots of drawing. You'll want to reread *Dynamic Figure Drawing* many times. Give this remarkable book the dedication it deserves and the logic of the human figure will finally become second nature to you. Your reward will be that you go beyond merely rendering figures — and begin to invent them.

Donald Holden

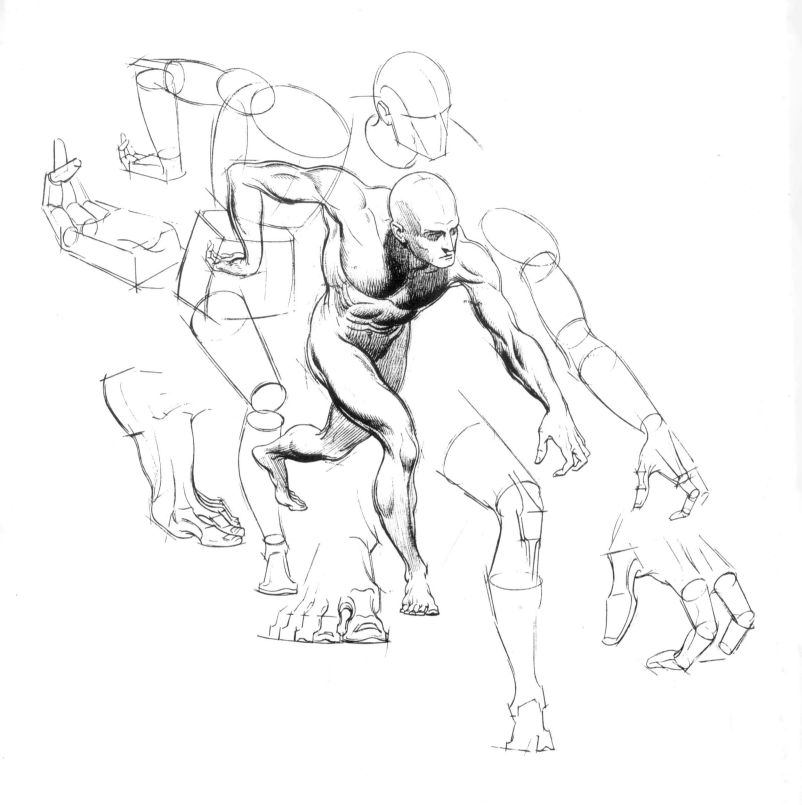

Figure drawing in depth is accomplished with ease and authority only when the student becomes aware of the characteristic body forms. He must train his eye to see three kinds of forms in the human figure: *ovoid* forms (egg, ball, and barrel masses); *column* forms (cylinder and cone structures); and *spatulate* forms (box, slab, and wedge blocks). These three kinds of forms should be distinguished from one another and studied separately according to their individual differences. Comparisons should be made with respect to relative shape, width, and length; and special emphasis should be placed on variations in bulk, thickness, and volume. This is an approach which seeks to define the body as the harmonious arrangement and interrelationship of its separate and individually defined parts.

1

The Definitive Body Forms

At some point in the art student's development, figure drawing reaches a stage where better performance becomes the norm. With his work at this level, the student may be able to draw a variety of natural forms (those usually seen in landscape and still life) in space. Capable as his work appears at this point, the student should develop a deeper insight into the forms and interrelationships of the parts of the figure. He may be thoroughly familiar with figure work in conventional attitudes, with depicting the posed movements and gestures of the art class model; but these, if the student is aware, begin to look predictably dull and static.

It takes a different kind of effort to conceive and draw the figure in *deep foreshortening*, in form-over-form spatial recession. If the student is called upon to show the unexpected and unfamiliar actions of the body—those seen from high or low angles—he feels taxed to the limit of his resources. At times, in direct confrontation with the live figure, he may do passably well by copying the model in the see-and-draw studio method; but this approach is not always successful or satisfying. To invent, to create at will out of the storehouse of his imagination—that is the challenge which so frequently eludes the most intensive efforts of the art student.

Shape-Masses of the Figure

The significance of foreshortened form lies in describing three dimensional volume rather than in delineating flat shapes. Our approach, therefore, involves more than contour drawing only. Since shape which is delineated only by outline is two dimensional and has no volume, it cannot express form in depth; but when the forms of the figure are visualized as being three dimensional in space, the result is a *three dimensional shape-mass*.

Inherent in the concept of shape-mass is the idea that the body is a defined mass, a three dimensional volume existing in space and depth, which is made up of a number of parts. Each of these parts is also a three dimensional volume existing in space and depth. It follows that the figure is a multiform complex of shape-masses, all independently formed and all related. It will be our first task to research the form properties of each of these shape-masses which go into the formation of the over-all shape-mass of the figure. In observing the parts—the shape-masses—of the human figure, we shall try to look at them from new angles, from a series of changing viewpoints, describing them especially with a "filmic" concept of vision in motion.

Shape-Masses of the Head: Ball and Wedge

Different views of the head expose different dominant forms. The cranial ball, for instance, is usually considered fairly equal in size to the lower facial wedge. This is especially apparent in straight-on, front views. But when the cranial ball is seen from an overhead angle, it presents a far more impressive bulk than the facial wedge.

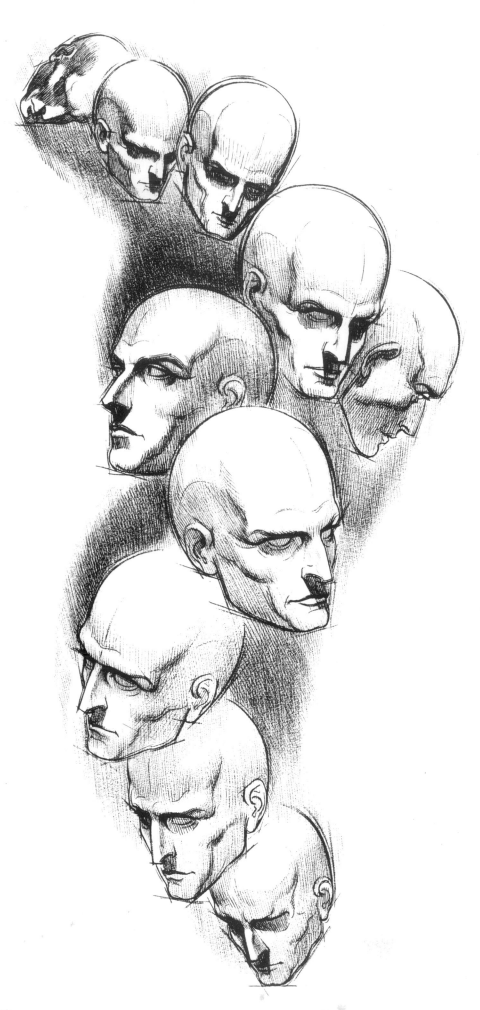

As we observe the head from a high position, from the top, the cranial vault dominates the narrow, constricted mass of the face coming from under the projecting brow arch.

As our viewing angle becomes lower, the facial mass tends to enlarge as the cranial mass recedes.

Then, as our vantage point is raised once more, this time in a right-to-left turn, the cranial mass is once again dominant.

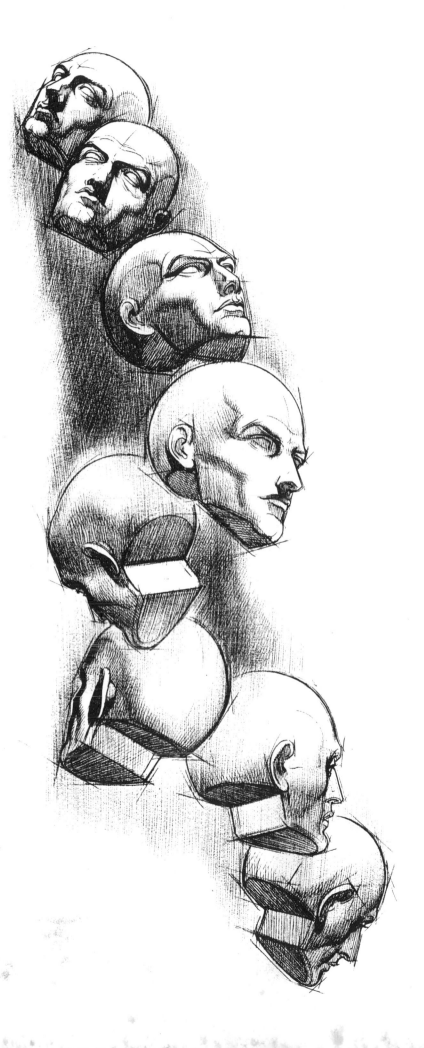

From a bottom view, the wedge of the face takes on a more important appearance in relation to the cranial structure. The features of the face reveal a new aspect: looking upward at the face from underneath, we see the undersurfaces of the jaw, lips, nose, ears, and brow, and these forms assert a commanding presence over the side and frontal planes.

From the rear, the skull case and the facial wedge show their most characteristic differences in shape: the facial wedge, angular and hard-cornered, is small when contrasted with the larger, dome-shaped cranial mass.

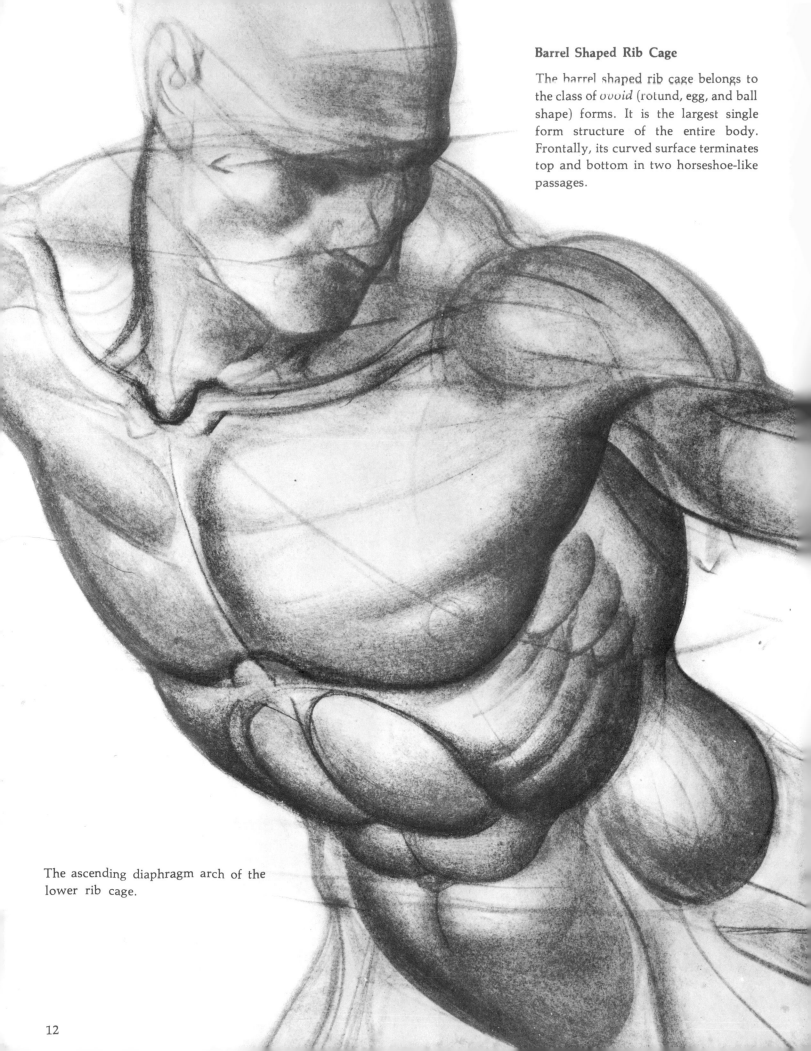

Barrel Shaped Rib Cage

The barrel shaped rib cage belongs to the class of *ovoid* (rotund, egg, and ball shape) forms. It is the largest single form structure of the entire body. Frontally, its curved surface terminates top and bottom in two horseshoe-like passages.

The ascending diaphragm arch of the lower rib cage.

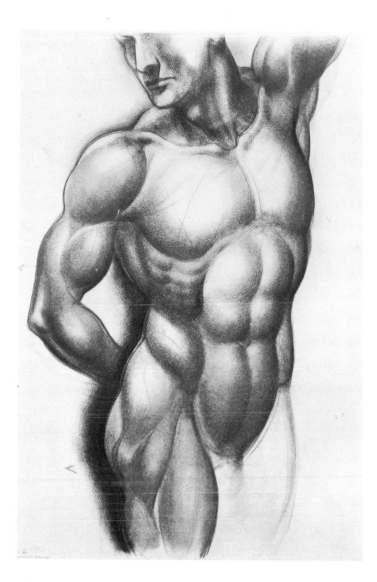

The descending collarbone depression of the upper chest (left).

When the figure is tipped forward into a deep frontal view, the swelling curve of the rib cage, front to rear, is so great that it is able to girdle the head within its encircling contour (below).

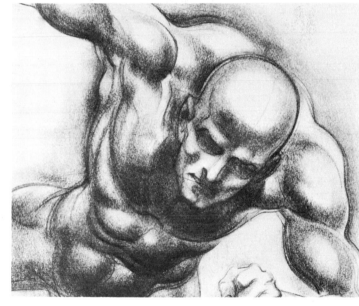

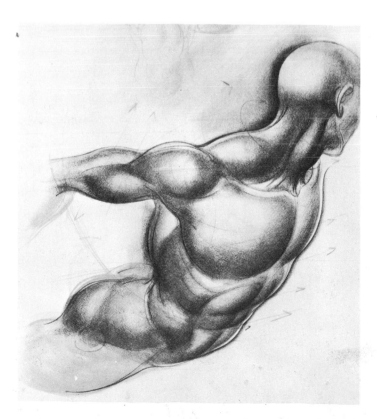

The cylindrical column of the neck emerges like a thick, short tree limb growing from within the triangulate hollow of the chest (left).

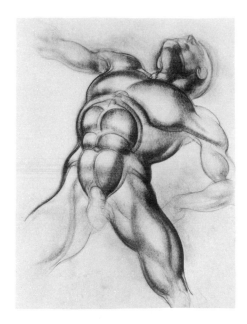

In any view looking upward, the barreling chest mass dominates all other forms; like a curving landscape, the pectoral arch overlaps the neck.

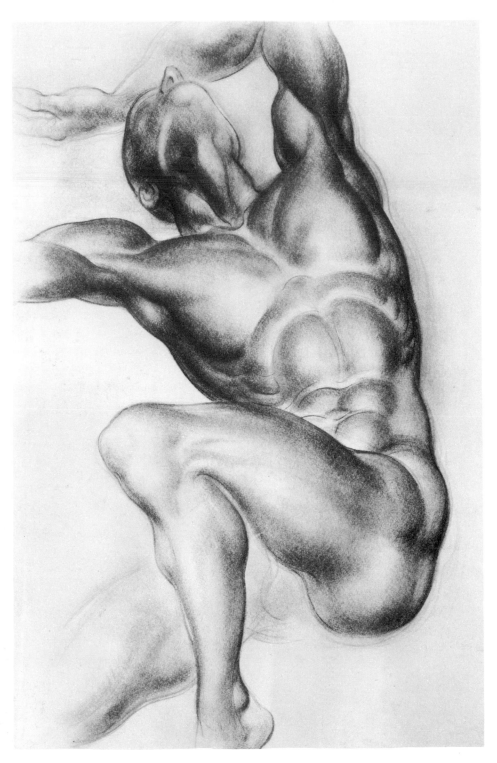

This torso, shown upview front, reveals how much larger the mass of the chest is compared with its attached members, the head and shoulders.

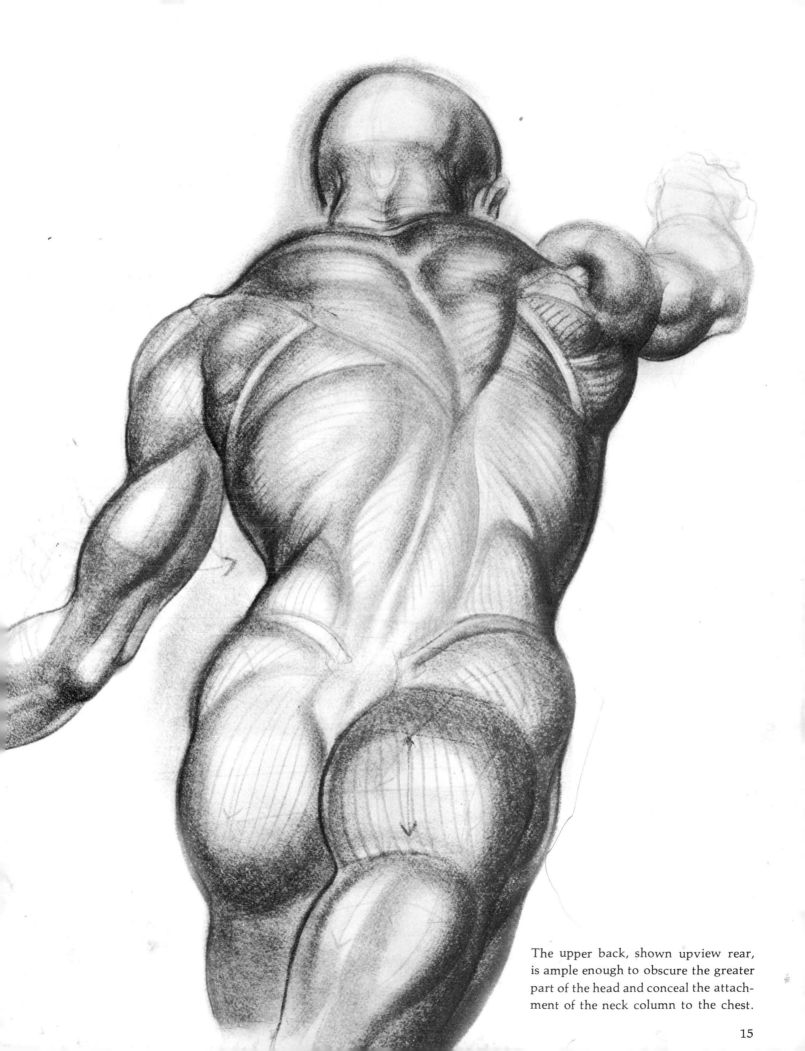

The upper back, shown upview rear, is ample enough to obscure the greater part of the head and conceal the attachment of the neck column to the chest.

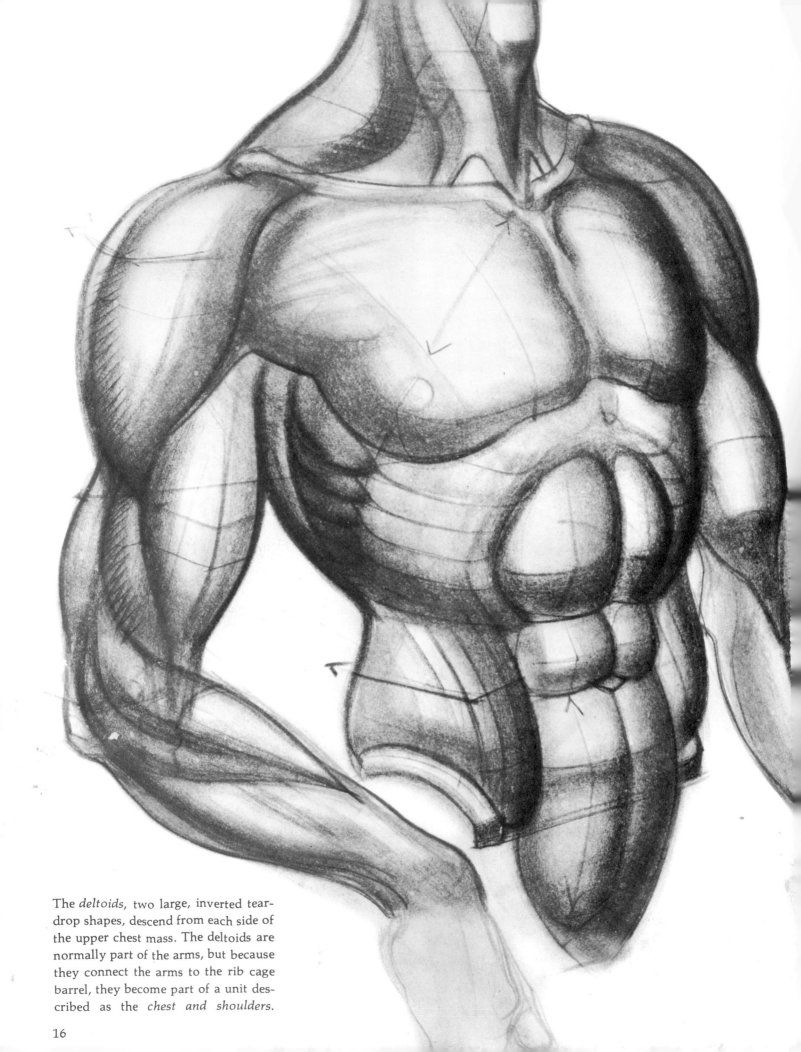

The *deltoids*, two large, inverted tear-drop shapes, descend from each side of the upper chest mass. The deltoids are normally part of the arms, but because they connect the arms to the rib cage barrel, they become part of a unit described as the *chest and shoulders*.

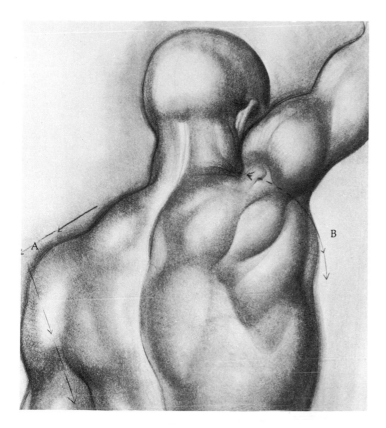

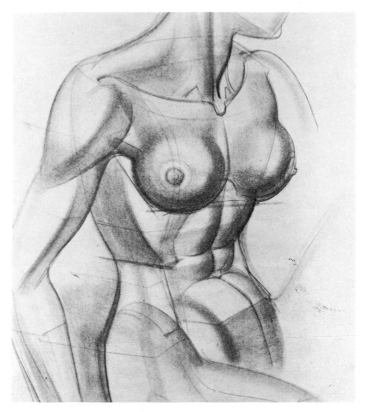

When the *chest and shoulders* are considered as a combined form, we must be aware of a change in appearance in the upper chest mass: with the arm down (A), the shoulder merges with the chest (in this position, the upper torso takes on the qualified appearance of a *wedge*); and with the arm upraised (B), the shoulder lifts from the chest, exposing a *barrel* shape (above).

Special note should be made of the drawing of *female breasts* on the rib cage. In general appearance, the young adult female breast has the look of an overturned teacup positioned at the lower angle of the chest (above).

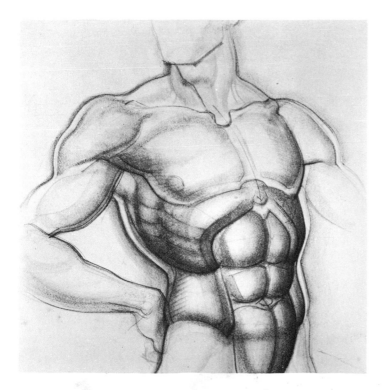

The diaphragm arch appears as a great, vaulting tunnel of bone at the base of the front of the chest. From this opening, like the hollow bottom of a brandy bottle, the long abdominal mass emerges and descends in three undulant stages, or tiers. It should be observed that the terminal belly form (the third tier), starting at the lower level of the navel and compressing to the pubic arch, is not only the largest of the three stages, but is roughly equivalent in size to the frontal head mass of this figure (left).

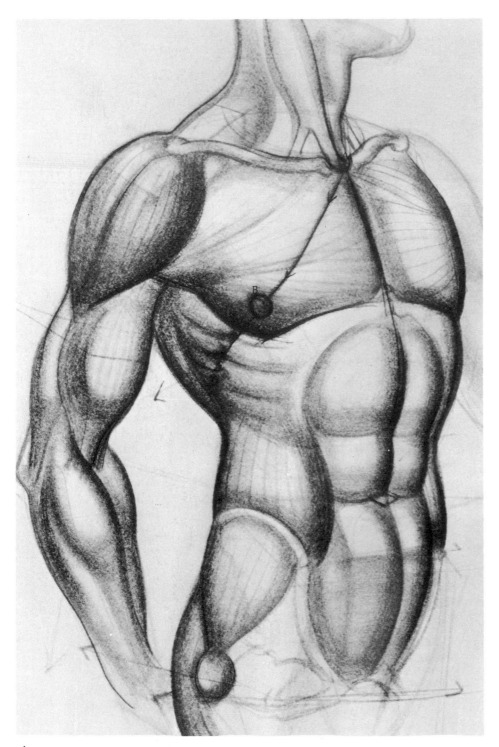

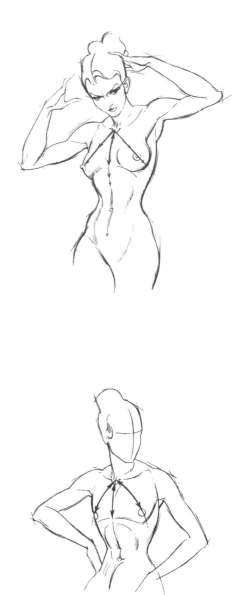

△
To place the breast correctly, it is necessary first to find the position of the *nipple* on the chest muscle. Using a male figure (for the sake of clarity), we start at the pit of the neck where the collarbones join (A). From this point, we plot a curve at a 45° angle to the vertical, central line of the body, which follows the barrel shape of the rib cage and progresses outward and down across the chest. The nipple disc (B) is located on this line just above the deep corner margin of the chest muscle.

△
If we draw two 45° lines outward from the center body line to the right and to the left across the chest barrel, we can correctly place the nipples on the chest base (above).

When the cuplike breasts are superim-▷ posed on the nipple positions, and the discs are advanced to the surface of the breast mounds, note that *both* breasts point off the curve of the chest at a *combined* angle of 90° (right).

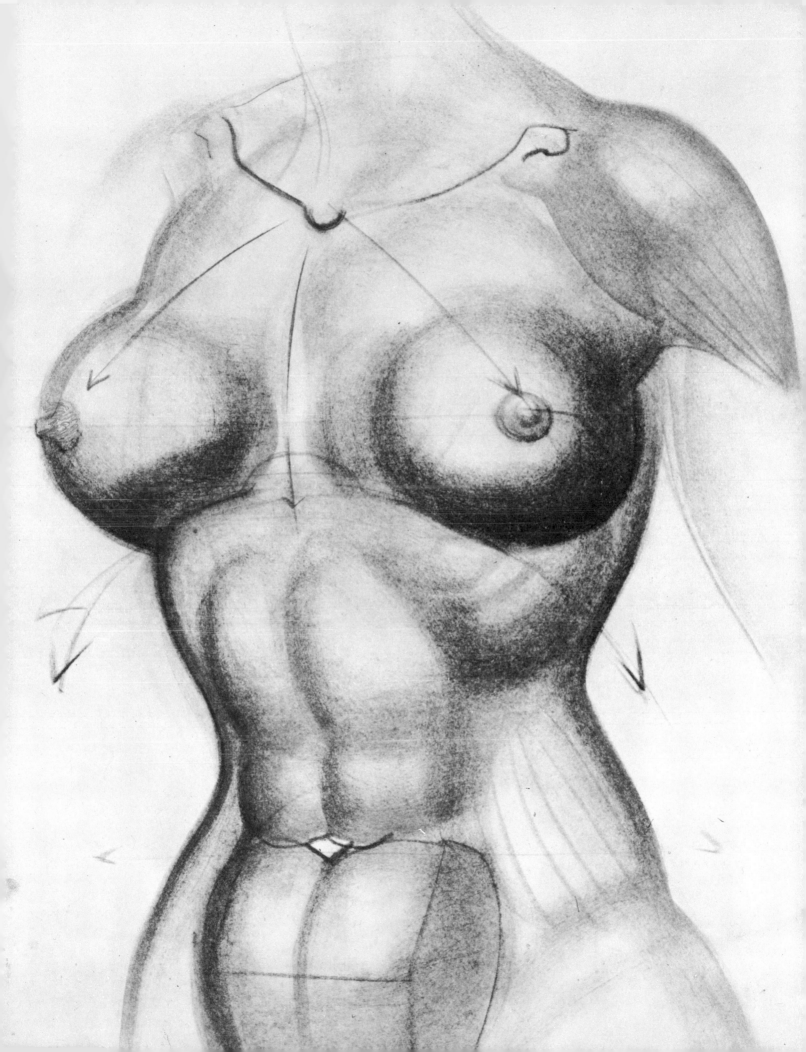

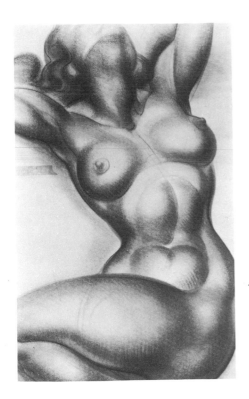

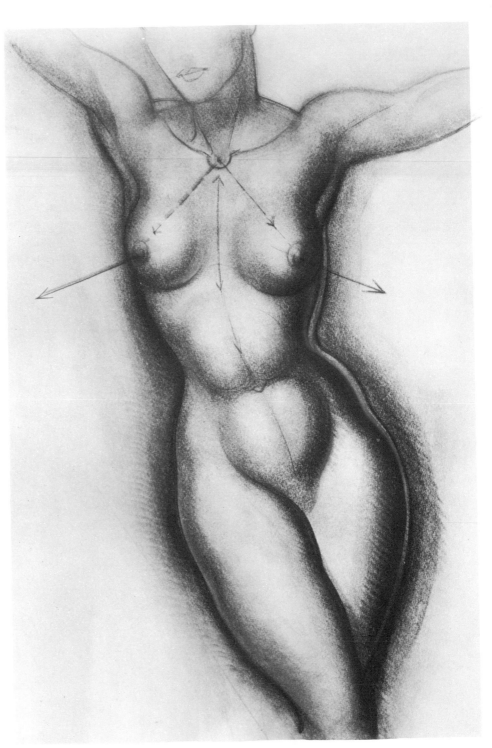

When both breasts are shown, especially in a three quarter view, they can *never* be seen simultaneously from a direct, frontal position. One breast will be seen with its centrally located nipple disc face on, while the other will be seen in a side view, with its nipple projecting in profile.

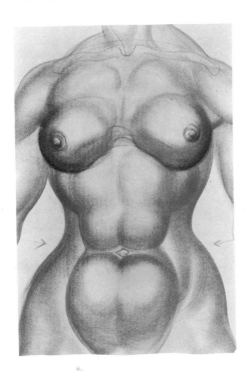

In observing the full front view of the body, note an interesting contradiction: *neither* breast is seen frontally; *both* breasts in this case point *away* from the direct line of vision in an off-angle, outward direction.

Observe the positioning of the nipple discs; check the 90° angle at the pit of the neck for the correct placement of the nipples.

The Wedge Box of the Pelvis

The lower torso (the pelvic mass) has the general shape of a wedge box, in direct contrast to the upper torso (the rotund barrel of the rib cage). After the rib cage, the pelvic wedge is the second largest mass of the body. Locked to the barrel by the tapering muscles of the waist, the wedge box is narrow at the top, broader at the base.

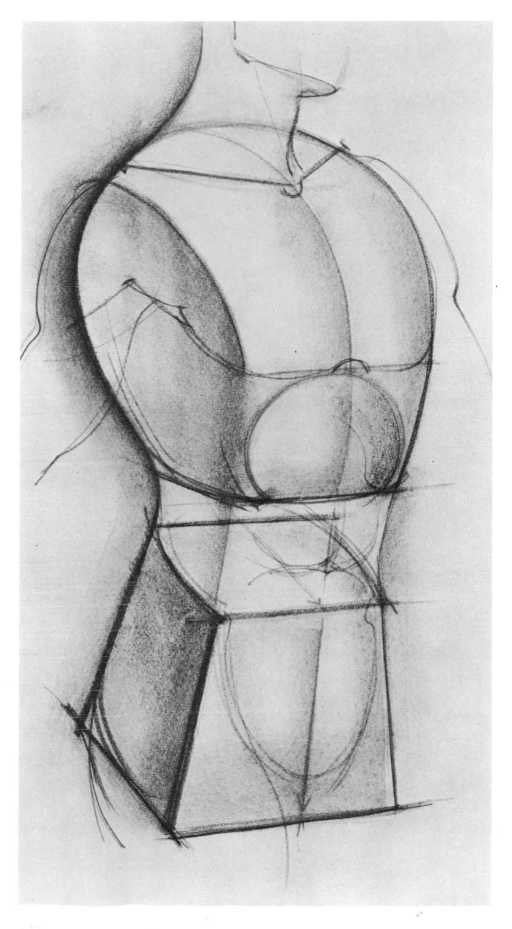

Schematic rendering of the two torso masses: the wedge box of the pelvis and the barrel of the rib cage.

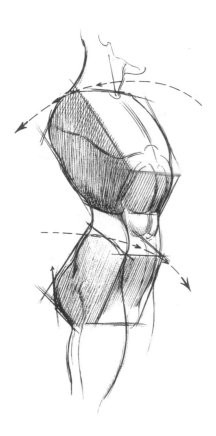

In the normal, erect attitude of the body, the two torso masses express an inverse, counterpoised relationship: the barrel is tipped back, the shoulders are drawn rearward, and the chest facade is exposed.

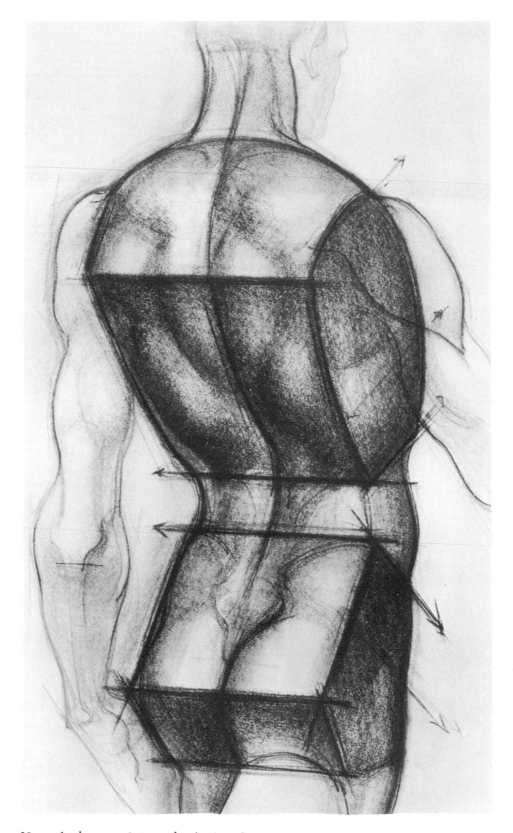

Here, the lower pelvic wedge is tipped forward, the underbelly is recessive, and the rear buttock area arches upward into view.

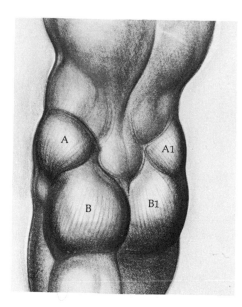

In a rear view of the lower torso wedge, the pelvic region is seen as a compound form with a *butterfly* shape. The wide gluteus medius masses, under the arched hipbones, form the *upper* wings (A, A1), and the thick gluteus maximus masses (the buttocks) form the close-set *under* wings (B, B1).

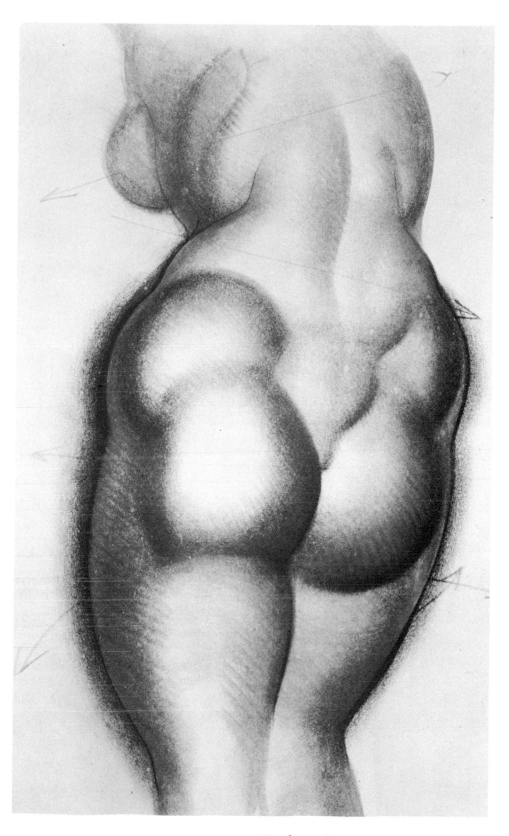

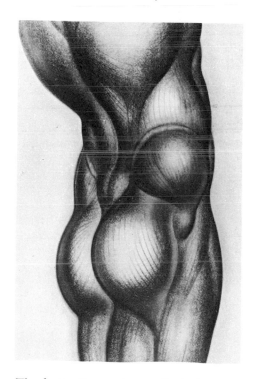

The butterfly wedge easily indentifies the pelvic wedge masses in this rear, almost side, view. The wing forms are overlapped and foreshortened from front to back.

The butterfly configuration is ·evident in a rear view of the mature female pelvic mass. Note the relatively larger hip structure, both in width and in bulk, compared to the upper chest mass. A narrow rib cage combined with a wide pelvis identifies the female torso and is a distinguishing characteristic of male-female differentiation.

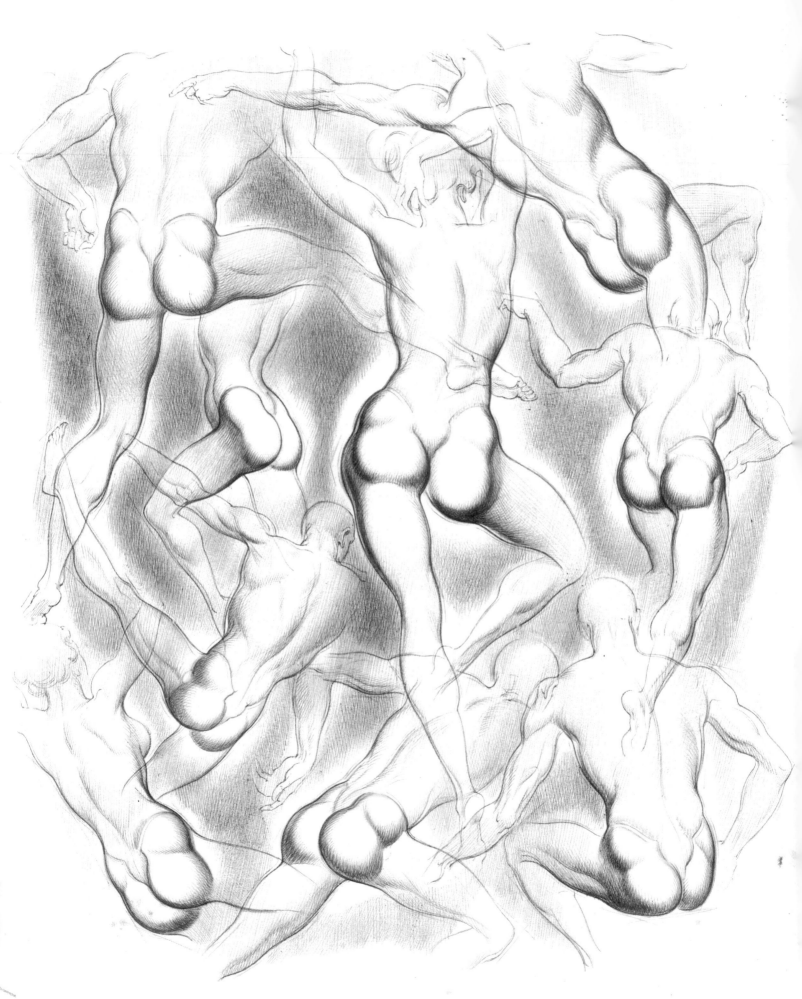

24

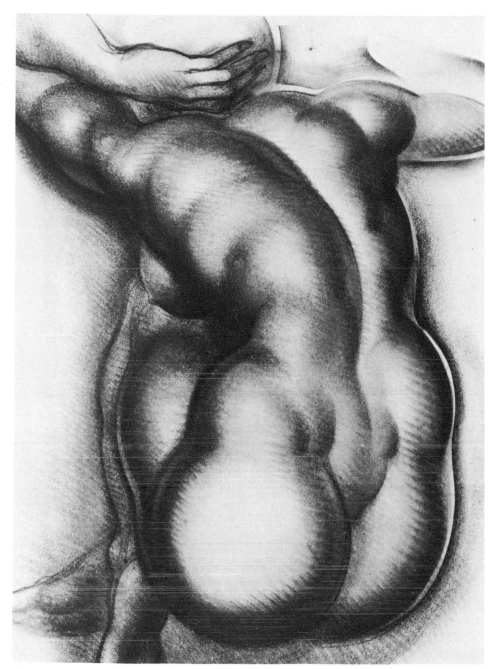

△
When the two torso masses are joined, the result is a compound torso which assumes the simplified form of a massive *kidney* shape (above).

△
The kidney shape of the combined torso masses is characterized by the distinctively narrow waist of the body, the flexible central axis between the upper torso (the rib cage barrel) and the lower torso (the pelvic wedge). The waist, because of its axis-like quality, is capable of great versatility of movement.

◁ In this series of sketches, the butterfly device is shown to be an easily established point of reference and an aid in drawing any rear view of the pelvic forms of the lower torso (left).

Column Forms of the Arms and Legs

The arm and leg masses have a general similarity and correlation of form. Described simply, the arm and the leg are elongated, jointed two-part members, each of whose parts has a modified cone or cylinder shape.

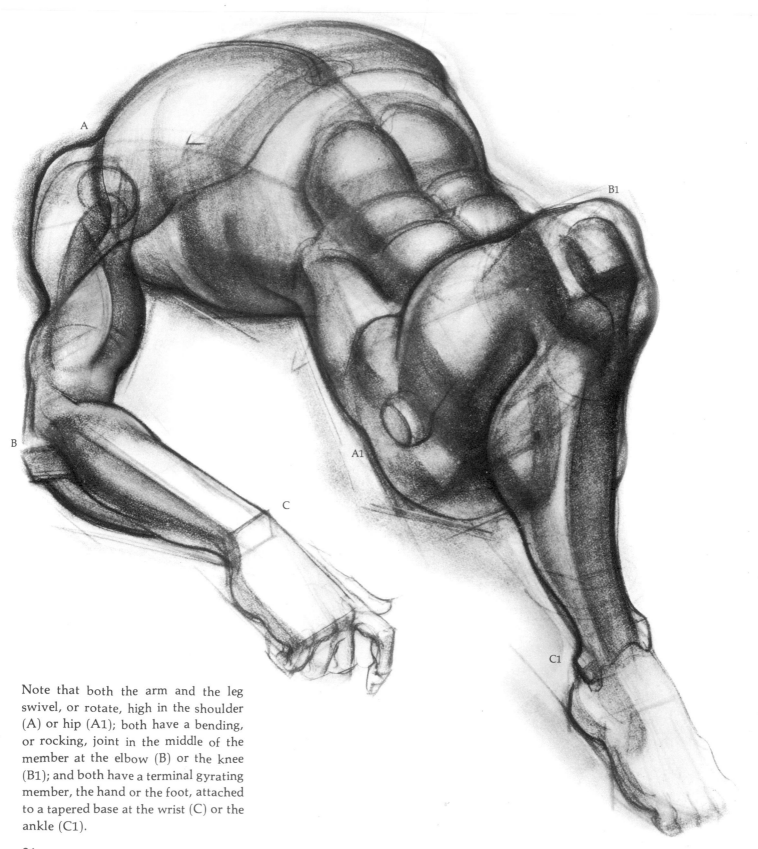

Note that both the arm and the leg swivel, or rotate, high in the shoulder (A) or hip (A1); both have a bending, or rocking, joint in the middle of the member at the elbow (B) or the knee (B1); and both have a terminal gyrating member, the hand or the foot, attached to a tapered base at the wrist (C) or the ankle (C1).

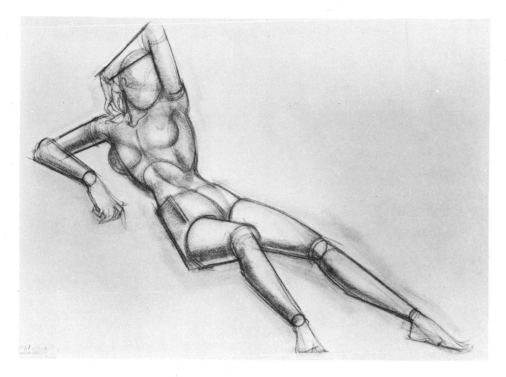

In this female figure, the arms and the legs have been given a straightforward, cylindrical appearance and have been joined to an equally simplified chest barrel and pelvic wedge. Rendered in this schematic way, forms take on a hard, uncompromising appearance. Their value is clear if we accept them as being merely a primary stage in drawing which permits us to see forms directly in the round, as whole entities related to adjacent, different forms. Using this simplified method of figure notation is a way of understanding and setting down the volume masses of the figure in correct proportion.

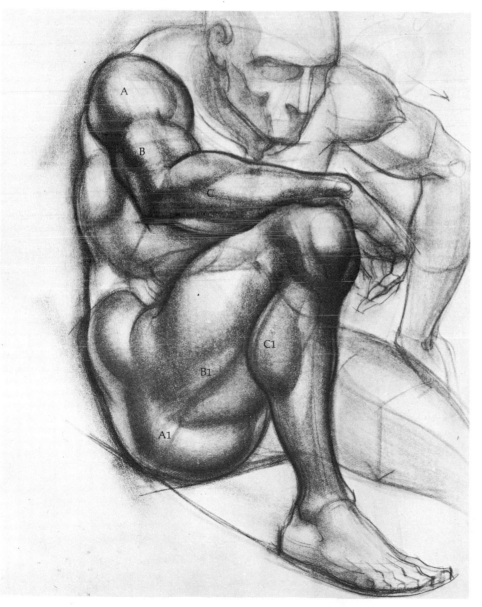

Both the arm and the leg are surmounted by a broad, compact mass high on the upper member: the *deltoid* muscle at the shoulder (A); and the *gluteus* muscle below the hip (A1). The two upper members of the arm and the leg reveal two extended, centrally located form volumes: the *biceps* and the *triceps* masses of the arm (B); and the *hamstring* and *rectus* muscles of the leg (B1). The lower members of the arm and the leg show lesser double volumes: the *flexor* and *extensor* bulges of the forearm (C); and the *calf* muscle mass of the lower leg (C1).

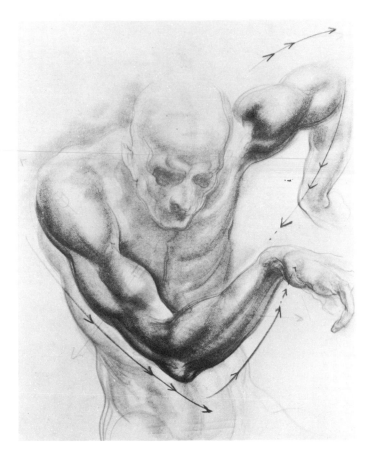

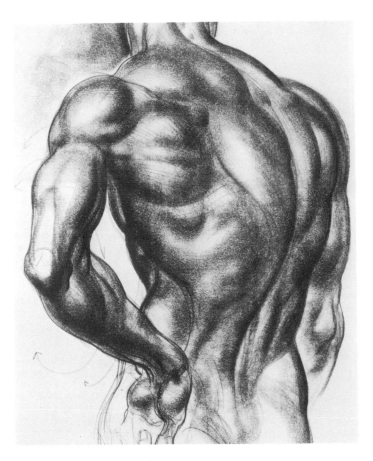

For all their similarity, the arm and the leg have decidedly different structural rhythms. In the arm, for example, a consistent *upward*-curving rhythm is present along the entire *underarm* length from shoulder to elbow, and from elbow to wrist (see arrows).

The curving rhythm of the arm in a rear view. The elbow turns out; therefore, the underarm lifts and the line takes a clear *overcurve*.

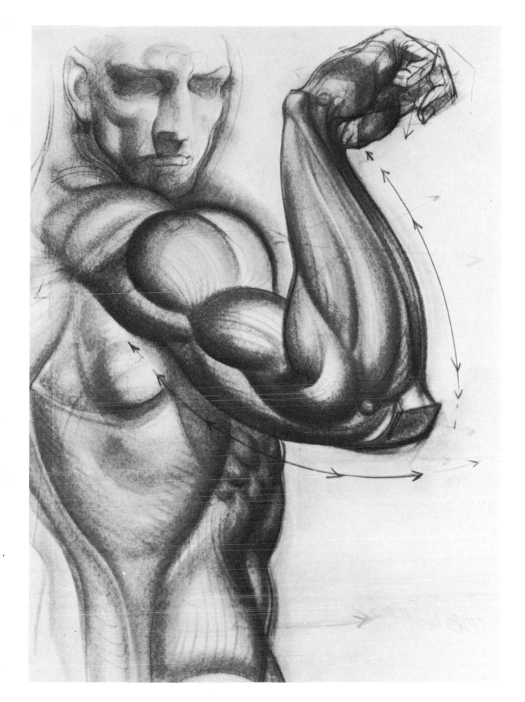

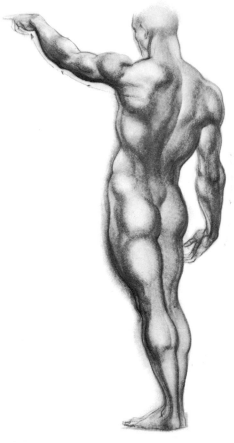

The clue to the underarm curve is found in the position of the *elbow*. Locate the elbow, and you will be able to trace the line upward toward the rear armpit; the lower line can be followed from the elbow down to the base of the outer palm. No matter how the arm moves, from simple positions, such as the two extended arms shown above right, to deep, active bends (left), the consistent undercurve is always present. Invariably, this curve provides the basis for the arm's structural rhythm.

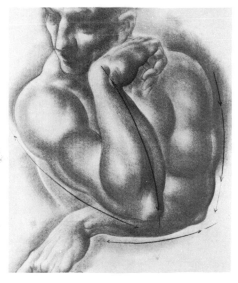

A frontal figure with arms flexed and foreshortened shows the correlation of double curves (see arrows).

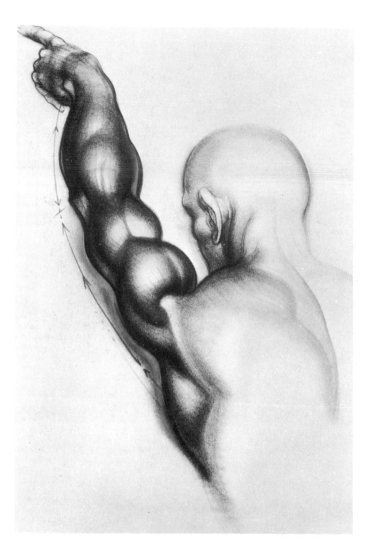

◁ An arm in deep space extension gives us the underarm double curve (see arrows), proof of the arm's unvarying structural rhythm (left).

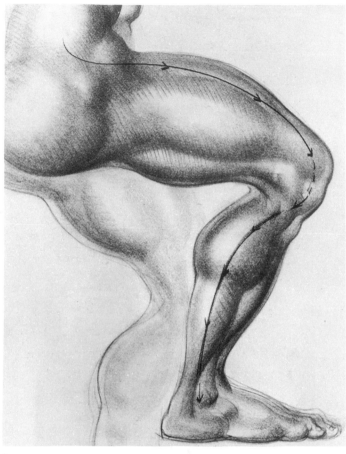

△
This side view of the right leg, bent at the knee, shows the structural rhythm of the bent leg clearly indicated (see arrows) with an *S*-line curve (above).

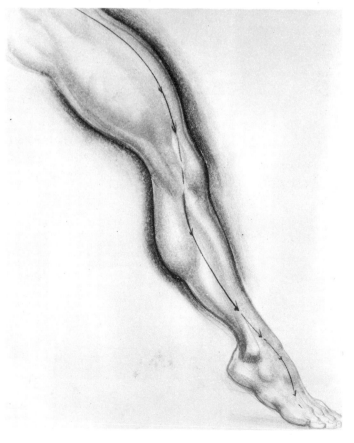

◁ The leg has *two* structural rhythms, one for the *front* view and one for the *side* view, each of which is decidedly different from the other. This side view of the right leg shows a long *S*-line curve taken from the active thrusts of the leg muscles (see arrows). This *S*-line starts high on the front thigh, reverses at the knee, and moves rearward down the calf bulge (left).

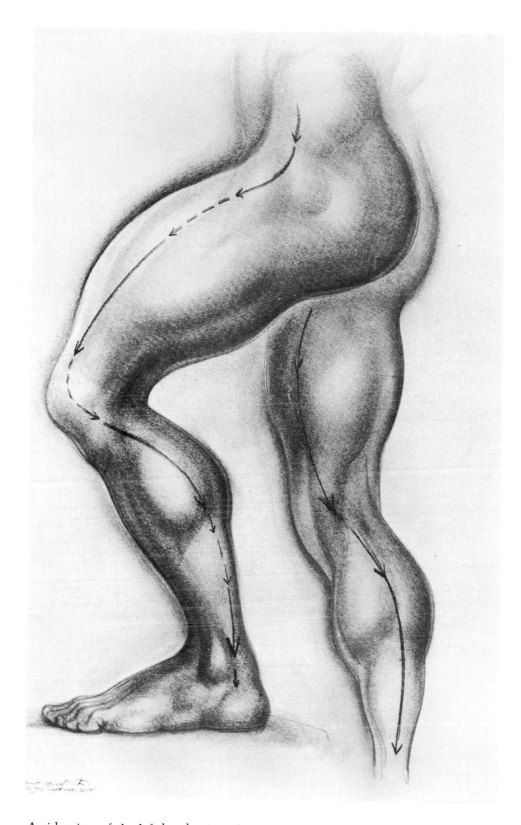

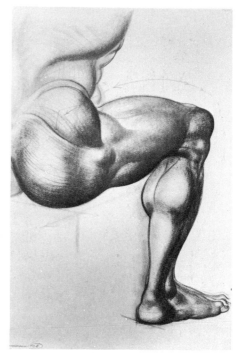

A three quarter view of the leg of a seated figure seen from the rear. The S-line curve of the leg (see arrows) shows how clearly the structural rhythm of the leg can be seen. While the S-line rhythm establishes a guideline for drawing side views of the legs in many different positions and movements, there is a point where we find a *frontal* appearance beginning to overrule the *side view* position. As our viewpoint changes from indirect *side* to indirect *front* view, how can we know when the critical point of change has been reached? This question is answered by looking at the position of the *anklebone* projections. *The rule of the side view leg is:* an anklebone *enclosed* by the lower leg contours generally represents a *side view orientation.*

A side view of the left leg, bent at the knee, shows the S-line curve governing the action of the leg. The erect, far leg (the supporting leg) is in a three quarters position, turned slightly away from side view; but the S-line is still evident in it because the rhythm of the leg structure has a basically side view orientation.

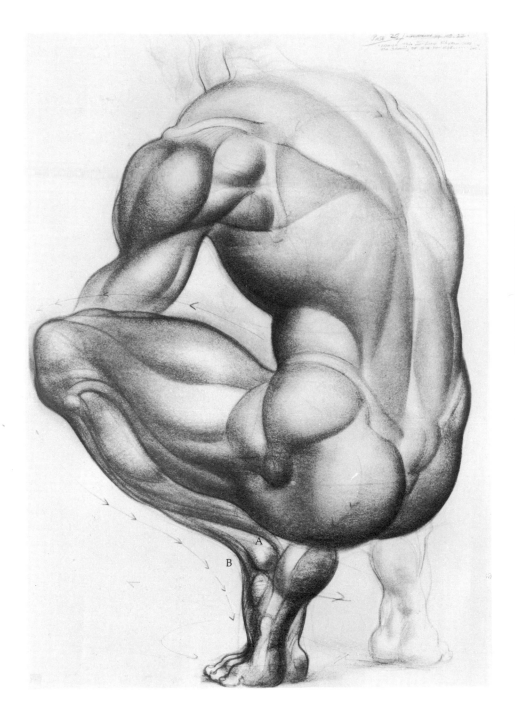

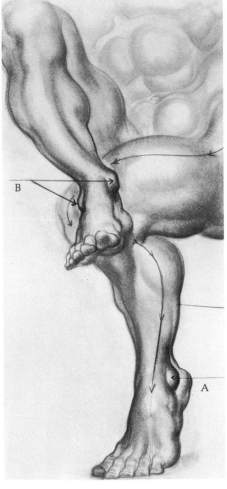

In this figure, the outer anklebone (A) is *inside* the contour of the left leg (B); hence, we take a *side view*, *S*-line rhythm approach (see arrows).

In this figure, a dual approach of the *frontal* leg and the *side* leg is dictated by the rule of the anklebone position. The lower (right) leg shows the anklebone held *inside* the leg outline (A), resulting in a *side* view, *S*-line curve (see arrows) which moves down on the thigh from hip to knee, then reverses from knee to ankle with a marked lift on the calf bulge. Compare this with the crossed (left) leg. In this leg, the anklebones are *exposed*, protruding beyond the outlines of the ankle (B); hence, it takes a *front* view orientation.

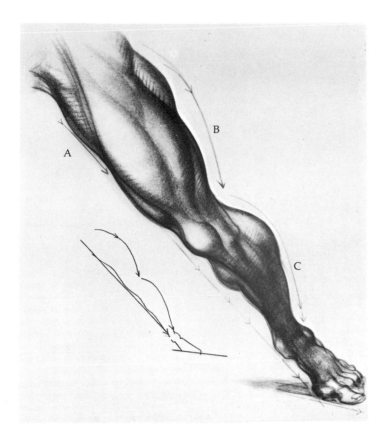

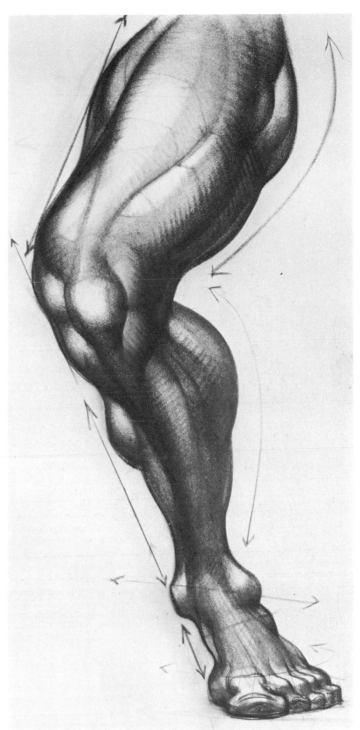

The structure of the leg when seen from the front takes on the appearance of an elongated *B*-shape (see diagram to left of drawing). In relating this diagram to the leg, the *straight* line of the *B*-shape will be seen on the *inside* length of the leg (A), tending to control all form bulges from pubis to knee to ankle, and in most cases the foot as well. The *outer* leg contour consists of a *double curve*, the curved part of the *B*-shape. This double curve can be seen on the *outside* of the leg (see arrows), moving down from hip to knee (B), and from knee to anklebone. (C). The small line diagram to the left of the drawing shows how the *B*-shape is applied in the conception of the front view leg as a simple beginning of the final workup beside it. *Here·is the rule of the front view leg:* When the anklebones *protrude* beyond the contour of the leg, the entire leg may be thought of as a *front view leg* and can be expressed in an elongated *B*-shape.

The *B*-shape rhythm of the front view leg accounts for all manner of leg bends and actions. In this figure, we see a front view leg with a bent knee; the straight *B*-shape line is given a corresponding break. Note the exposed anklebones. Once again, these protruding anklebones immediately signal a frontal leg approach, and call for a *B*-shape control of forms (see arrows).

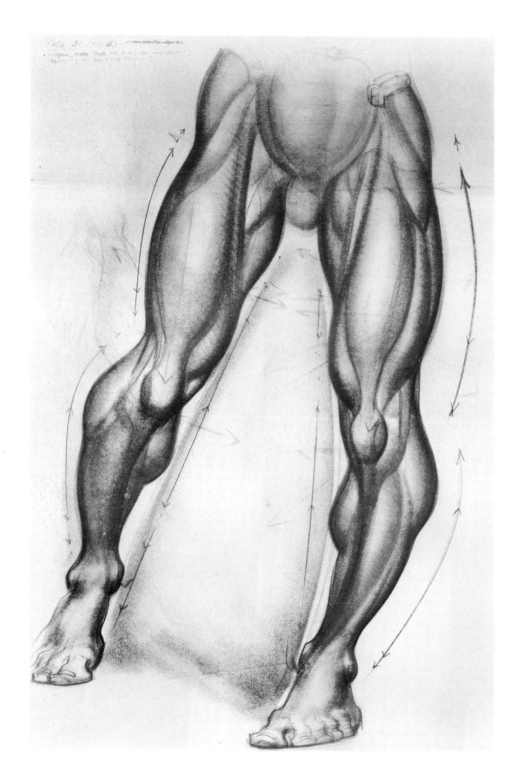

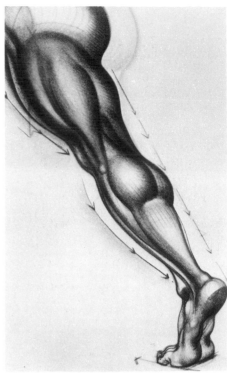

Rear view legs, without exception, follow the front view leg rule: exposed anklebones dictate a *B*-shape approach. Note the *reversed B*-shape in this three quarter action, rear view leg.

In these legs, notice the marked *inward* curve to the center of the body line. This inward curve especially applies to *all shinbones* (tibia). In this example, the inward curve of the shinbones has been accentuated (not an uncommon thing in many persons) in order to illustrate a variant of the straight control line of the *B*-shape formula for the front view leg: the straight line of the *B* can be expressed with a slight over-all curve (as was done here) to hold the inner leg forms in check.

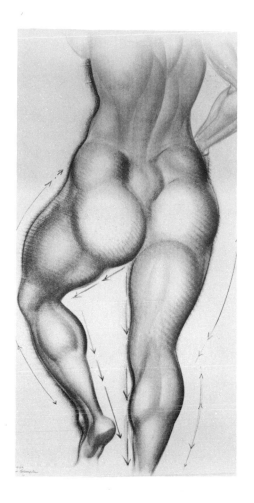

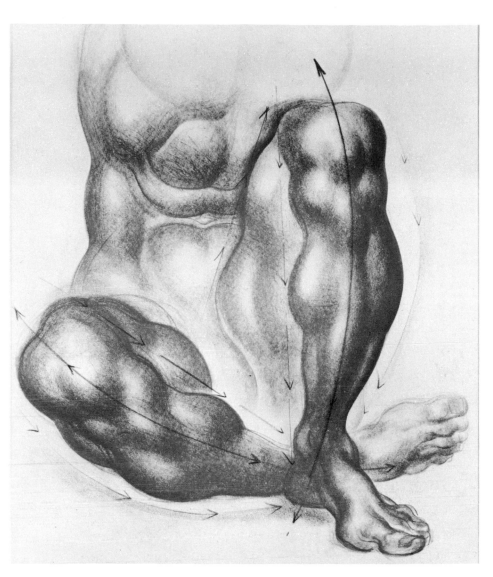

In this example of two rear view legs, the left knee bend produces a corresponding break in the inside line of the B-shape.

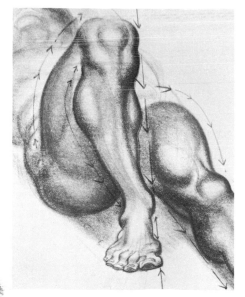

In looking at this figure projected into deep space, see how easily the B-shape works to orient the legs in this difficult view (see arrows). The position of the anklebones tells us that the approach must be frontal.

In these front view legs in a hunched, crossed-over position, curved accents have been inserted on the line of the shinbones to emphasize their inward curve. The problem of arranging flexed, overlapped legs is easily solved by using B-shape controls.

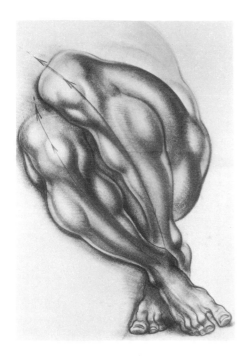

Here is another example of crossed front view legs in a cramped position. Only the accented shinbone curves have been drawn in; the *B*-shape controls have been left out, and the reader is urged to study the drawing and determine them himself.

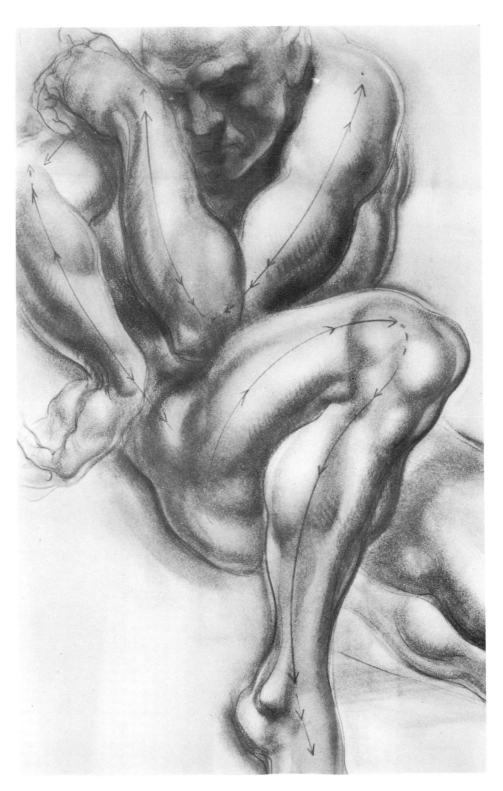

This figure is added here so that we may recapitulate and combine two of the earlier discussions of the different structural rhythms of the extremities: note the *double curve continuity* of the upper and the lower arms (see arrows); the upthrust bent leg is expressed in the *S*-line curve of a *side view orientation*, because the anklebone is held *inside* the leg contour.

Wedge Masses of Hand and Foot

The terminal forms of the extremities, the hand and the foot, are decidedly *wedgelike* in character. These two wedges, however, are very different in structure. In the two examples which follow, the wedge forms of the hand and the foot have been supplemented by companion sketches to show the unique character of each.

The hand in the drawing to the right shows how the fingers *separate* and become extremely active, performing an immense variety of actions. The foot in the drawing below shows its subsidiary toes to be *closed* and compactly arranged. The great toe, different from its opposite member, the thumb, lies *adjacent* to its smaller neighbor toes; the thumb, on the other hand, *opposes* all the fingers of the hand. Thus, we note the basic difference between the hand and the foot: the hand is a *tool*; the foot is a *support*.

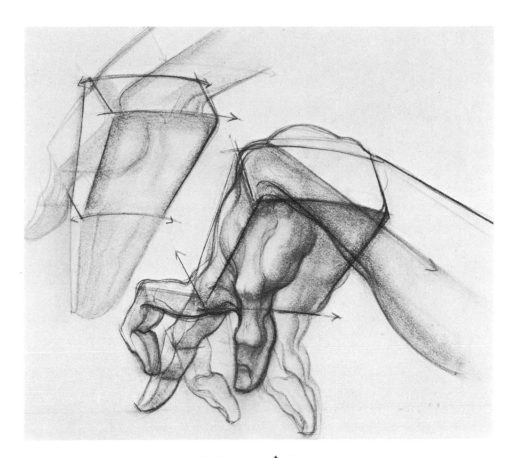

△
The shape-mass of the hand is broad, flat, and generally spatulate; it is thickset and wide at the rear palm where it joins the arm, and narrower and shallow at the fingers.

◁ The shape-mass of the foot is a broad-based wedge, showing a remarkably high, triangulate elevation at the rear, from whence a steep diagonal descends to the front.

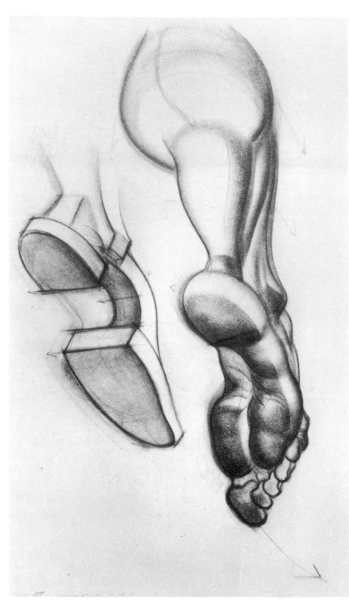

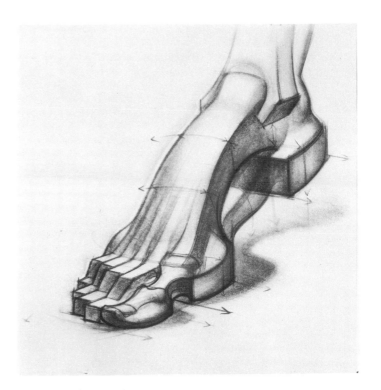

The front sole divides into two sections: (1) a platform support next to the arch; and (2) the five close-set toes in front. The toes differ from the platform support in their function; they act as traction and projection devices — gripping and pushing.

The foot wedge is a compound form that consists of three main parts: (1) the thick heel block in back; (2) the larger ellipsoid sole base in front; and (3) the interconnecting span of the arch, which bridges and holds together the heel and the sole.

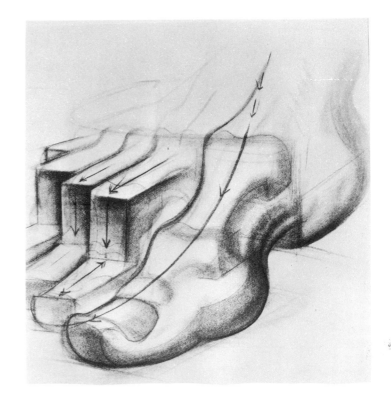

The toes reveal a high, upthrust rise of the large toe tip, contrasting sharply with the downthrust, closed pressure of the small toes (see arrows).

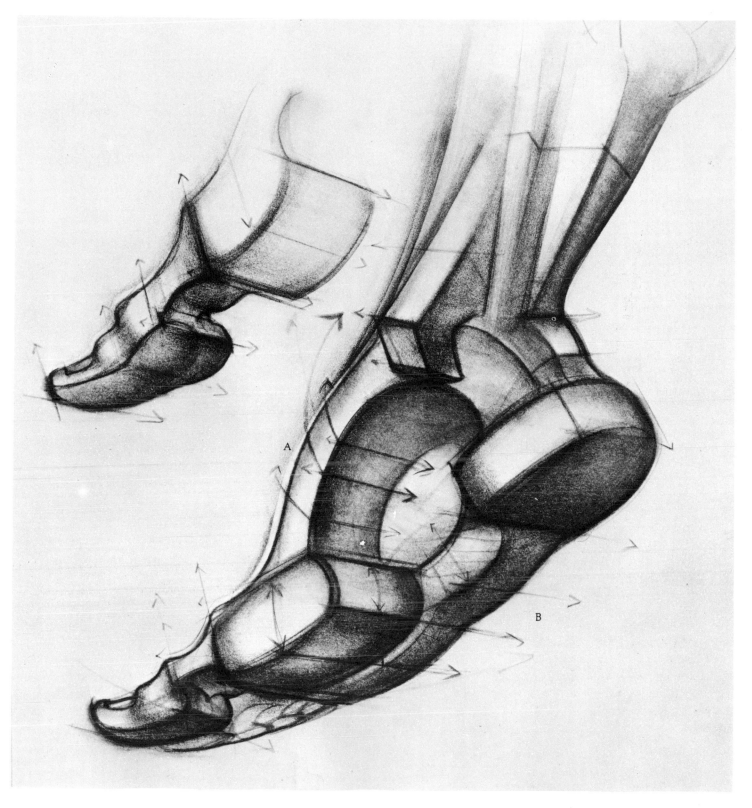

Of major significance in describing the foot is the deeply curved instep formed by the high, open arch (A) connecting the base supports of the heel and the sole. Viewing the instep from the underfoot surface, we see that the foot base supports are connected in another way by the long elliptic ridge (B) of the outer foot. Note the differences between the inner and the outer foot connec- tions: the outer foot gives *continual* surface contact, while the inner foot contact is *interrupted* by the open arch of the instep. *A secondary note:* The great toe (small sketch) shows an arch, effective though small, bridging the front toe pad and the large, rear sole pad — a relationship not unlike that in the great foot arch proper.

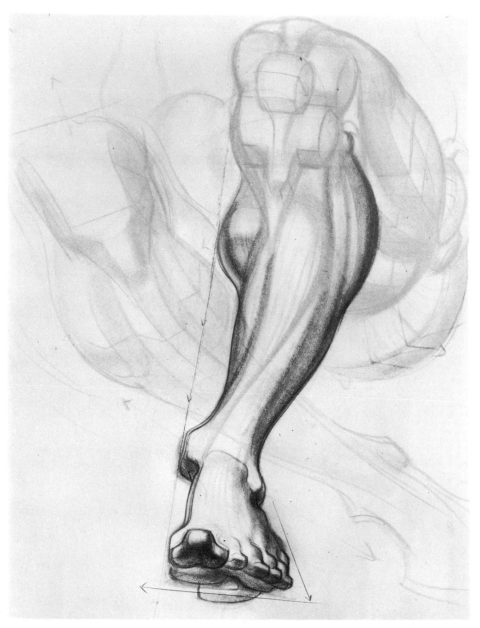

From the front, the foot wedge has the appearance of a wide, high block shape with a steep forward ramp on its top surface. This slope ends in the quick upcurve of the tip of the large toe. This rise, seen from the immediate front, shows the toe tip thrusting up from the base plane of the foot (left).

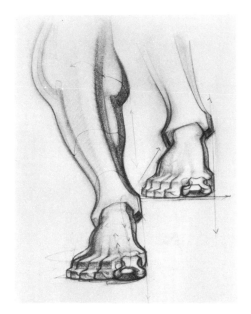

The wedge of the front foot, showing stepped toes, contrasts with the upthrust large toe. Note the inside arrow control line which holds inner forms in check (above).

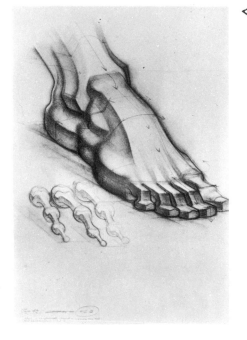

Toes, like fingers, show miniscule rod and ball construction (small sketch): the rod forms relate to the narrow shank structure of each digit; the ball forms represent the knuckle capsule arrangement. Because they are quite small and close-set, the toes are frequently difficult to draw without distortion when done in this way. A more agreeable solution, therefore, may be seen in the *step arrangement* (large drawing) of the toes. In the step arrangement, the toes emerge from the sweeping descent of the arch and close down in a three-stage formation which resembles a short flight of steps. There are *two horizontal steps* on each of the small toes with a *vertical riser* in between (left).

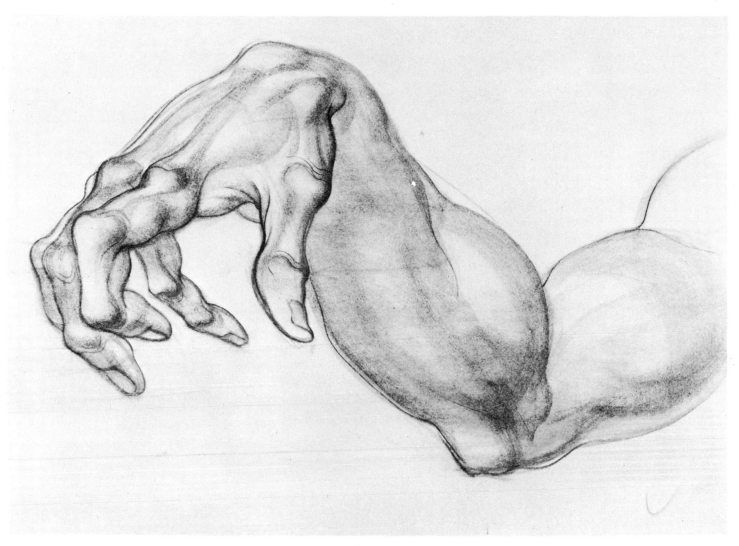

△
The rod and ball construction of the hand derives from its internal skeletal structure. It is the skeletal structure which is plainly responsible for the hard, bony surface throughout the upper palm and fingers (above).

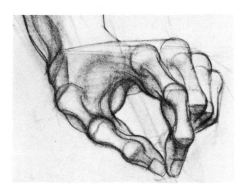

△
The fingers are remarkably longer and more flexible than the toes. They tend to override the plane of the palm easily in active contrapositions which are not possible in the passive, closed toe system of the foot.

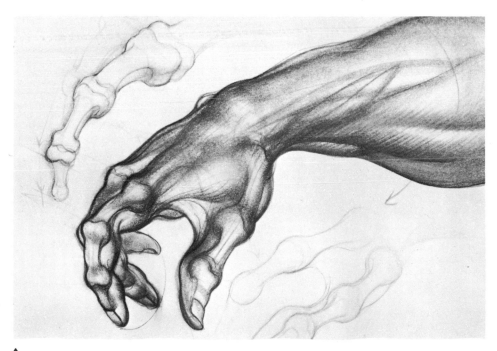

△
The hand, like the foot, gives us a set of rod and ball constructions in the alternating bone shanks and knuckle capsules of the fingers.

41

The visible rod and ball forms of the ▷
hand develop a rising and falling rhythm
which gives a *wavelike* motion to the
entire finger system, all the way down
to the fingertips.

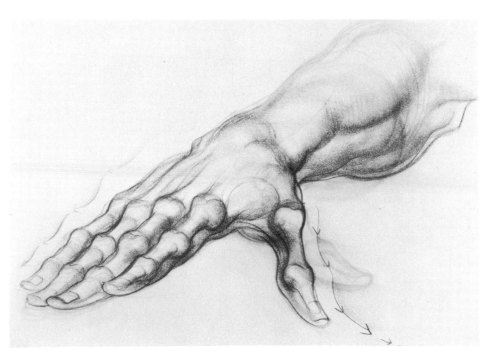

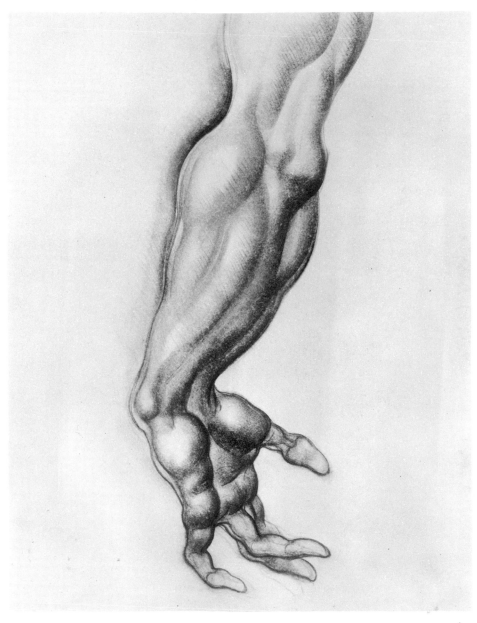

◁ The bottom of the hand is soft, fleshy,
and cushioned throughout, revealing
three large padded cushions: (1) the high,
ample thumb mound; (2) the tapered,
lateral little-finger cushion opposite; and
(3) the low, horizontal row of palm pads
bordering the fingers. The finger units,
too, are thickly protected with a fleshy
mantle. *A special note of interest:* The
tri-cushion arrangement of the palm
leaves a triangular depression in the
center region whose apex points up-
ward to the mid forearm (left).

After studying the general rod and ball ▷
finger forms, we must call attention to
the thumb. The thumb is the key finger
of the hand, and with its striking wedge
shape, is built like a thick spade, or
spatula. The initial form of the thumb
is a narrow length of shank bone topped
with a squarish head (A). The thumb
narrows, then spreads wide with a
heavy pad (B). It tapers to the tip (C),
and swings from its base upward in a
strong, curved rise (D). The thumb,
unlike the other fingers, does *not* lie on
a horizontal plane equal to the palm
wedge. It assumes a contrary, tipped-
over position which is obliquely
opposed to the mutual, flat arrangement
of the other four fingers. Also, the
thumb tends to drop quite far below
the level of the palm (right).

42

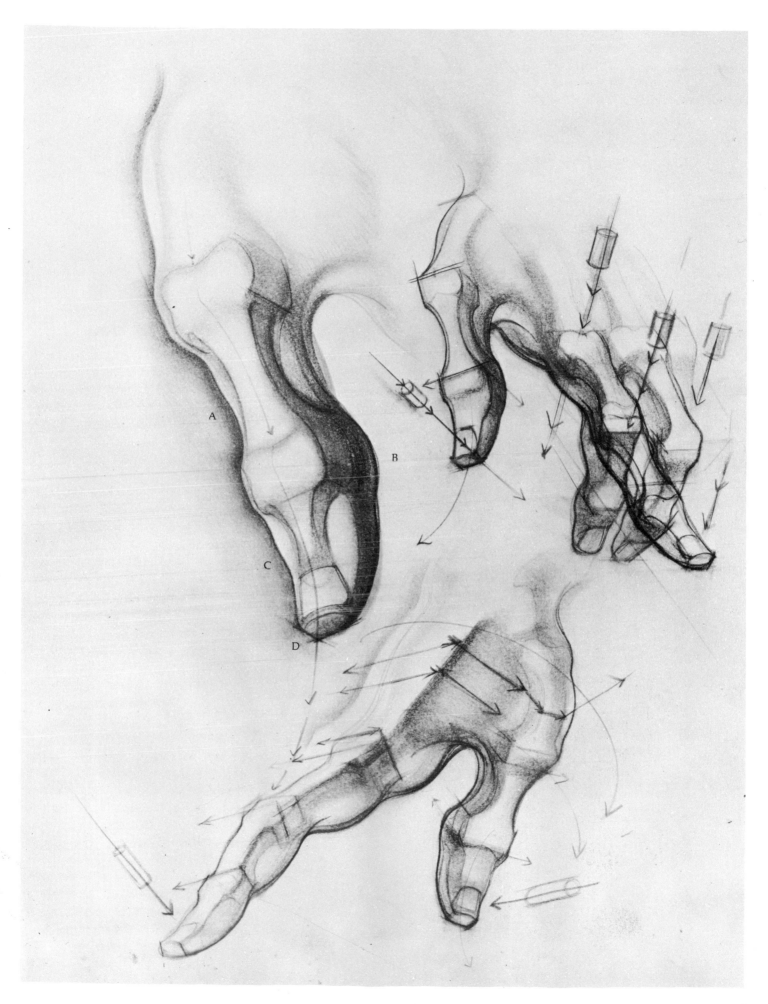

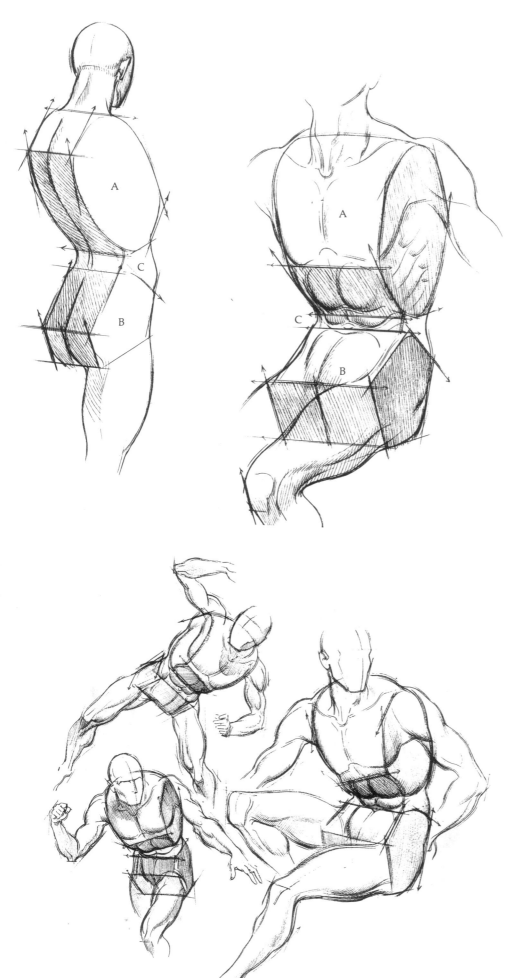

Let us start by restating the simplified description of the compound torso shape-masses in two views: an erect torso, back view (left); and a seated torso, front view (right). In both sketches, the large chest barrel (A) and the pelvic wedge (B) are joined together by the mid-axial muscles of the waist (C), a region of remarkable flexibility.

When we work with the torso masses as separate entities, we can draw a great variety of movements. The advantage of putting in the essential body planes is that it permits us to see clearly the correct angle of placement and how to attach the secondary forms. In these sketches, the masses are structured firmly, then tipped in greater or lesser degree, and shown in three quarter front views. The rudimentary head, arms, and legs are indicated here to let the viewer grasp the over-all working of the total figure.

2

Figure Notation
in Deep Space

In Chapter 1, we attempted to show the major body forms as shape-masses, conceiving them according to their differences as *solid objects in space.* This means that we have tried to define form as three dimensional volume, not simply as flat body silhouette.

Seeing the body as a flat silhouette encourages a simplistic description of the figure as a mere *area,* and a drawing of this flat shape commonly assumes the character of an outline, or contour, drawing only. Shape-mass, on the other hand, demands to be understood as volume structure in three dimensions; this makes it possible to draw the figure in deep space projections, putting the human form into the most inventive and varied conceptions of foreshortening, advancing and receding in space.

Conceiving the figure as shape-mass permits the artist to manipulate the figure creatively, part by part, making changes according to his desire, *without copying* or using file reference material. Like a sculptor working with modeling clay, the artist can structure and compose by building-up. He can alter the actions and projections of separate forms. He can revise and modify his

forms at will. But more important, he can choose to introduce radical innovations of form.

To do this, at least experimentally, the artist must approach his drawing with a *new order of form.* He must give up certain uncritical conventions and preconceived notions of figure drawing. For instance, he must put aside starting the figure by sketching in the head. He must give this up, firmly. According to the method which I propose, the *torso,* above any other form, is of primary importance. With this premise, let us initiate the new order of form and assert the opening rule. . .

The Torso is Primary

The reason for this statement will become clear after a few exploratory sketches have been made, and when we work out the following propositions. *The torso mass is the central double form to which all other forms attach. Any movement in the upper or lower torso will immediately throw the secondary forms — the legs, arms, and head — out of their previous positions and into a new relationship.*

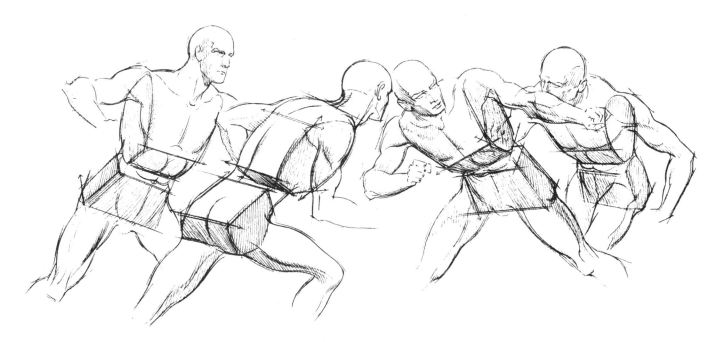

Here are four structured torsos, showing the ease with which figure notation may be indicated in a sequence of movements from left to right, front to back. It must be obvious now why the double

torso mass is instrumental. The merest movement of the rib barrel produces an immediate displacement of arms and head, while a pelvic shift compels total deployment of all the body forms.

An important drawing aid, in accommodating the changes of direction in the two-part torso, is the *center line* of the body. In this two-stage drawing, the primary torso masses are on the left, the completed figure on the right. Of crucial interest here is the insertion of the midline in both figures. Notice how this midline, or center line, gives unity and direction to the independent movements of the separate masses (right).

In movement, the separate torso masses need not face in the same direction. The midline insertion can produce *opposition* between the upper and lower forms. The clue to this opposition is the *spiral*, or *S*-line connection. Starting with a simple bend only (figure on extreme left), this series of torsos shows an *S*-line spiral insertion expressing a swivel, or twist, between the contrary views of the body masses: the rib barrel view on one side, the pelvic wedge pivoting to the opposite side (below).

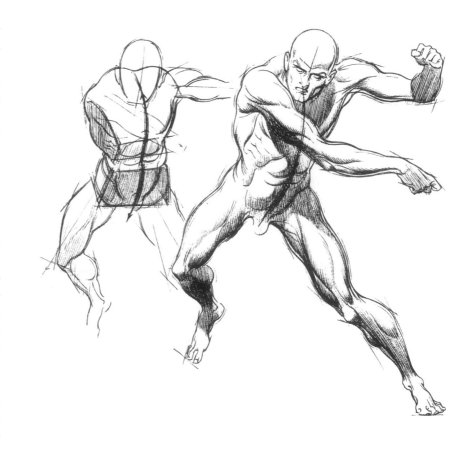

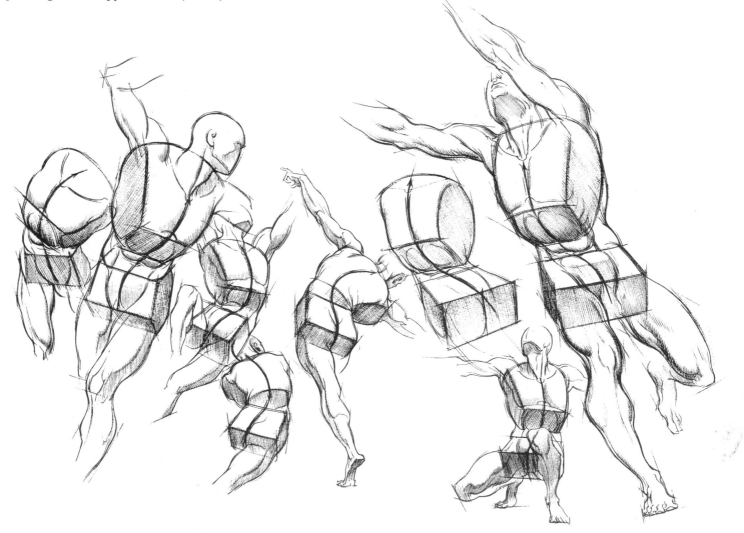

A series of figure variations showing the correlated and contrary directions of the torso masses, using the midline insertion connection. Legs, arms, and head have been added here to show how the torso, as the primary figure form, governs the positioning of the secondary parts.

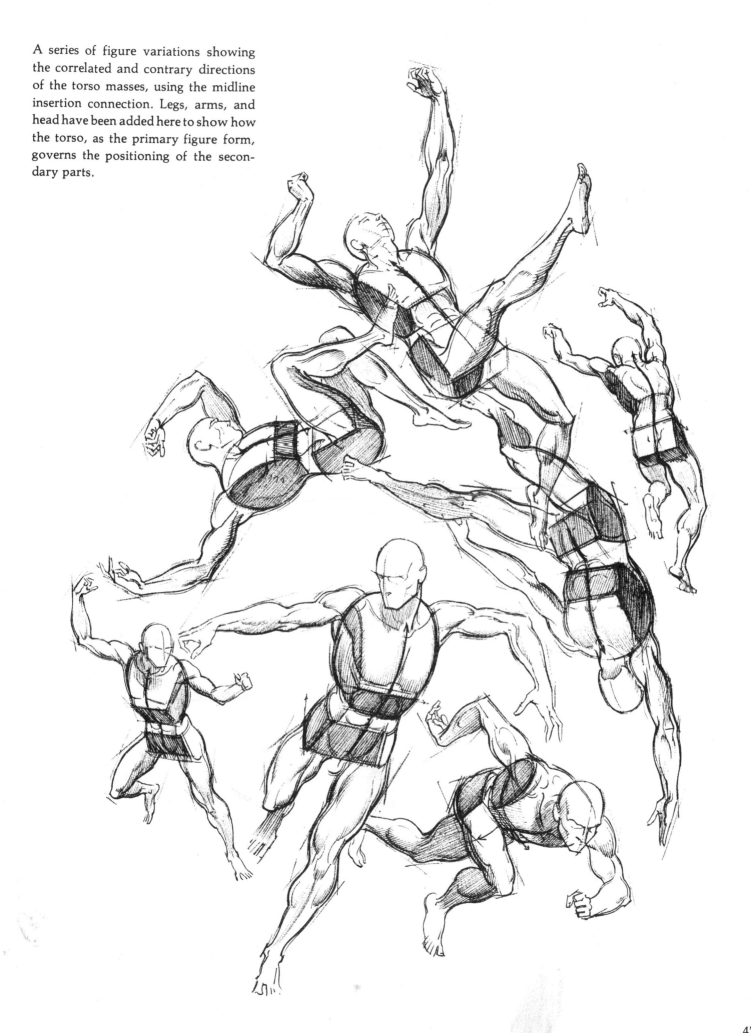

The Legs are Secondary

We have stated the necessity of using a new order of form in drawing the figure in deep space. Our initial assertion has been that the torso is first in importance. Following the primary torso masses in this notational order, our rule proposes that *the legs are secondary*.

The reason that the legs (*not* the arms) come after the torso masses is that the figure, in whatever action it takes, is for the most part related to the ground plane. It works against the pull of gravity, expressing weight, pressure, and tension; it needs leg support to sustain it. Without this support, the figure may not be able to project a convincing demonstration of exertion, effort, and dynamism. This fact also calls for a more emphatic use of the pelvic wedge than has previously been discussed. When the torso forms have been sketched in, the pelvic wedge must be clarified as to structure and direction, with the midline division well laid in so that the legs can be given their relevant attachment.

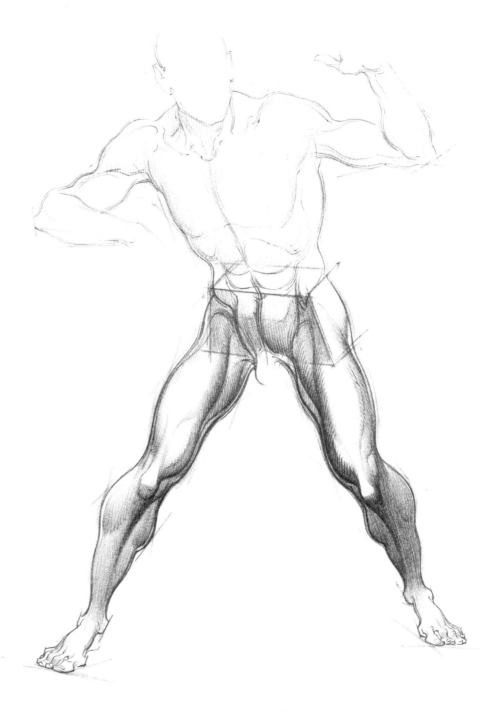

In this figure, the upper rib cage barrel has been lightly indicated. The lower torso (the pelvic wedge) on the other hand, has been explicitly defined, with the legs set into each side of it.

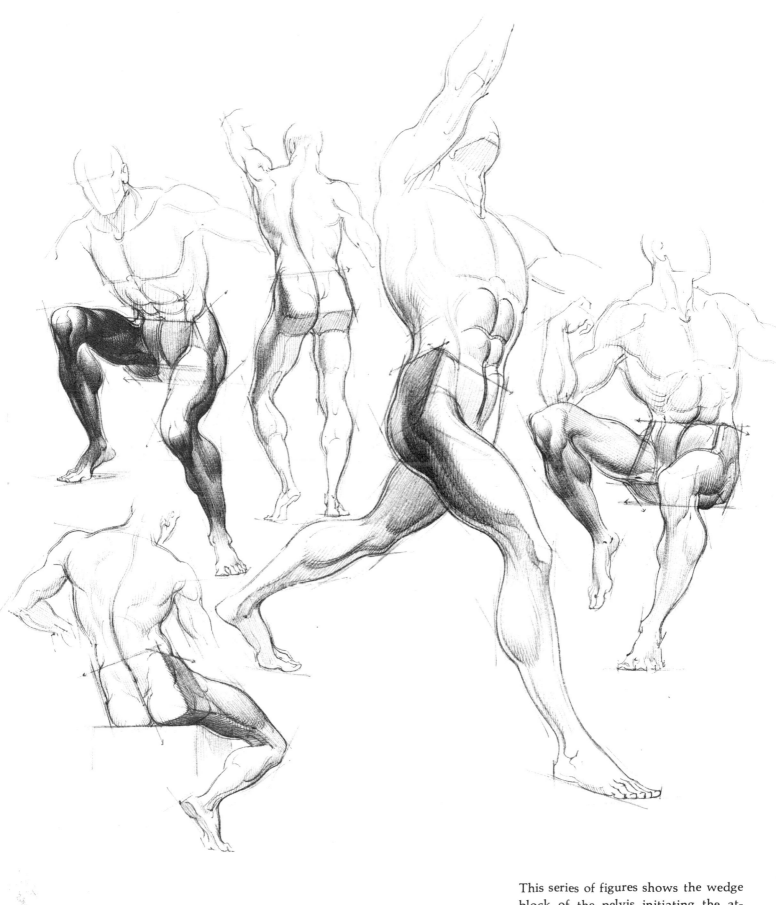

This series of figures shows the wedge block of the pelvis initiating the attachment of the legs. Notice how the cylindrical thigh form of the upper leg enters the pelvic mass well below its box-like front corner.

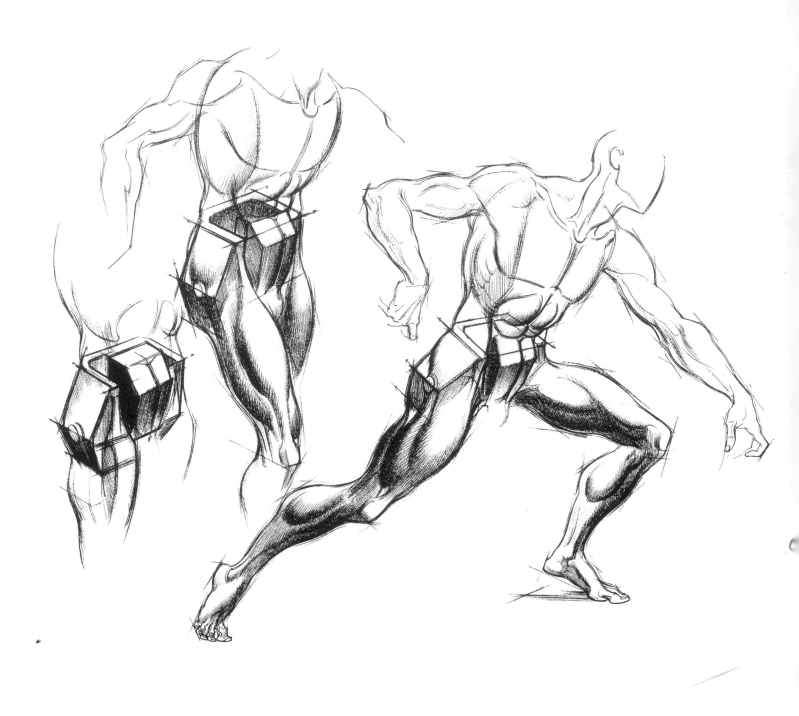

When we attach the legs to the sides of the pelvic wedge block, note the large, protruding secondary form, the centrally located lower belly (actually the mass of the small intestine), which is encased in the hollow of the pelvic basin. The figure to the left shows a schematized version of the bulging belly box mounted in the opening of the hip flanges. The center figure relates this belly bulge to the legs. Notice how the legs, entering the hips, tend to squeeze the base of the belly. Because of this apparent pressure, the belly rises high in the basin. The figure to the right emphasizes the high belly insert in an action figure: when the legs move, the wedge may spread to accommodate the change of position. The round protrusion, high in the sides of the legs, is the great trochanter, the bony eminence which lets us see the origin of the leg as it swivels, bound yet free, in the socket of the hip.

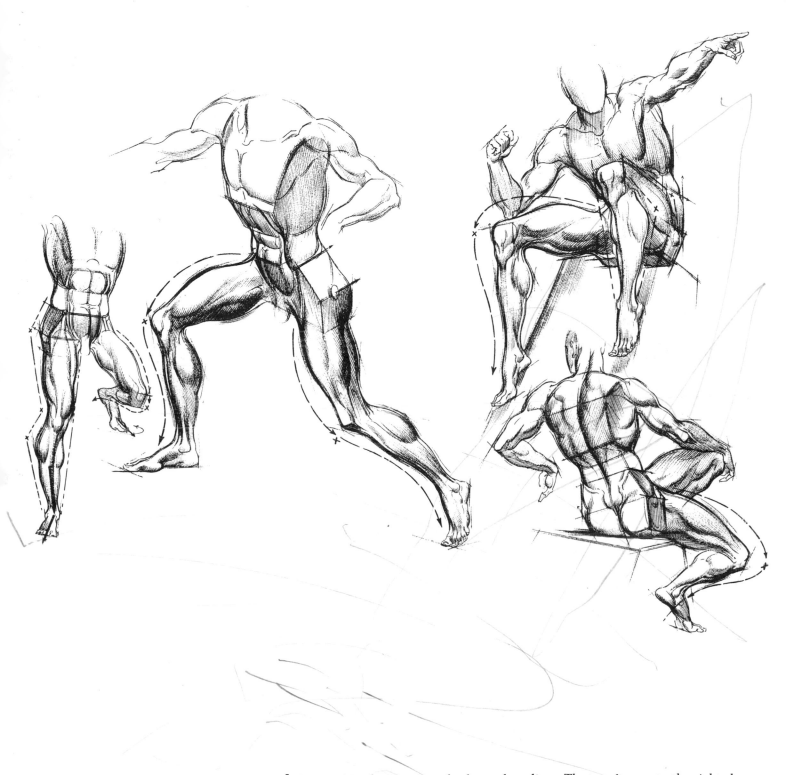

Let us review the structure rhythms of the leg. In the small, erect figure to the left, the front leg is characterized by a *B*-shape. The side leg (in a raised bend position) has an *S*-curve line. (Both rhythms are shown in the dotted lines.) The large, center figure faces left with both legs in a side view position which are expressed with *S*-curve notation lines. The two figures to the right show how the side view leg is easily interpreted in both front and back positions. The upper figure presents a front view leg in a deep bend, which is described with a *B*-shape curve. In this case, notice that the upper leg is shown with the *top* section of the *B*-shape *folded backward* as the knee bends back.

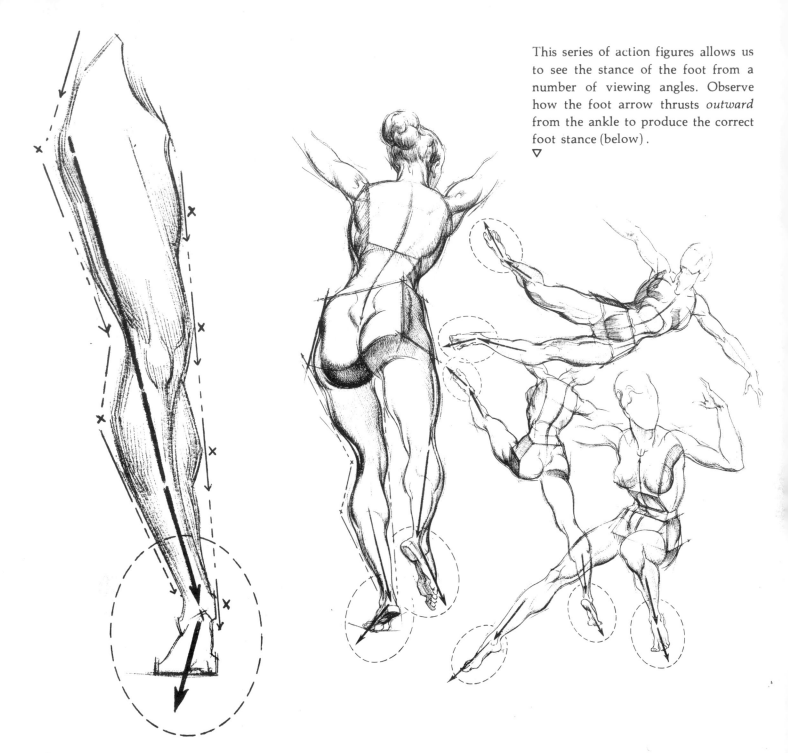

This series of action figures allows us to see the stance of the foot from a number of viewing angles. Observe how the foot arrow thrusts *outward* from the ankle to produce the correct foot stance (below).
▽

△
No discussion of the leg would be complete without noting the stance of the feet and their relationship as support platforms to the pillars of the legs. In this front view leg, notice how the entire length of the leg thrusts *inward* from the high, outside hip projection to the low, inner ankle projection (see long leg arrow). The foot stance is shown in the dotted ellipse. Note the thrust of the foot as the ankle connection reverses the bearing of the leg and thrusts the support direction of the foot *outward* (see short foot arrow).

We have mentioned the enormous ▷ flexibility of the two body masses of the torso, which effect extreme movement in the mid-axial connection of the waist. When the body weaves, sways, or gyrates, it is important to give the leg pillars an effective and convincing support. In the figure to the right—a multiple action torso— the front legs are underpinned with an *outthrust* foot stance support. (Notice how the long leg arrows reverse at the ankle, then bear the foot stance in an outward direction from the leg.)

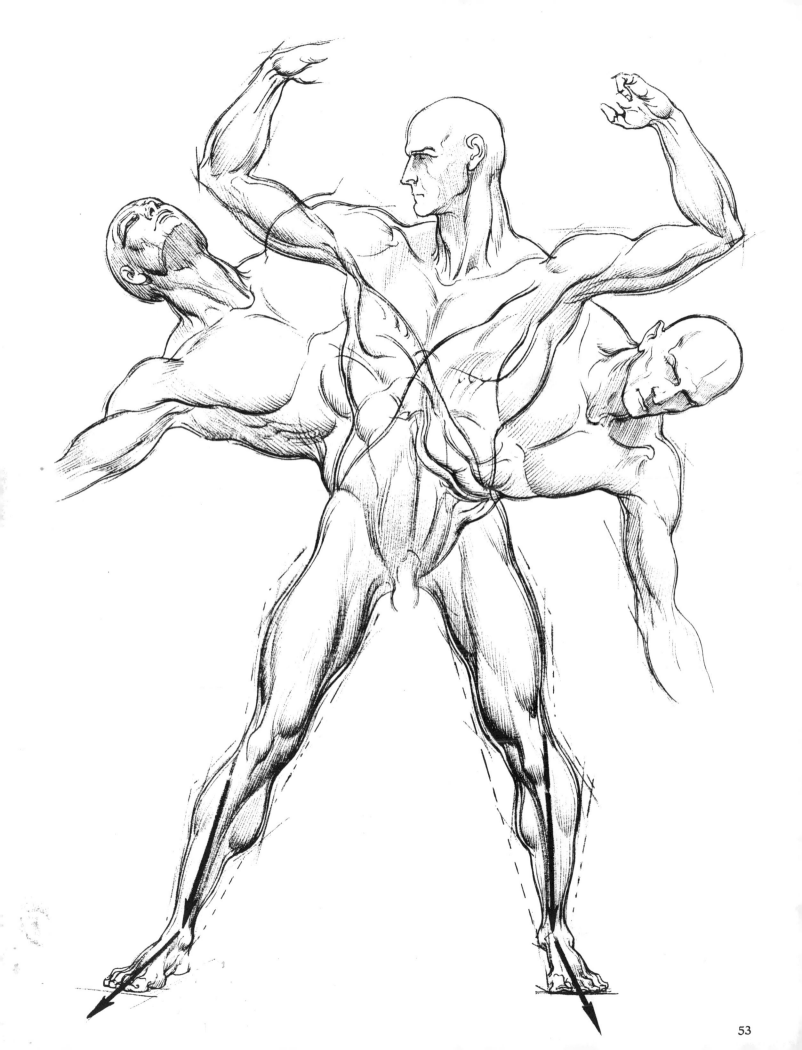

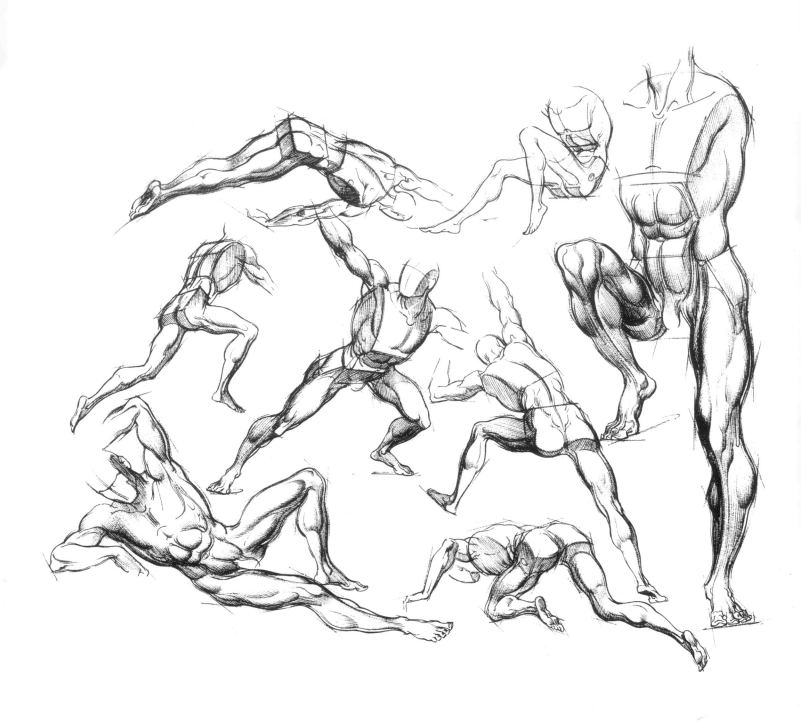

In this summary series of sketches, which show leg and torso positions and actions, the reader is asked to let his eye range casually over each figure. Can you identify easily which of the legs is drawn from a side view (*S*-line) orientation and which from a front view (*B*-shape) orientation? In making your judgment, do you observe how the anklebone relates to each leg view —whether the bulge is inside or outside the outline of the leg? As you look at the lower legs, are you aware of the outward thrust of the feet?

The Arms are Third in Importance

In our proposed sequence of figure sketching, we have so far discussed two stages of the notational order: (1) the torso masses, and (2) the legs. Now we propose the third factor in this sequence: *the arms are third in importance in the sketching order.* While movements of the arms do not cause major shifts of the torso or displacement of the legs, the arms are capable of great versatility of movement which cannot be equaled by the other members. No matter how they move, whether singly or together, parallel or in opposition, it is important, in sketching them, to see them as a *unit*, a bracketed or yoked pair of correlated members. Earlier, we spoke of the structure rhythm of the double underarm curve. This, together with tapered cylinder forms, is a rudimentary description of the arm. To this description, we will add the *armature bracket*, the connecting yoke of the linked arms.

Linking the arms through the chest is no arbitrary device. The arms have no proper anchor to the skeletal frame. Free-swinging as they are, their position in the region of the shoulder is secured with fiber and tissue. The shoulderblade (scapula) to which the arm is attached is itself unanchored, and the lesser attachment of arm to collarbone is a variable connection. The arms at this juncture are independent of the frame, but the collarbone is anchored in the breastbone (sternum), and here, all the way down to mid-chest, the junction is firmly secured and cannot be displaced. The only real movement here is equal to that of a fixed hinge. For this reason, we conclude that *the collarbone is a true extension of the arm*, and we assert that the yoked arms are a proper use of this concept.

In the small figure (upper left), the arms are indicated in strong line with a light line cylindrical overlay. The arms are linked *through* the chest barrel, from shoulder to shoulder, on the yoke of the *collarbones*. The large figure carries the schematic drawing, begun in the small figure, a step further. Cylinders are replaced by arm forms (dotted lines). The armature yoke of the coupled arms is still emphasized. The total figure has been advanced and tightened up.

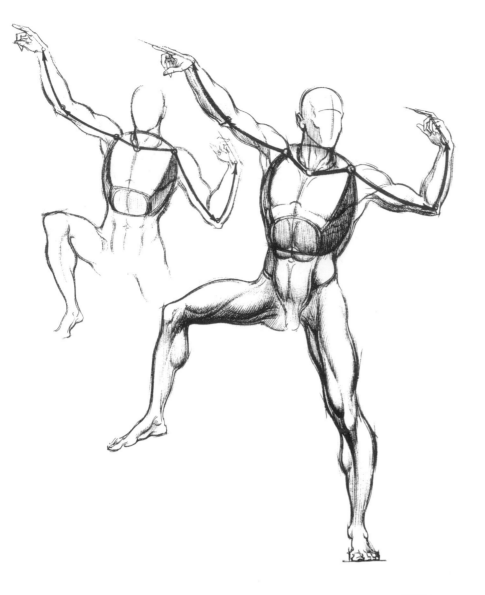

Here is another example of the linking of the arms. The smaller schematic drawing is taken to an advanced stage in the larger figure, reinforcing the interconnecting transit of the linked arms through the chest barrel.

In drawing the arms, it is important to combine the coupled arms in the collarbone yoke with their structural rhythm. The structure of the arms, upper or lower, has a consistent and similar curved rhythm, starting from the base of the elbow. A double curve develops (see dotted lines), holding to the underarm exterior position of the member.

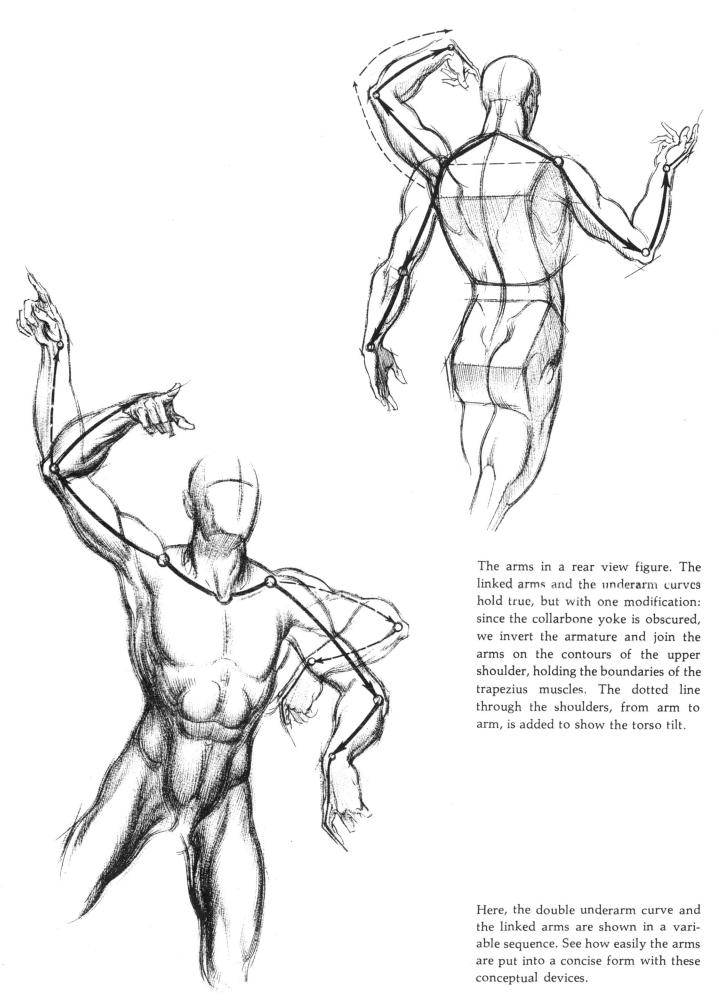

The arms in a rear view figure. The linked arms and the underarm curves hold true, but with one modification: since the collarbone yoke is obscured, we invert the armature and join the arms on the contours of the upper shoulder, holding the boundaries of the trapezius muscles. The dotted line through the shoulders, from arm to arm, is added to show the torso tilt.

Here, the double underarm curve and the linked arms are shown in a variable sequence. See how easily the arms are put into a concise form with these conceptual devices.

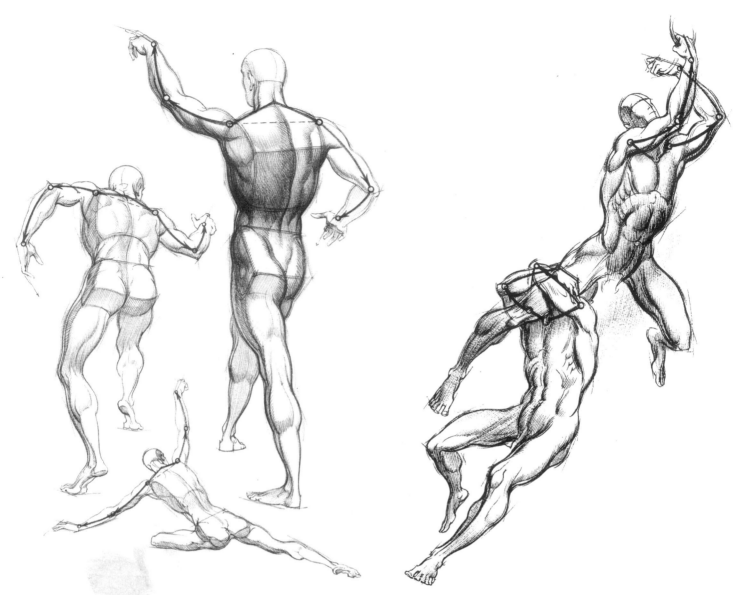

Three rear view figures in completed form, drawn in notational sequence. The torso masses, supported by the legs, are followed by the armature yoke — inverted — on the shoulders. The student is urged to experiment with the linked arms (on this page, if necessary!) to test the facility of the approach.

Here we see a notational sketch of the *overlapping* of arms, a problem not covered in the previous examples. The upper figure shows one arm over the other; the lower figure shows the arms paired, flexed, closed, and folded together. The important thing to remember in the treatment of overlapping forms is the value of being able to see, transparently, the origin of attached members and the construction of obscured parts.

The Head is Last

We have already dealt with important evidence that the head is the terminal form, and now we reach the fourth and last proposition in our notational order of form in drawing the figure: *the head is last in the sketching order.* We shall confirm the fact, alluded to earlier, that the head may be drawn in a variety of twists and tilts on a given figure *without* causing any important change or disposition of the figure action.

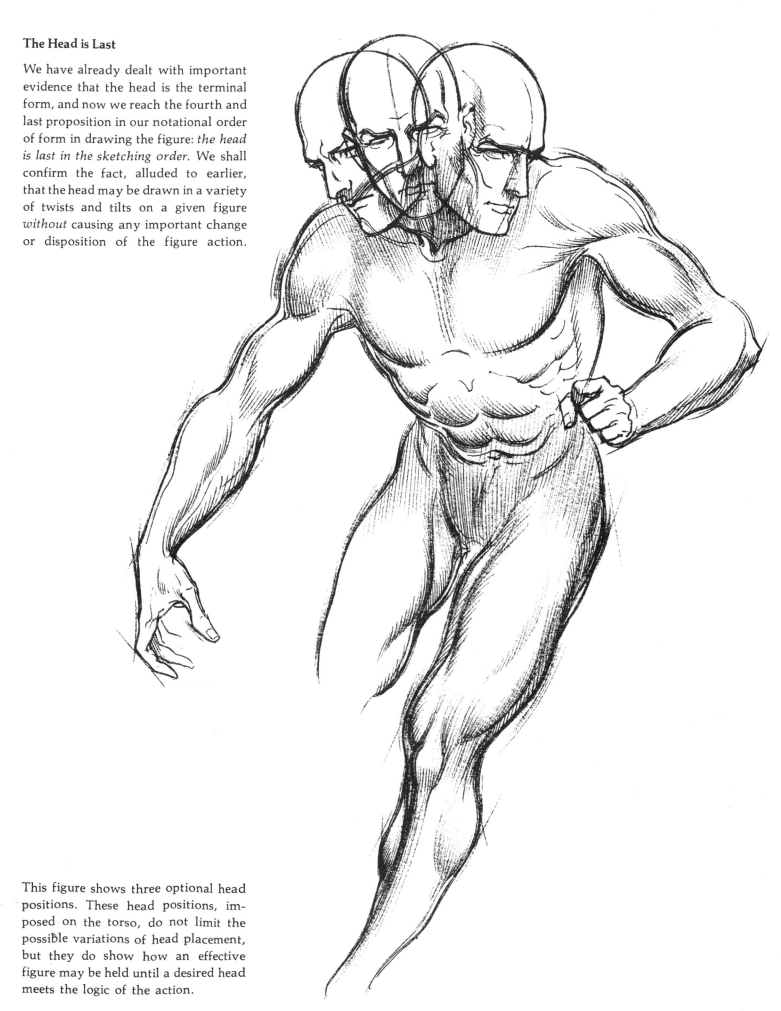

This figure shows three optional head positions. These head positions, imposed on the torso, do not limit the possible variations of head placement, but they do show how an effective figure may be held until a desired head meets the logic of the action.

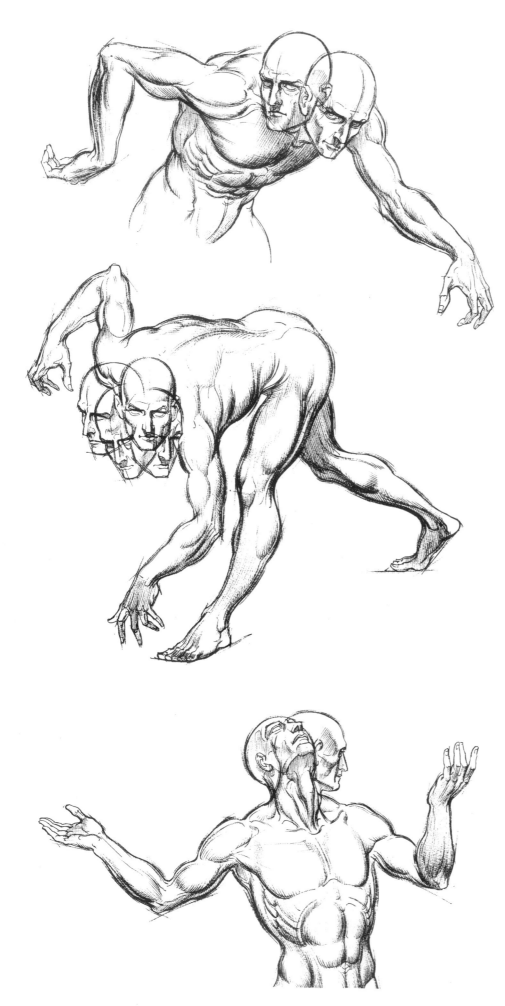

Here, two figures with deep torso bends give overviews of the figure from the front and from the back. The superimposition of each of the heads, in any number of trials, can proceed with ease and directness when the figure is initially laid in. Indicating the head first would create a needless obstruction to the effective notation of the figure, which confirms the proposed rule to put the head in *last*.

In this example of two head placement possibilities, the erect figure is conventional in treatment. The two heads, however, suggest the extreme uses which may be advanced within the context of the figure. In this case, an averted profile head or a three quarter underview position can both be tested against the stable support of the torso.

Exercises in Notation

The way is now open for a practice session using the proposed form order of figure notation. Without resorting to visual aids, illustrated references, photos, or models, start a series of action sketches, giving vitality and liveliness to the forms of the torso. When you add the legs and the arms, try to avoid passive, insipid attitudes. These tend to be unimaginative and unstimulating, and what is worse, they usually project a pedestrian, art-schoolish look. *Challenge the eye!* Make your figures spirited, animated, provocative. The extremities should be free and open; forms should stretch, extend, thrust, exert. Your figures should convey energy and vigor.

If figure ideas are hard to come by, perhaps the governing motif of a sports action might encourage you to visualize the actions of, for example, a skater, a wrestler, or a runner in a phase-sequence or "filmic" series of changes. This approach—a figure going through a number of related, sequential acts, none alike in their mobile, momentary progression—is illustrated below.

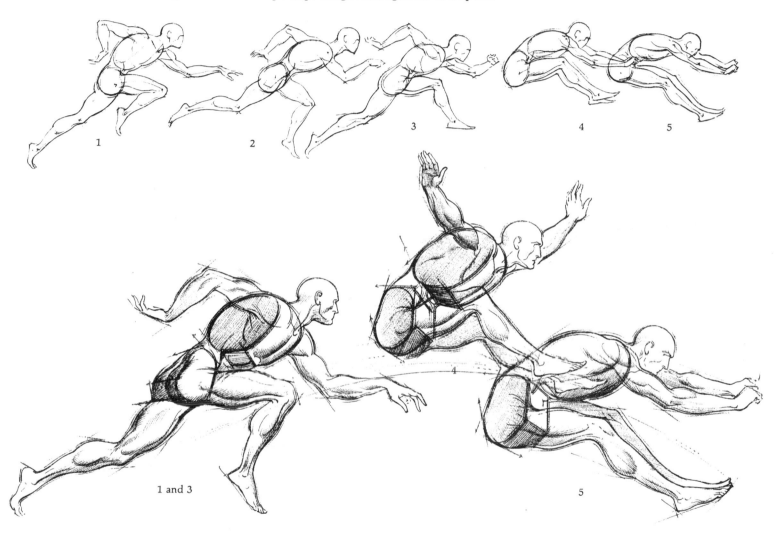

A series of side view figures might be a good way to begin in an opening exercise. *Above*, we see a running figure gathering impetus for a leap and jump. The drawing of this sequence is quite arbitrary, and does *not*, for the artist, have to respect the technique of the broad jumper. In this five-phase action statement, the figure (1) leans forward, (2) runs hard, (3) takes off, (4) leaps, and (5) projects forward to a mark. *Below*, we see the companion illustration to the above five-phase action

statement. These figures show a further developing, enlarging, tightening, and finishing. To compress the action of the athlete and achieve a heightened tension and excitement, parts of figures 1 and 3 have been combined; figure 2 has been dropped. Because of this condensation, the running action has a greater concentration of drive and thrust. The leap of the middle figure (4) has been raised. His arms are outstretched, and he appears to fly. This idea was developed in the final workup

and was inserted before the final stretch and landing figure (5). The important things in this three-part finish are: (1) having a pool of original figure ideas to work from, and (2) making a critical assessment of form and function to meet a required goal. (It is at this second point that the art student becomes the artist—when he is able to assert a definite judgment of his needs and work out his own solutions.

Here, the use of the notation sketch is shown as an initial stage in working a figure to a completed stage. Compare the sizes of each of the figures—the small, "thumbnail", primary figure ideas—with their enlarged, developed counterparts. This is a *method* of working, a two-stage procedure where the artist explores and probes in a tentative, searching series of rough sketches, then breaks off to resolve and finish his concept.

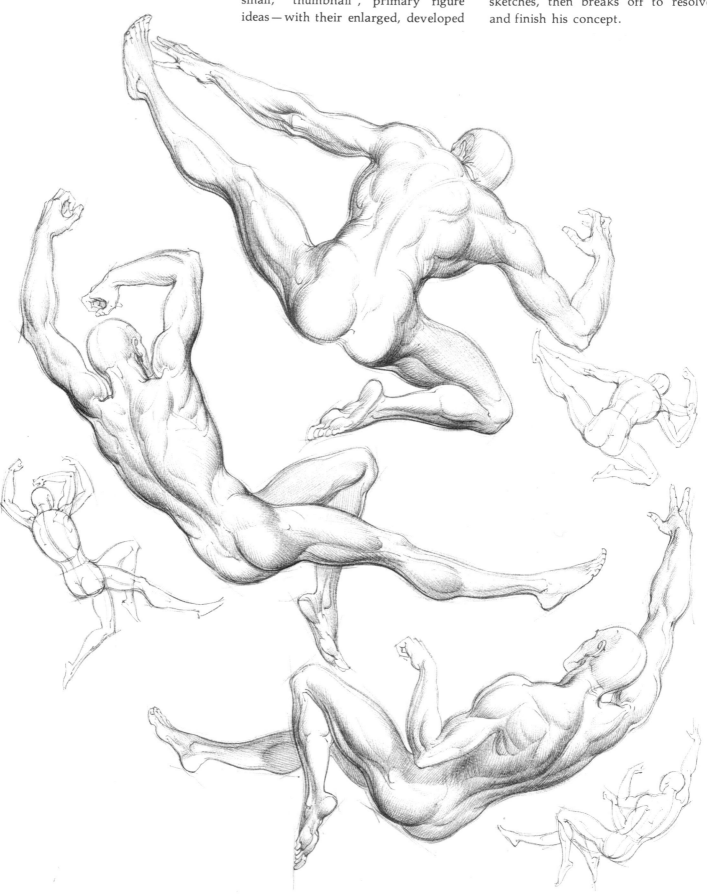

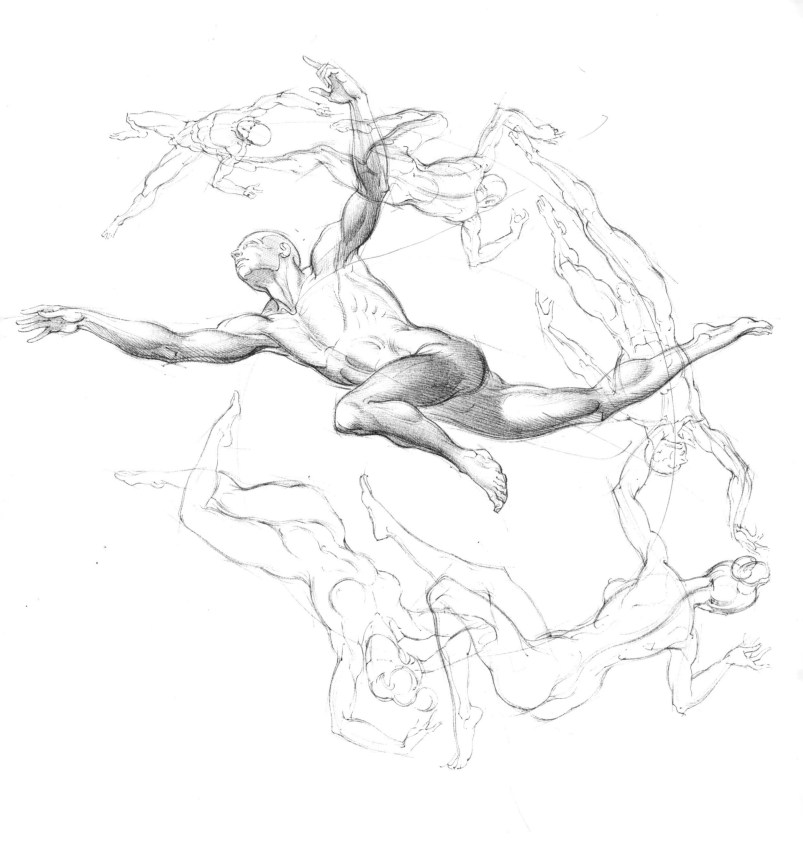

There are times when a notation sketch is placed on the work surface in its final large size, rather than in a smaller size. In this case, the same sketch idea is carried through, without interruption, in a continuous sequence from probing to finish. The advantage of this second method is that the "sudden vision" or "inspiration" of the first sketch has such a concentrated visual impact that the figure will go flat, or stale, if its development is inhibited. In this illustration, a group of figures, from small to increasingly larger sizes, have been sketched in a spiral pattern which evolves to a center workup. *Note*: size is no bar to carrying a spontaneous notation to its final stage.

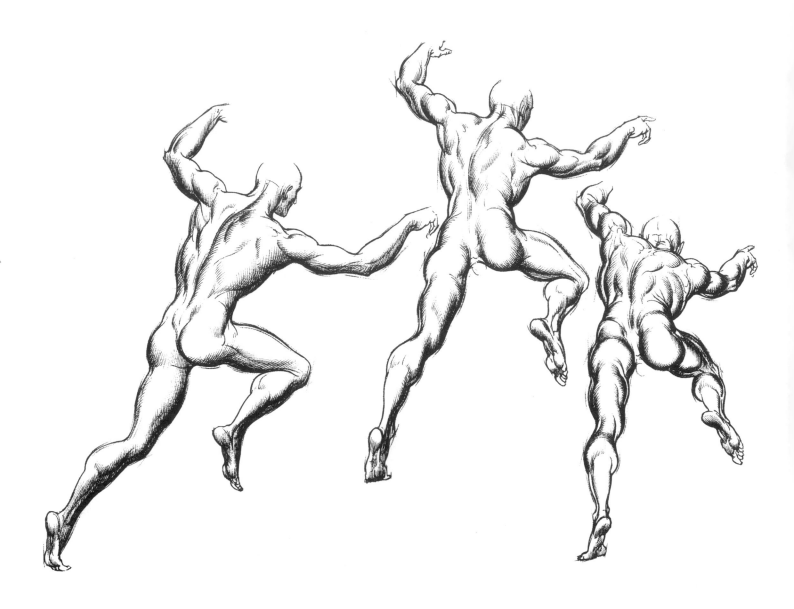

This three-stage sketch shows how the forms of the figure change when they are foreshortened. These three figures are the same, but they are each seen from a slightly different view. The figure on the left gives a predominantly side view; the form effect shows an easy transition, especially in the extended members. The center figure shows a partial back view; now the forms begin to show more depth, and a tendency to bulging occurs (expansion and compression) as the forms close into one another in the process of foreshortening. The figure on the right, seen from a predominantly rear, low-angle view, produces a form-over-form, "lumpy"

effect; the expanding and compressing effect decribes what happens in depth recession, but it inhibits the flow of forms — the result is segmented and discontinuous. In this last figure (right), the forms seen on end tend to divide and detach; the array of dissimilar elements becomes an aggregate of parts, rather than a coherent whole. If there is a seeming unity in the forms, it is in their positional sequence and direction, as well as in the viewer's familiarity with the contour of the figure. But if you look closely, you will see that the partitioning and the divisions that chop up the flow of body lines are, nevertheless, uncomfortably there.

3

Figure Unity in Deep Space: Interconnection of Forms

Thus far we have examined the basic shape-masses of the figure and some elementary means of their construction; and we have seen these carried into the direct notational sketch in which body forms are expressed in large, structural rhythms which give an over-all linear relationship to the primary drawing. These ideas, as we have seen, tend to work best in conventional side views and straight-on figure views. It is when we attempt to draw the figure in *deep space* or *foreshortened* views that a peculiar effect occurs: the smooth transition of figure forms tends to become inhibited, and an abrupt, segmented quality develops. The figure takes on the appearance of an assemblage of parts, something like a loose-knit sequence of adjacent but separate elements, stacked together in a series like beads on a string.

Overlapping Forms

Our task now is to discover a means of putting the figure into deep foreshortening, give it a form flow and a form unity so that all the parts of compound figure forms will be fused into an organic whole. Placing one form over another is called *overlapping*, which creates a view of forms receding into deep three dimensional space.

When overlapping occurs, the principle of *interposition* is called into play. Interposition is the placing of one form over another, the first partly cutting off (as it were) the second. By means of this apparent cutting off, the illusion of depth is created: the *complete* form seems to be the one *in front*; the *partial* form seems to be the one *behind*. This illusion can be concisely summed up: *when a total form is overlapped by another, and is seen only in part, the partial form, nevertheless, has all the force of the total form.* We see it as complete — not amputated or fragmented, but partially hidden. The part seen is actually the whole, but it is understood to exist in a depth of space behind the form which covers it in front.

Conversely, it may be useful to state the *opposite* of the above proposition in order to reinforce the premise: *when no overlapping occurs, and all forms are shown entire and complete, no illusion of depth can take place.* When no form is interposed on another it is implied that no one form is behind or before, in front or in back of, any other. Consequently, they are all, and at every point, equidistant from the eye and must lie simultaneously on the picture plane. This, of course, precludes any illusion of depth.

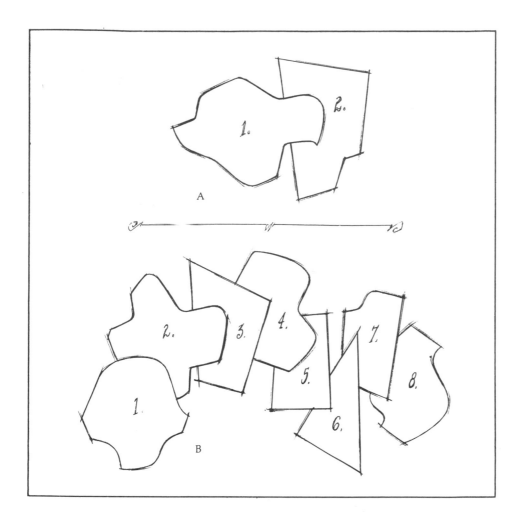

A

B

This two-part illustration explains the logic of overlapping. In example A, the complete form (1) is the forward and near one; the partial form (2) is behind and farther away. In example B, we see an array of forms. As each form overlaps the other — starting with a complete form (1) as the first — the interposing effect produces an illusion of depth-in-space sequence; the overlapping forms can actually be given numerical positions (1, 2, 3, 4, etc.) in spatial recession.

Here is an illustration of the *opposite* of the preceding proposition. In this case, all the forms in the group are shown complete. None overlap. Note how each form seems to hold to the front of the picture plane, and not one can be felt to recede into depth.

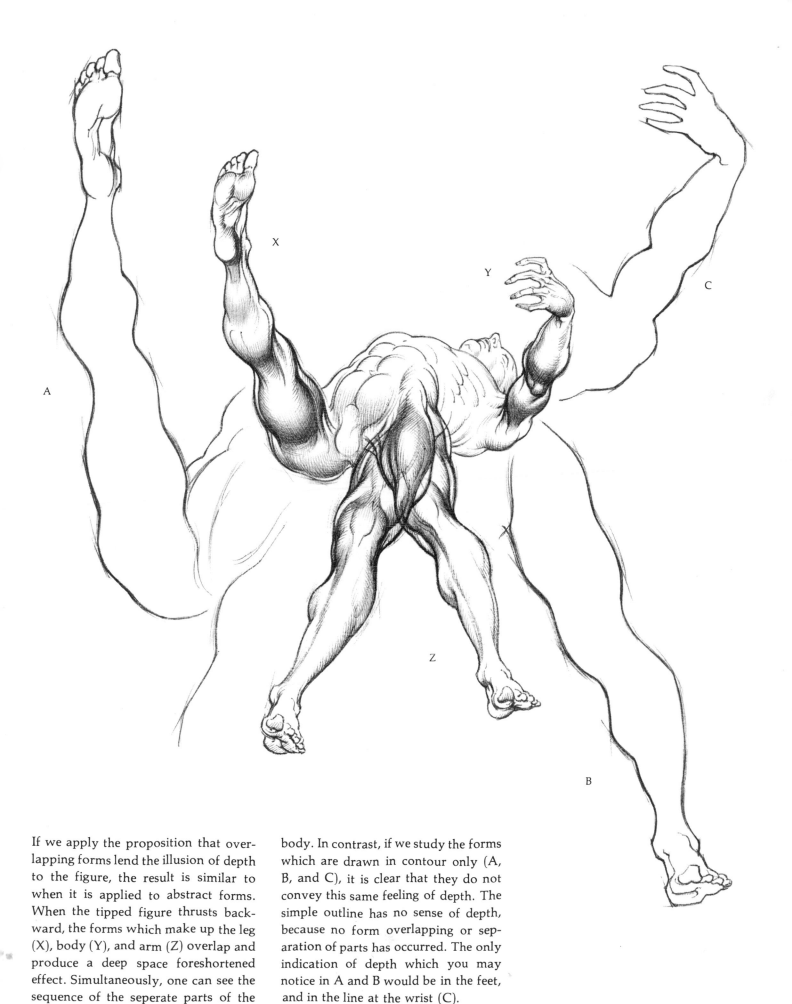

If we apply the proposition that overlapping forms lend the illusion of depth to the figure, the result is similar to when it is applied to abstract forms. When the tipped figure thrusts backward, the forms which make up the leg (X), body (Y), and arm (Z) overlap and produce a deep space foreshortened effect. Simultaneously, one can see the sequence of the seperate parts of the body. In contrast, if we study the forms which are drawn in contour only (A, B, and C), it is clear that they do not convey this same feeling of depth. The simple outline has no sense of depth, because no form overlapping or separation of parts has occurred. The only indication of depth which you may notice in A and B would be in the feet, and in the line at the wrist (C).

Form Flow and Form Unity

It is clear that interposed, or over-lapped, forms create depth-in-space recession. But we have also found that this device, because of its very nature, produces form partition and separation as well. We shall now discuss ways of achieving form cohesion and unity within the means of overlapped, deep-space forms. We will propose, and attempt to show, that forms in space may be held together in three ways: (1) *by interconnection lines* developed at joints between forms, where skin wrinkles and surface tensions arise, where tendon insertions occur, where muscle masses intervene and interlace large structures; (2) *by strong end-of-form outlines and terminal contours* worked to control and consolidate the overlap-separation tendency; and (3) *by continual tone gradation* expressed in a total fusion of form, completing the process begun with linear interconnection, contour cohesion, and member control.

Interconnection Lines

The first means of holding together forms in space—form unity through interconnection lines—may be clearly seen at prominent joints which mediate and fuse the more active members of the body. Where high skeletal protrusions appear, such as at the knuckles, ankles, knees, elbows, and wrists, certain obvious surface linear tensions will develop. The hand, for example, shows channels of stress and tension coursing above and below the compound digital forms.

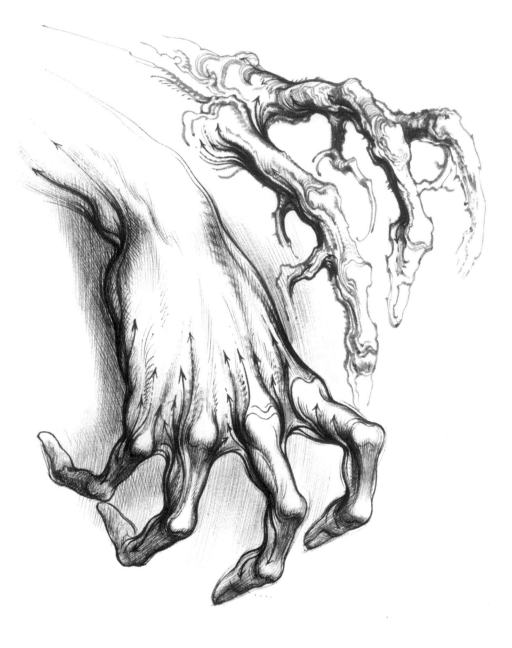

The patterns of interconnection illustrated in this hand (shown by the arrows) tend to flow in the hollow depressions between the knuckle mounds and to lace one form to another. In the small companion illustration above the hand, we see a complex of compound forms—a sequence of twigs, branches, limbs, and trunk—all interlaced and uninterruptedly fused. Shown with arrows, these forms are made analogous to the forms of the hand.

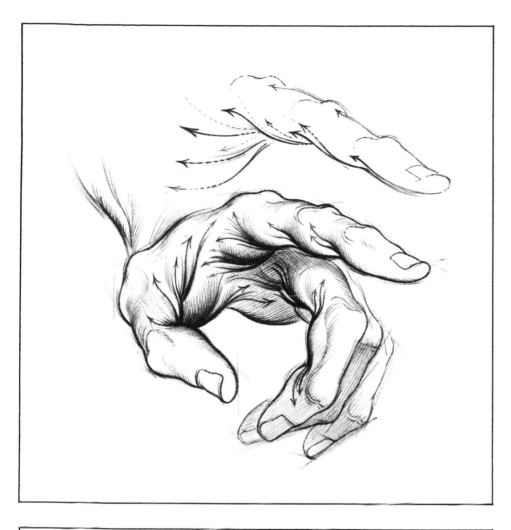

Here is another example of linear interconnections used to effect form continuity. The insertion lines (emphasized by arrows) carry from an *outline*, or outer contour, of one form to an *inner* lacing with the next. This device makes two separate digital forms into a joined, compound form. (See the finger diagram above, and the developed concept in the hand drawing below.)

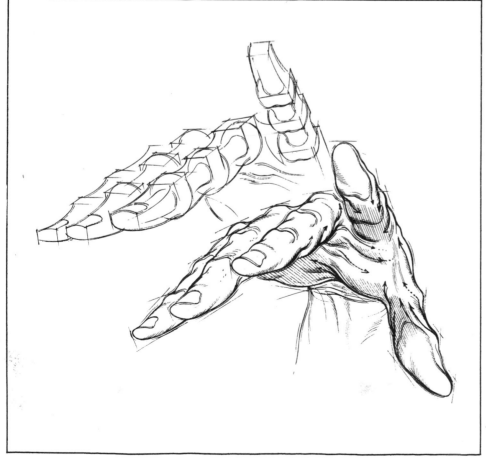

Sometimes, in the initial stage of a drawing, when forms are studied separately for a projected foreshortening, a tendency to form separation may occur (see upper portion of illustration). If the artist is not careful, a disconcerting, lump-like effect will prevail. The bottom sketch, modified and more finished, gives the changed aspect when concentration is placed on the interconnection lines which lead to a merging and fusion of forms (see arrows).

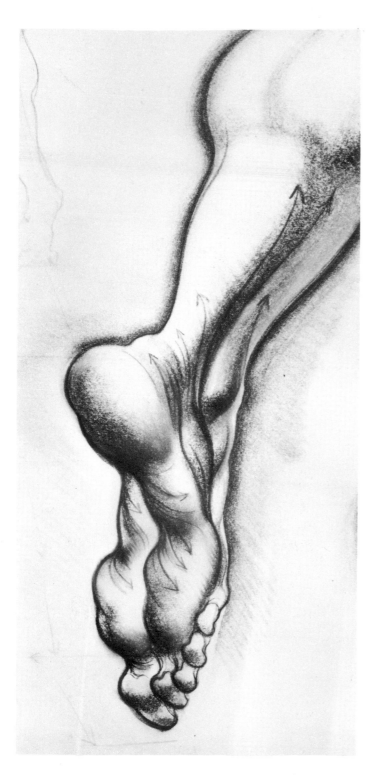

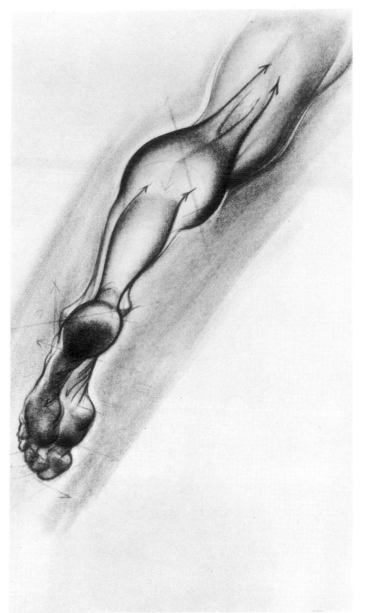

As in the hand, a net of linear fusion ties can be seen lacing the surface forms of the base of the foot. The form flow pattern, if pursued, can move unhindered high into the leg itself.

We have by no means exhausted the typically familiar skin and wrinkle connections (face, neck, belly, etc.). We shall examine these more profitably in conjunction with interconnections of a more prominent and pronounced variety: the sinews and tendons which emerge under stress and which bind active members with long, powerful, extended cables. These large interconnection cables include the calf muscle tendons behind the crook of the knee; and lower, the Achilles tendon of the heel (see arrows). These are remarkable interconnection factors in their expression of form unity.

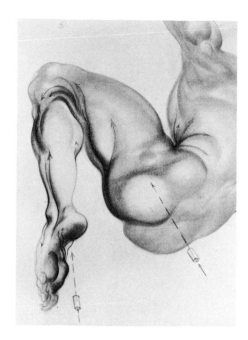

Here, we observe how skin and tendon interconnection lines (shown in arrows) fuse elements of the entire lower body. Coming up from the base of the foot to the lower leg, and coming down from the torso and the tendons of the thigh, we see an interaction of merging interconnection lines. Of special note are the opposite, or contrary, directions of the fusion lines (see arrows). The reason for their going in opposite directions is this: we see the leg forms in deep recession—that is to say, we view the lower leg from the foot *toward the knee;* likewise, we view the upper leg from the buttock plane *toward the knee.* Thus, both movements are pointed toward a crux point pivot in the closed knee.

The interconnections of the leg can be seen here to pass into the body, rising to the torso base and the back. In this example, three basic points of fusion integrate the pattern of form flow continuity: the progression moves from the (1) foot wrinkles to the (2) leg tendons, and higher to the (3) large muscle volumes of buttock, hip, and back—those overriding masses which harness the greater body structures into a coherent figure.

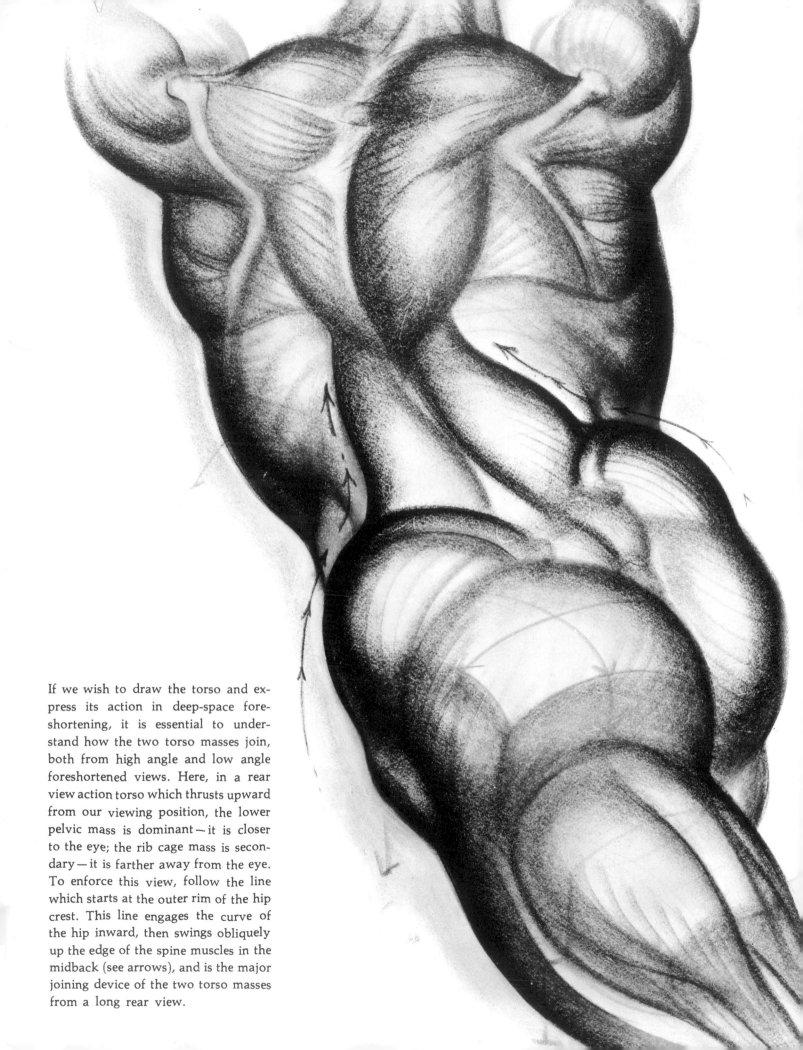

If we wish to draw the torso and express its action in deep-space foreshortening, it is essential to understand how the two torso masses join, both from high angle and low angle foreshortened views. Here, in a rear view action torso which thrusts upward from our viewing position, the lower pelvic mass is dominant—it is closer to the eye; the rib cage mass is secondary—it is farther away from the eye. To enforce this view, follow the line which starts at the outer rim of the hip crest. This line engages the curve of the hip inward, then swings obliquely up the edge of the spine muscles in the midback (see arrows), and is the major joining device of the two torso masses from a long rear view.

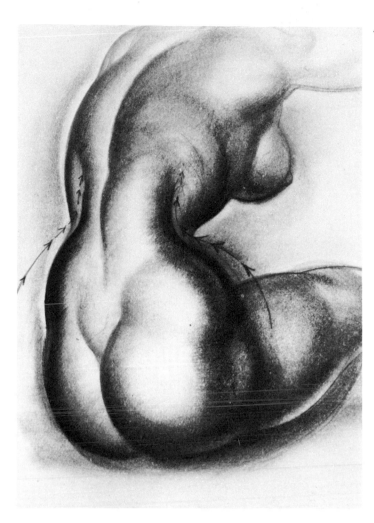

Here is a variation of the linear interconnection of the two torso masses seen from a low angle, three quarter left view. The female figure makes this linear description very explicit. (left).

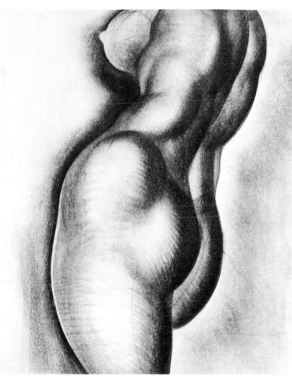

A left, rear view of the female torso, with a swing to an incipient side position. The dominant curve of the hip moves from the extreme left outline and carries deep into the rise of the spine muscle. The right side, while not obvious, cuts in from the far hip. In this illustration, arrows have not been used to show the interconnection process, but key forms are emphasized to convey it clearly. Observe the related use of ascending overlap lines on the upper torso, left and right, from front and back, and note the way form unity is induced (above).

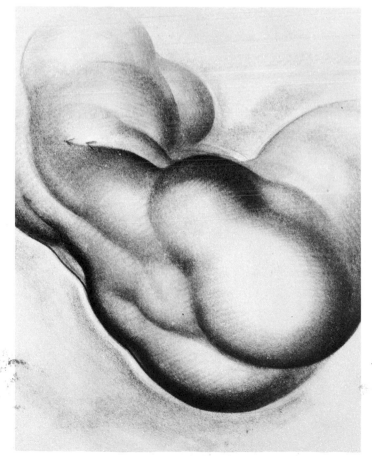

This figure illustrates the linear interconnection of the two torso masses from a low angle, three quarter right view. See the preceding illustration, which illustrates this device on the left side (left).

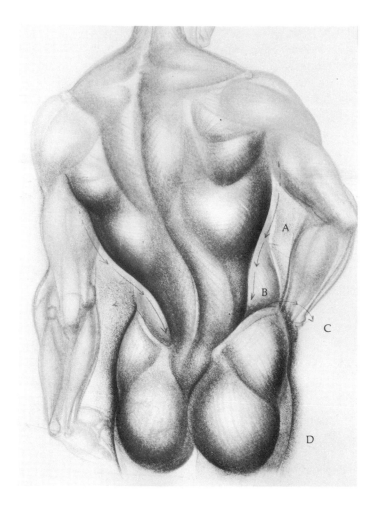

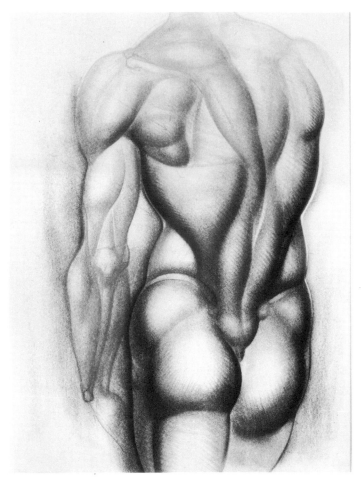

When we take a position *above* the rear torso, we note first the higher and more dominant rib cage; we see the pelvic mass as secondary and subordinate. In this case, the interconnection of the two torso masses develops on the side of the body under the arm, the *latissimus* muscle line (A), which compresses inward to the rear of the hip crest (B) near the spine; from here, the curve turns outward (C) to embrace the butterfly shapes of the pelvis (D).

Here is the latissimus interconnection line shown on the left side of the rear, down view torso. It is important to recognize the difference in the overlap devices in the torso masses in up and in down views. The device here gives a sequence of *overcurves* on the body (as we look up), but a compression develops especially on spine muscles going high into the back. In this example, the compression reverses, and points low toward the region in the base of the spine.

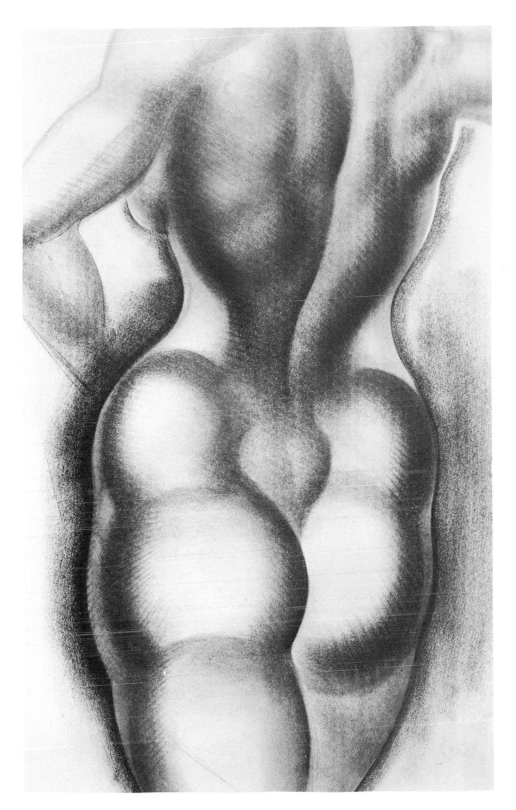

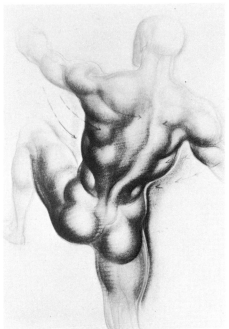

A view of the male torso from a high viewpoint. The accented latissimus line here emphatically asserts the superior position of the chest barrel over the recessive pelvic wedge. The student is advised to take note of an important visual premise: while the anatomical forms in the *down* view correspond to the forms given in earlier *up* views, the curves on the body and its forms are seen as a series of *undercurves* (see arrows), conveying the fact that the viewing position is from *above*.

Here, the use of the latissimus line is illustrated on the female torso. Compare the female pelvic crests with the lesser curves of the male figure.

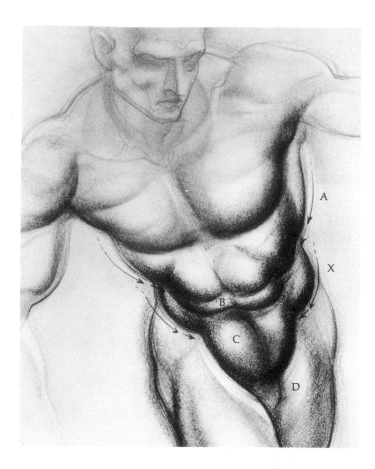

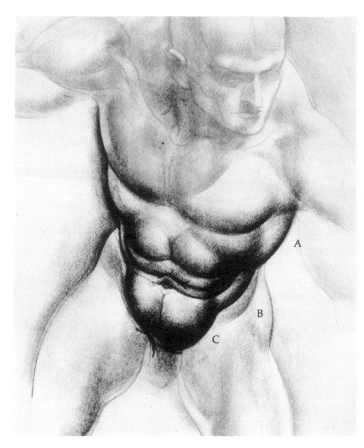

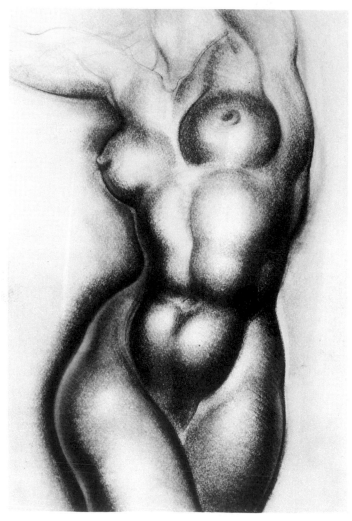

The front (above left) also has special interconnection devices, depending on which deep space viewpoint is taken — high or low. If we examine a *down* view (as in the previous example, but now shown frontally), we will see that the chest barrel closes on the body with a double set of *undercurves:* starting with the outer chest curve (A), one direction moves inward on the middle belly curves (B) to join the large, pelvic belly bulge (C); another direction continues the outside contour of the chest down to the hip muscle line (X), which curves in to join the low belly bulge (C), and there descends inward to the terminal pubic compression (D).

Above right is another example of the two-curve, frontal interconnection as seen from a higher elevation. Note the inside, mid-belly curves (A); the outer hip embrace (B); and the lower pelvic belly mass (C).

The linking of the front view torso masses is illustrated (left) in the female figure. In this example, see if you can determine the interconnection factors without indicators to guide you.

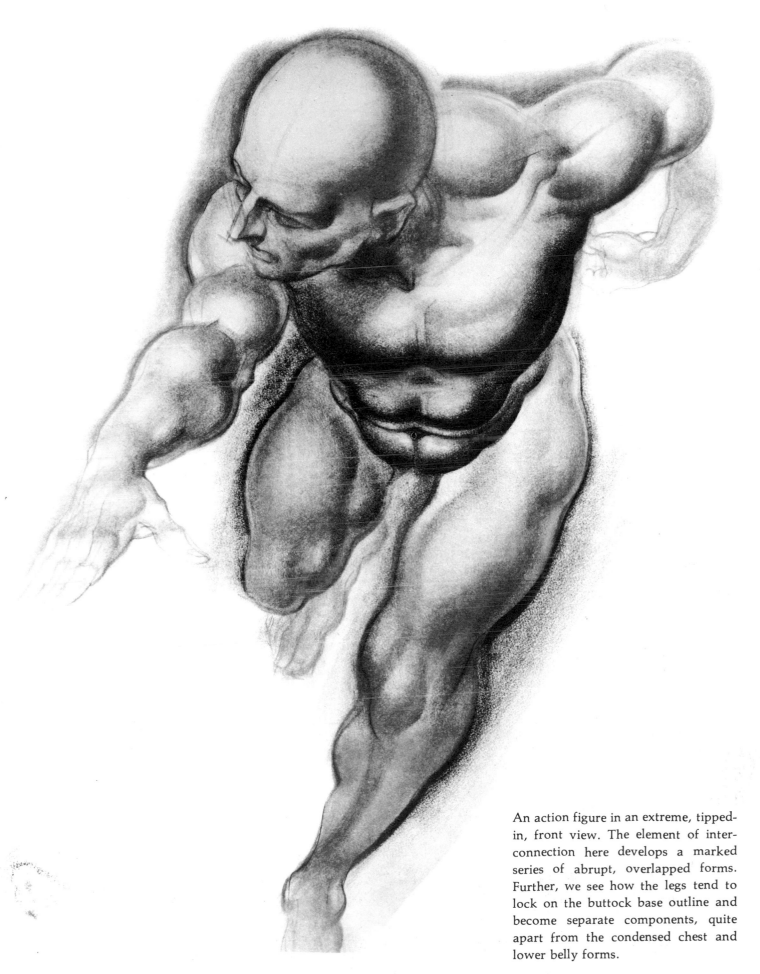

An action figure in an extreme, tipped-in, front view. The element of interconnection here develops a marked series of abrupt, overlapped forms. Further, we see how the legs tend to lock on the buttock base outline and become separate components, quite apart from the condensed chest and lower belly forms.

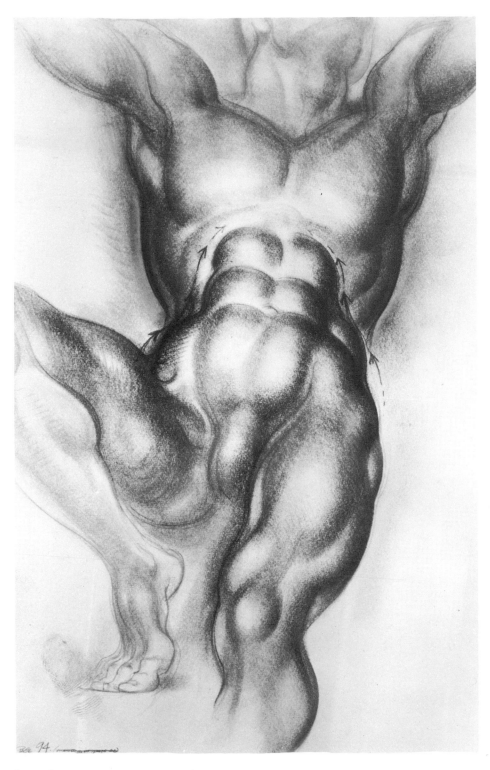

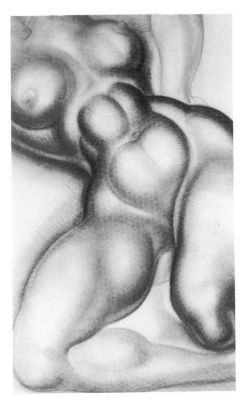

A low, front view of the female figure. The torso interconnection moves from the outer leg contours obliquely inward along the hip curves; then the linear channel thrusts up to complete the rise in the rib vault.

In a change of viewpoint to a low position, the frontal, linear interconnections of the torso masses reverse the order of fusion: starting with the pelvic mass, a line moves upward along the edge of the waist muscles (externus oblique) in mid-body; the joining line then turns in on the central belly forms (rectus abdominis), and rises high into the rib cage arch (diaphragm), where it completes a vaulting swing from left to right (see arrows).

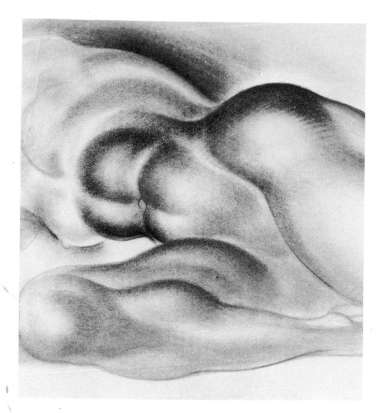

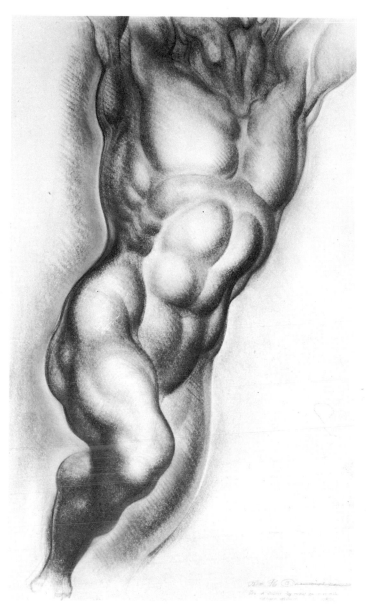

Here is an example of the fusion of the torso from a low view as seen in a reclining female figure. The joining of the upper and the lower torso masses is given with diffused interconnection lines. In this figure and in the one which follows, see if you can relate the the forms: first, as to the mid-belly rise into the rib cage arch; second, as to the consistent overcurve form-sequence in depth across the entire expanse of torso.

A right, three quarter turn, male action figure, which illustrates the same fusion of the torso masses as seen from a low view as is shown above left.

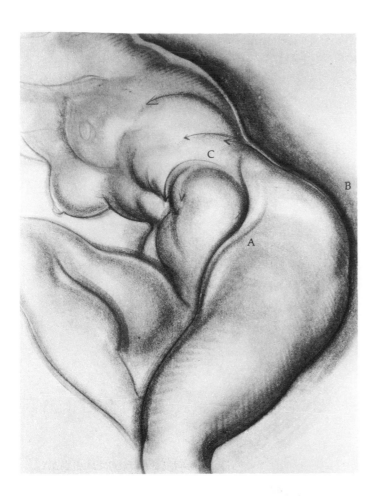

In this figure, seen from a lower angle than the two preceding, the thigh closes with the body on the inside belly groove of the groin (A); outside, the thigh forms a flying buttress against the hip (gluteus medius) bulge (B); and, here, at mid-body, the interconnection (externus oblique) begins (C) with a series of quick curves mounting high into the rib vault (left).

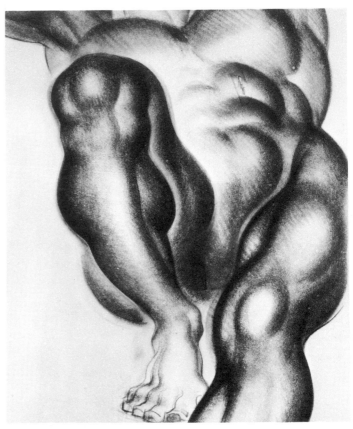

Here, the interconnection of the groin and hip buttress (illustrated in the previous female figure) is seen in the male figure (above).

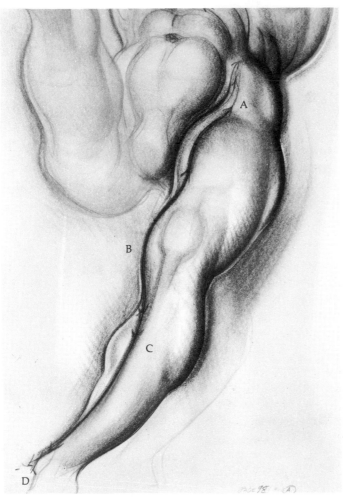

In this view of the mid-leg, the inside (sartorius) channel (A) drops from the hip, runs deep, and bursts free with an elliptical swing to become the *outline* around the knee (B); lower, the contour of the knee tools into the shinbone (tibia) line channel (C), and grooves down the length of the lower leg, where it suddenly reappears as an *outline* (D) on the anklebone (left).

80

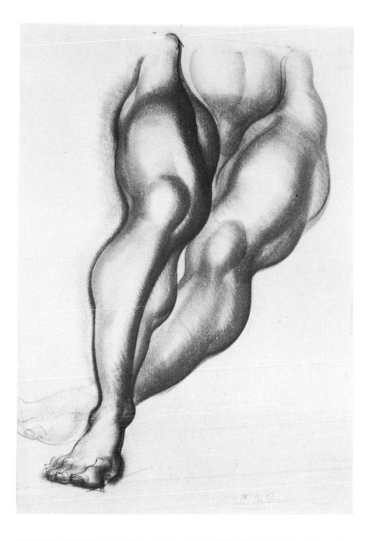

◁ This compound interconnection line is the longest in the body, and the student is advised to memorize it. It is like an archer's bow, linking both upper and lower leg without interruption, from the high, inner groin to the knee, from the knee to the ankle, and from the ankle all the way down the length of the foot (left).

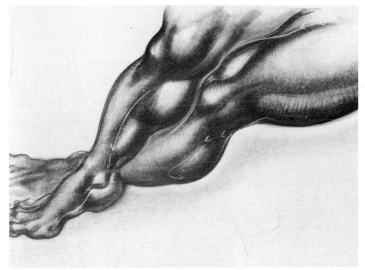

△
Here is a down view of a pair of crossed, extended legs. See if you can follow the "bow" line pattern of interconnections in this figure, using the previous examples as guides (above).

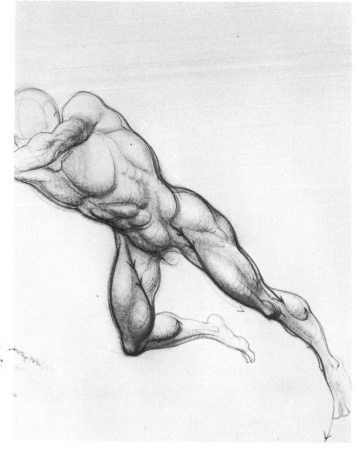

◁ In this reverse angle, down view of the right leg, the inner "bow" line can be seen running down the total length of the leg from hip to foot. On the left, bent leg, this inside "bow" line breaks into two sections (a section for the upper leg, and a section for the lower leg) with the knee between. In the outside interconnection line of the right, straight leg, notice how the back thigh line hooks into the lower leg on a hamstring tendon and curls back on the outer calf muscle (left).

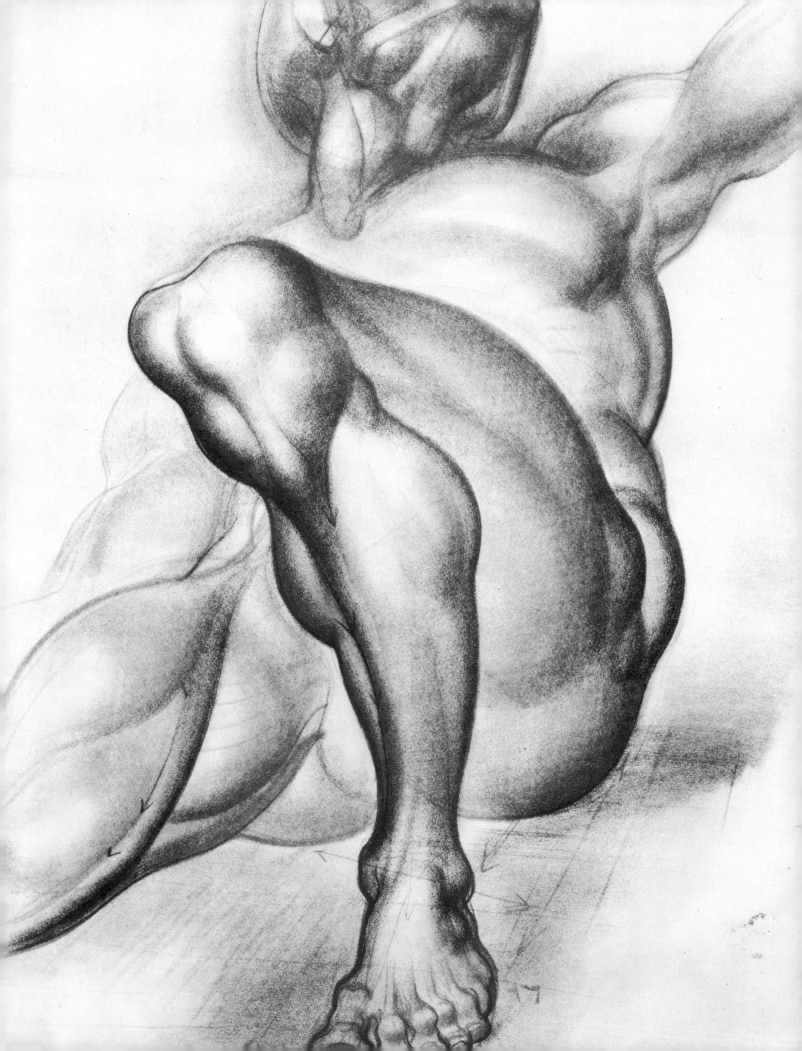

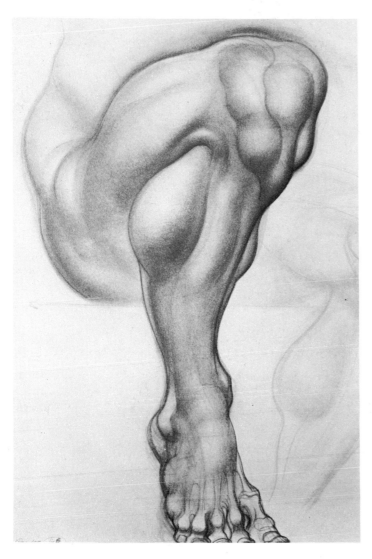

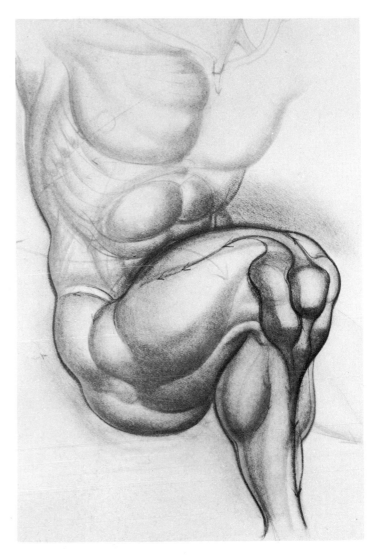

The bony, triangular knee compression is seen here in a down view, from the left. Note the continuity of linear accent in the rear thigh tendon as it closes with the bulge contour of the calf.

The same knee seen from a slightly higher elevation permits us to see the lower leg tendon, with the attached kneecap, rising to connect with the upper tendon and front thigh muscle contour going toward the hip.

◁ The knee is a major interconnecting form between the upper and the lower leg. The kneecap (patella) is latched onto both with powerful tendons. The knee joint is articulated by the remarkable, spool-shaped protuberances, called condyles, of the leg bones. In a down view, the knee and the lower leg give us a distinctly blocked, bony form-complex, squared at the top, but closed down to a tight, triangular compression toward the bottom, and laced into the inner line of the shinbone, or tibia (left).

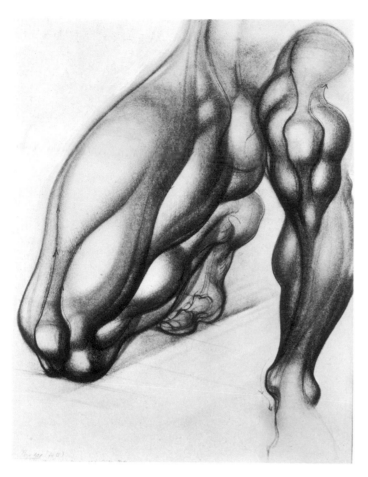

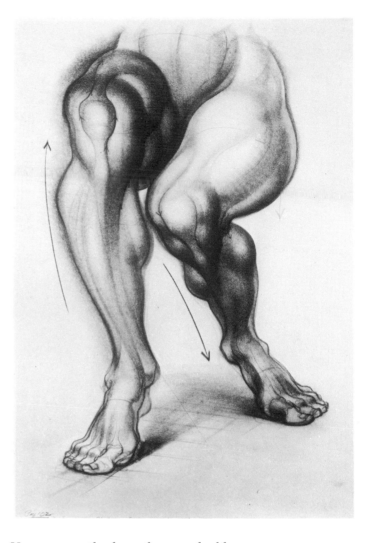

The knee, as an interconnection center between the upper and the lower leg, blends bone articulation, tendinous lacing, and muscular interfusion. In this illustration, can you see where these factors of form connection are at work?

Here we see the knee from a double viewpoint. Compare the two knees and leg positions. The left leg shows an upward movement (see arrow), which produces an exposed knee combined with an exposed lower leg. The right leg shows a downward movement (see arrow), which produces an exposed upper leg combined with the knee. In each case, the foreshortened, recessive member tends to detach. Hence, to make the leg forms unite, I advise the following procedure: *left leg* — the movement is up — put all interconnection lines upward to engage the receding member above the knee; *right leg* — the movement is down — put all interconnection lines downward to engage the member below the knee.

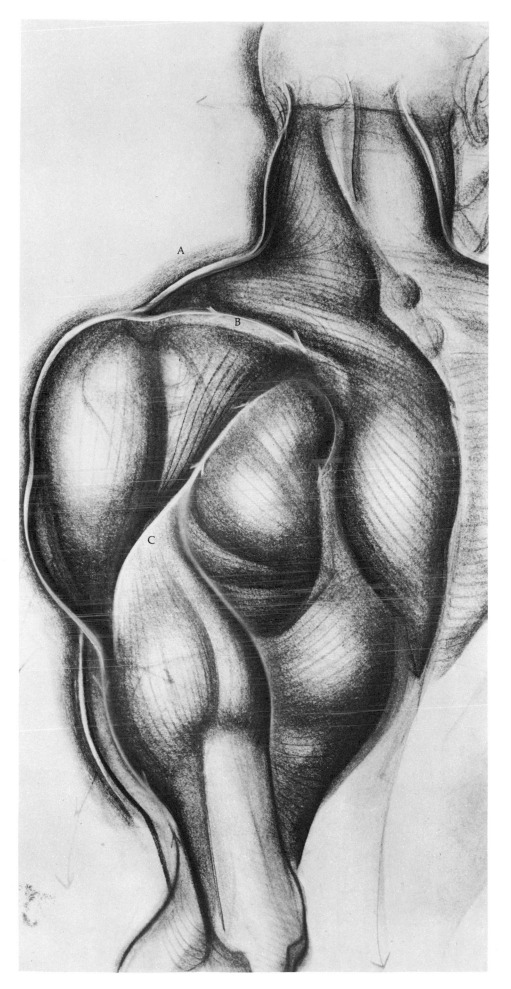

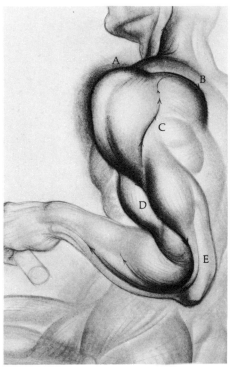

This rear view arm, open to the side, again shows the three linear connections with the deltoid (A, B, C) illustrated in the example at left. We also see the deltoid closing lower with the triceps muscle (D); the channel sends a tendon coursing around the elbow (E), where it fuses with the lower arm.

The main interconnecting form joining the arm to the torso is the shoulder (deltoid) muscle. The deltoid is a broad, thick muscle mass high on the arm, and can be compared in form and function to the large buttock masses of the hip and upper leg. From the rear, the deltoid-to-torso connection describes three linear passages: (A) the higher deltoid contour rides up to the top body line (trapezius) and thence to the rear neck line into the head; (B) the mid-connection moves across horizontally to join the ridge of the shoulderblade (scapula) line; (C) the third passage takes the under-deltoid contour and rises angularly back to wheel into the rear shoulderblade muscles.

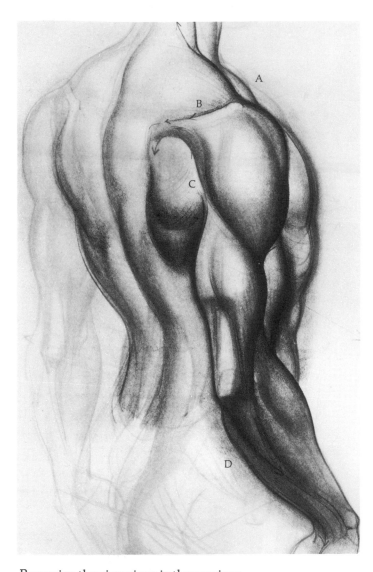

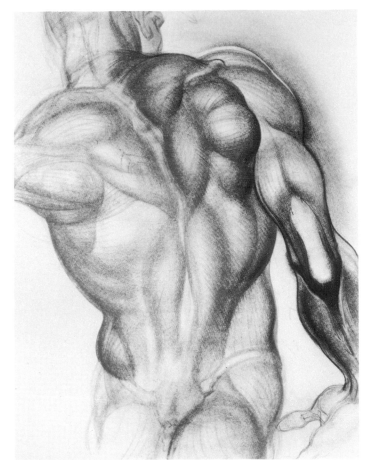

The elbow projection (olecranon) from a direct back-arm view clearly shows its dual function in conjoining the upper and the lower arm. In this slightly raised arm, the receding forearm is depressed, foreshortened, and modulated rearward by the use of tone. The uplifted elbow puts an emphatic linear thrust into the recessive forearm.

Reversing the view given in the previous examples, the deltoid interconnections give us: (A) *an upper line*, shoulder-trapezius-neck; (B) *a mid-line*, deltoid-scapula ridge; and (C) *a rear line*, the under-deltoid, shoulderblade muscle complex. Note how the rear deltoid line (C) moves down the mid-arm from the triceps to the elbow, and lower (D), involving the forearm below. Most important here is the function of the elbow, that high, bony protuberance around which the upper and lower muscle masses interlace and interact, in its role as mediator between the upper and the lower arm.

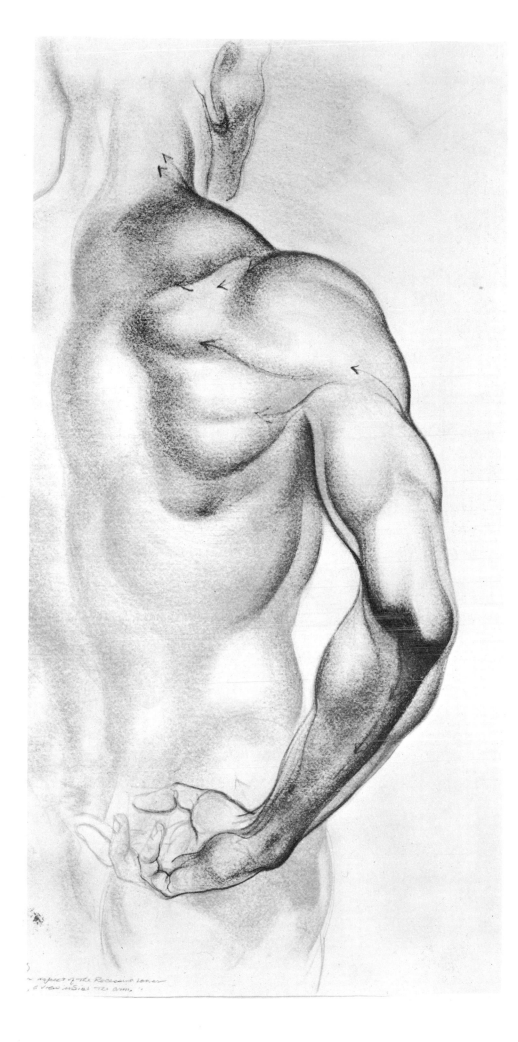

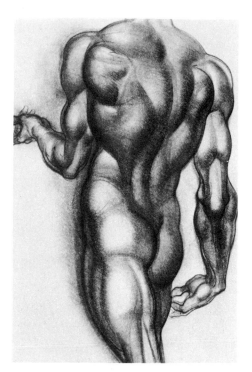

Here we see the elbow as an interconnecting form from a double viewpoint; the right arm, extended, repeats and emphasizes the dominant upper arm bone (humerus) and elbow projection, sitting astride and thrusting deep into the lower arm; in the left arm, projected into space and bent, the contours of the dominant forms shift from being hard to engage the muscle masses of the forearm in a series of interlaced undercurves, developing an overlap effect in the foreshortening.

Here is an inside view of the recessive, lower arm. The combined dominant members, the upper arm and the elbow, set the course of linear connection downward into the shank line of the ulna bone and deep into the wrist. Also, note the shoulder interconnections to the body (see arrows).

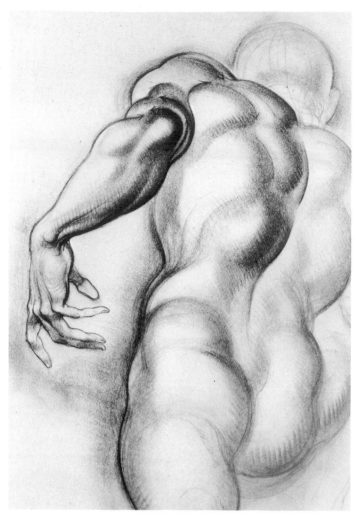

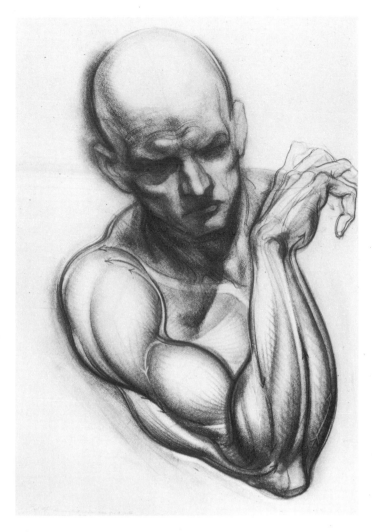

When the arm action reverses, putting the elbow into a high, upthrust position, the dominant member is now the exposed forearm—seen, with the elbow, from below. The upper arm is largely lost to view. The linear interconnections move from the forearm and elbow upward to the upper arm muscles in a group of tight overcurves. Observe how these overcurves continue into the larger complex of related body forms.

The arm, bent and seen from the front, puts the upper arm and the lower arm in two different foreshortened directions: the forearm vertical; the upper arm horizontal. The bulges of the flexed arm, interesting as they are, tend to disengage and separate the arm into a sequence of parts. The decisive addition of linear thrusts—contours going beyond the immediate muscle bulges and threading in and out, relating and connecting the parts into a coherent whole—is necessary to form totality and continuity. See if you can follow the linear interconnections (use the arrows as clues); also notice how linear devices are used to link horizontal and vertical members.

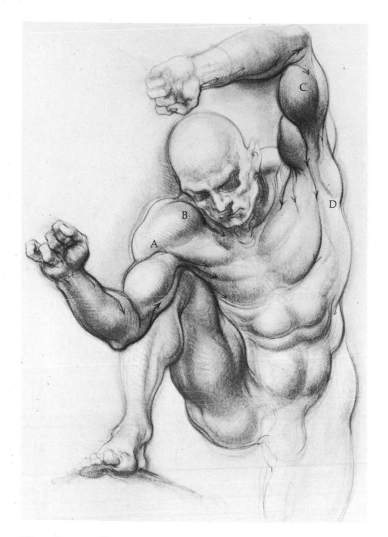

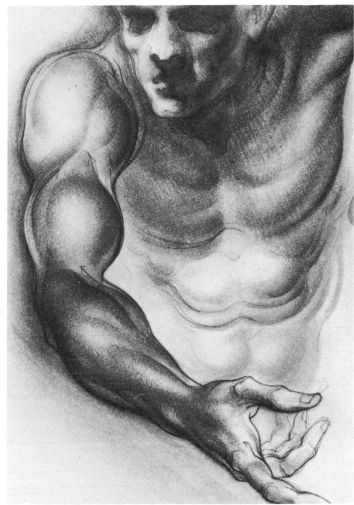

This figure illustrates how the arm is attached to the body from a front view. The flexed forms of both arms develop marked separation tendencies in the underarm views. The left arm, extended forward and raised, virtually cuts the arm from the deltoid muscle. Here, a conscious interlineation with the chest is required (A), as well as an overcurve continuation of the deltoid-to-clavicle (B) connection with the torso. This is also true for the uplifted right arm, where the underarm and armpit passage — biceps (C) to axilla (D) — must be laced into the chest mass both internally and externally (see arrows). The deltoid, seen low, is also carried into the chest. Throughout both arms, the muscle expansions of lower and upper members are threaded into and connected with the adjacent neighbor forms.

This extended arm shows the interlace lines moving backward from the hand and fingers in a progression of outline-to-inline contours, developing a cohesion and flow of the parts. Notice the linear tying-in of the right shoulder with the chest and lower body.

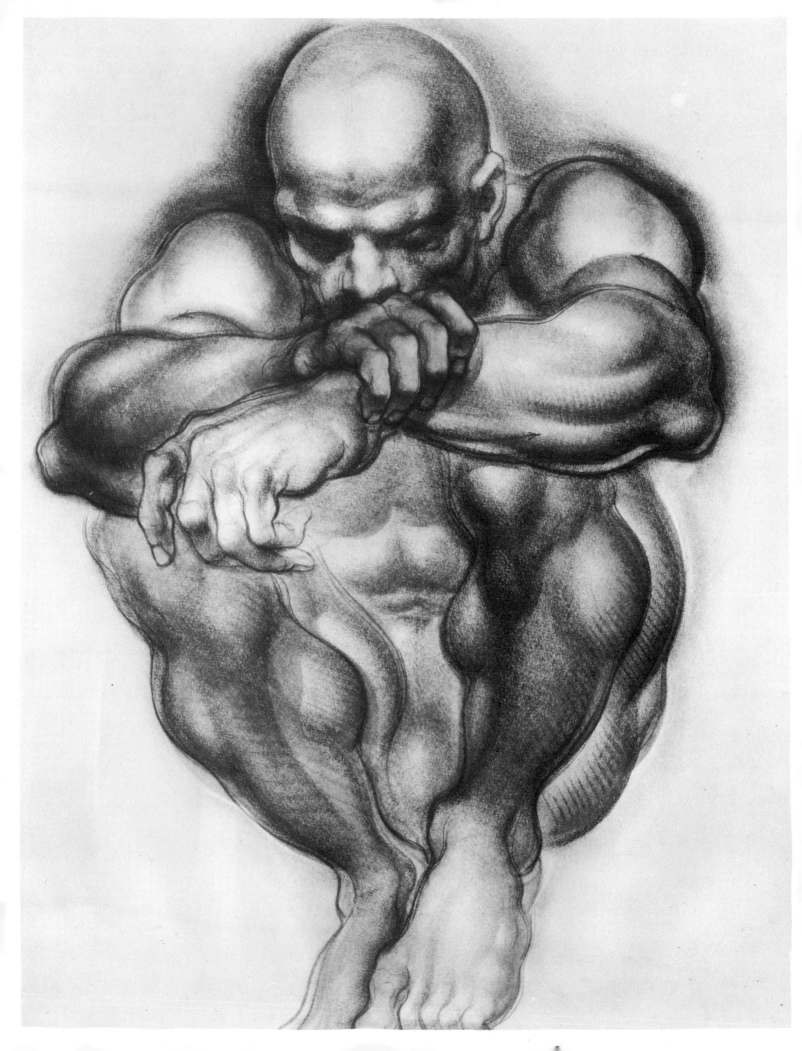

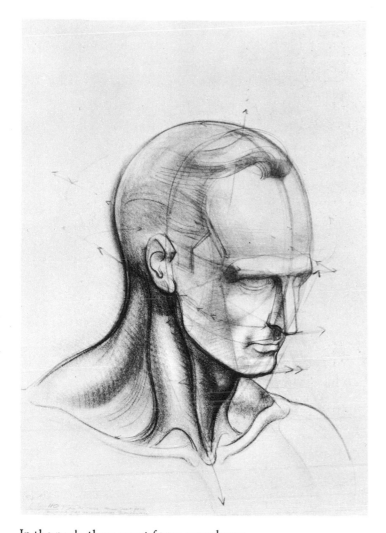

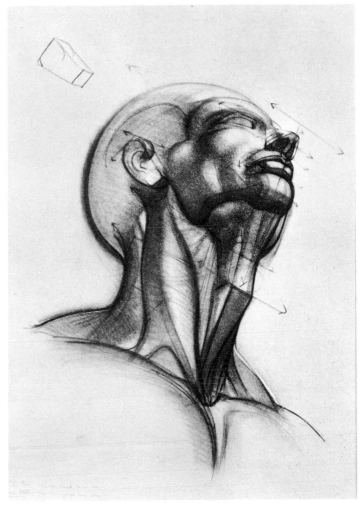

In the neck, three great form complexes act as mediators between the head and the body: (1) *the sternomastoid* (two passages, left and right), which links the side head with the mid-chest; (2) *the trapezius complex* (two sides, left and right), which links the back torso with the rear skull base; and (3) *the neck funnel* (front), which links the underjaw with the central neck pit. In this down view, the head mass blocks any evidence of the underjaw attachment; but the central neck forms can be seen to thrust deeply into the chest cavity, bounded by the *V*-shaped collarbones. Here, the neck pit is the terminal for the frontal neck harness.

In this up view of the head and neck, the low neck pit connection is inhibited. The open underjaw horseshoe form curves around the neck funnel, and from mid-chest two branches diverge and rise high into the skull base behind the ears. In this example, like the previous one, the rear trapezius shoulder connection maintains a direct, unconditional presence.

◁ In this concluding arm example, the lower arms almost obscure the upper arms. What keeps the arms in visual relevance here are the deltoid bulges rising and passing into the mid-body from the left and from the right (left).

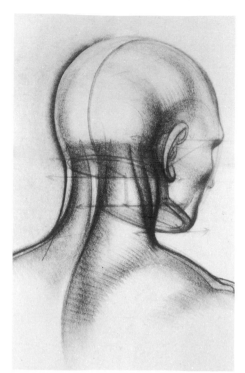

From the rear, the neck interconnection with the head is easy to understand. Here we see the trapezius shoulder curves closing from the left and from the right to rise, column-like, into the rear skull base, where the cranial ball begins to develop. Note how the *outline* of the shoulder becomes the *inline* of the base of the head. Of major importance in the head's attachment to the body is the *spine*. The spine is central to any understanding of the head action. While the spine line connection may not always be included or used, its implied presence lends a subtle stress of authenticity to the head-neck relationship (above).

If you take viewpoints all around the ▷ body, the two sides of the neck express opposite sides of the body and the head; not only left and right, but front and back as well. A simple illustration of this can be seen in this profile head: *the front neck line* starts from under the chin and descends to the pit of the neck, tying all forward forms of the head, neck, and body together; *the rear neck line* is the opposite of the front line, linking all the rearward forms of the head, neck, and body.

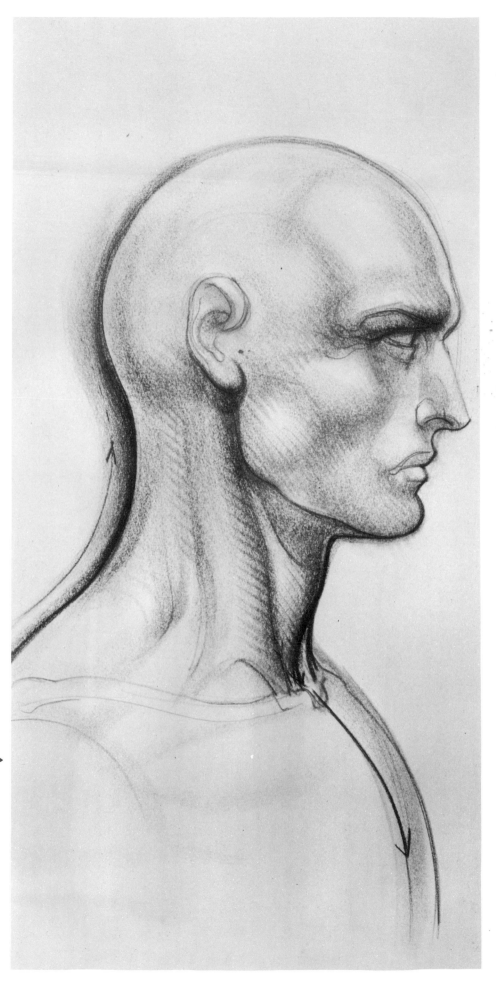

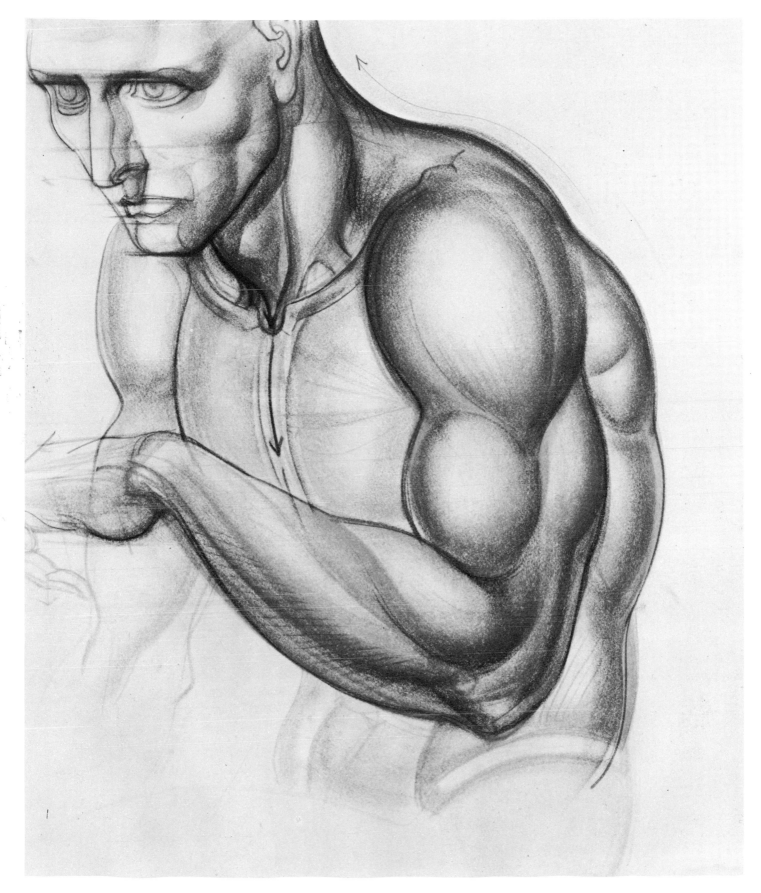

This three quarter figure clearly illustrates the difference between the rear neck line and the front neck line: *the rear neck line* is higher, and relatively shorter — it expands, and smoothly swells over the torso barrel in an *outside* line; *the front neck line* is lower and longer — it is a decidedly *inside* line as it plunges to the pit of the neck and continues down the central body.

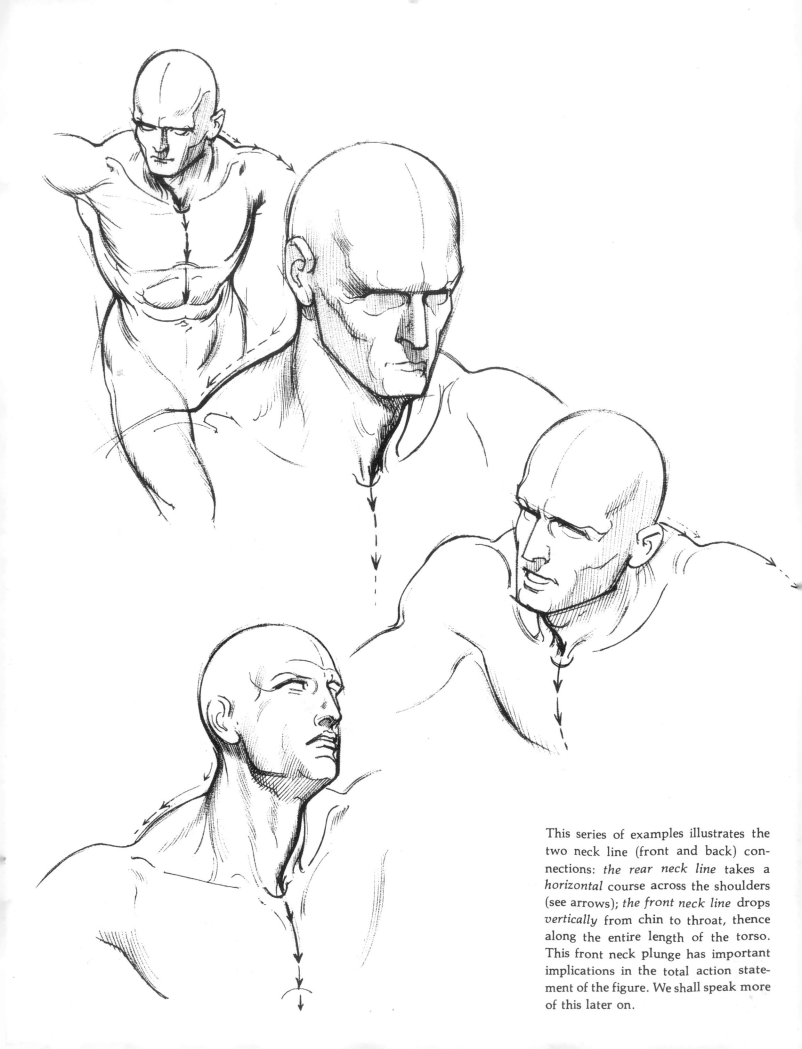

This series of examples illustrates the two neck line (front and back) connections: *the rear neck line* takes a *horizontal* course across the shoulders (see arrows); *the front neck line* drops *vertically* from chin to throat, thence along the entire length of the torso. This front neck plunge has important implications in the total action statement of the figure. We shall speak more of this later on.

Outline and Contour

We have discussed how foreshortened forms are held together with interconnection lines in order to effect figure cohesion; but there are times when too intensive probing of interlocking devices becomes a preoccupation with detail, and a genuine, over-all concept of form is impaired or overlooked. In this case, a secondary device is called into use: a firm, end-of-form controlling contour. Once a figure has been established with overlap and insertion devices, it can be brought to a full cohesion with an effective coordinating outline.

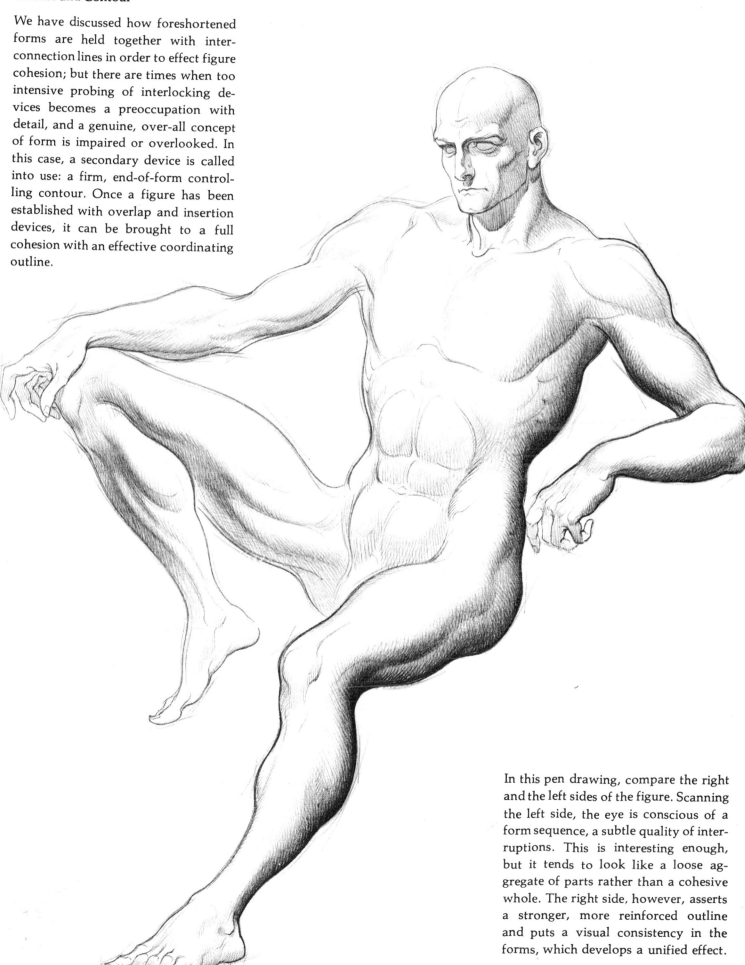

In this pen drawing, compare the right and the left sides of the figure. Scanning the left side, the eye is conscious of a form sequence, a subtle quality of interruptions. This is interesting enough, but it tends to look like a loose aggregate of parts rather than a cohesive whole. The right side, however, asserts a stronger, more reinforced outline and puts a visual consistency in the forms, which develops a unified effect.

When an action figure is expressed in contrary form directions, and large overlap elements produce visual barriers to form continuity, the clue to producing an unencumbered figure is a persistent, encompassing contour. Notice how easily the eye follows the unifying contour flow in this figure.

In this example of the use of the outline in the female figure, large, diverse body forms are integrated by a coalescing contour.

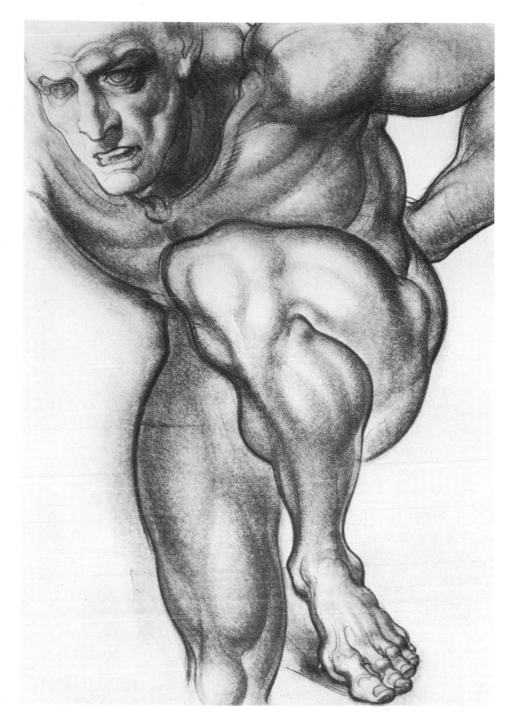

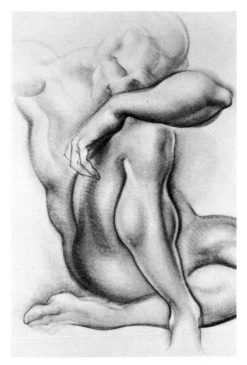

In this figure, as in the previous example, the defined, external contours take a dominant role, while the internal body forms are even more diffused.

Here is another example of an approach to contour control. In this case, the cohesion of parts depends on the reduction of minor forms by tonal diffusion and suppression of edges, which permits the major end-of-form outline to be grasped more clearly.

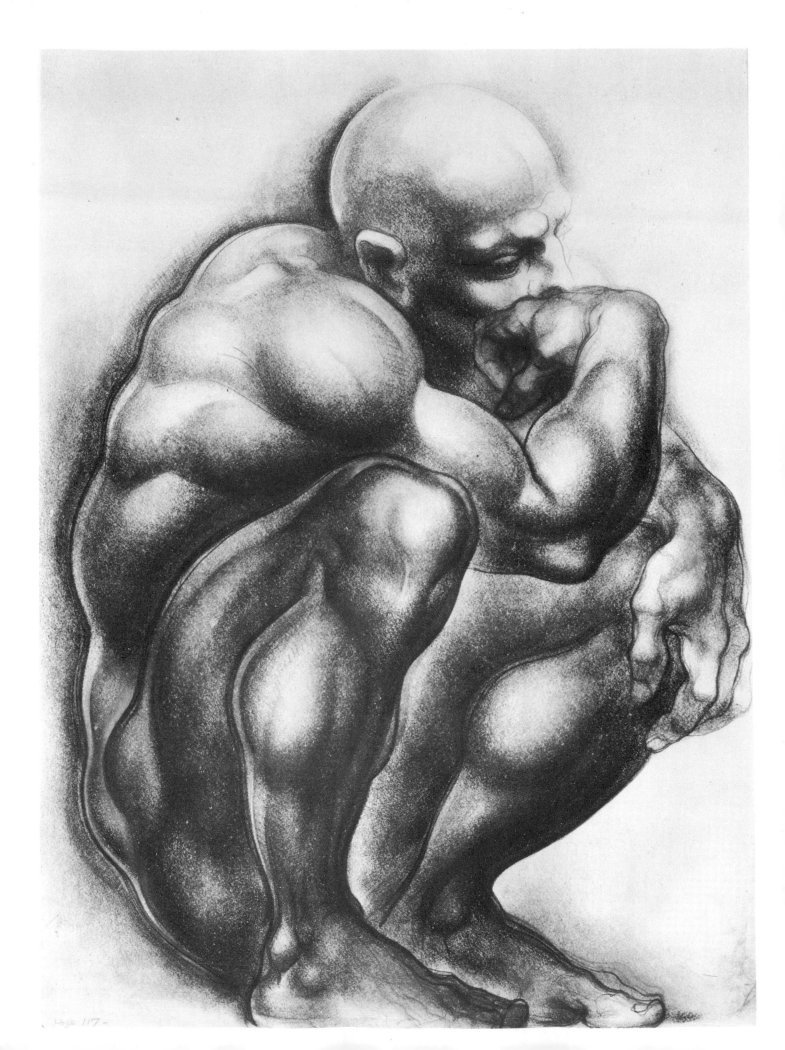

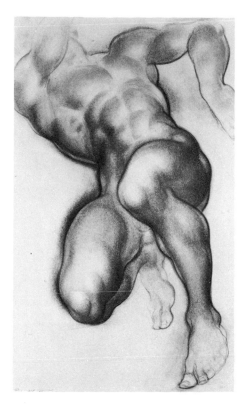

This figure is carried to a further stage than the previous examples. Here, the tone is used to hold down the large body forms and lets a pattern of light emerge on the figure. The path of this light guides the eye along the central forms, while the strong enclosing contour line around the figure gives it unity and coherence.

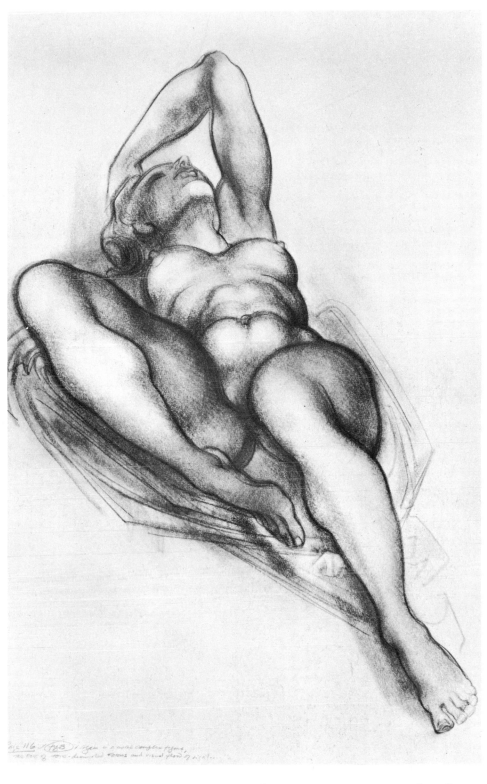

◁ There are times when a decisive increase of tone on the forms of the figure is more effective than the outline in achieving figure unity. In this figure, the outline is present, but it is secondary; a tonal character dominates the forms, and the effect closes the figure down into a *mass* which becomes a light-oriented figure statement. When the figure is illuminated, tone, value, and mass overrule line to control form.

Again, in a more complex figure, diminished tones and the visual flow of light subtly support the outline of the body. See if you can observe this interacting effect without the aid of arrows.

Tone Gradation

When a substantial increase in tone on a figure achieves a greater cohesion of form than the simplistic, direct outline, form goes into a more advanced stage of development. The predominant use of tone and value—rather than outline —describes the figure in its *total mass appearance*. The figure is characterized by conditions of atmosphere, light, texture, density, and weight. The problem, in short, is plastic and environmental, revealing the figure in its physical, tangible presence. Such qualities must be conceived as mass—their formulations are resolved by the use of value and tone.

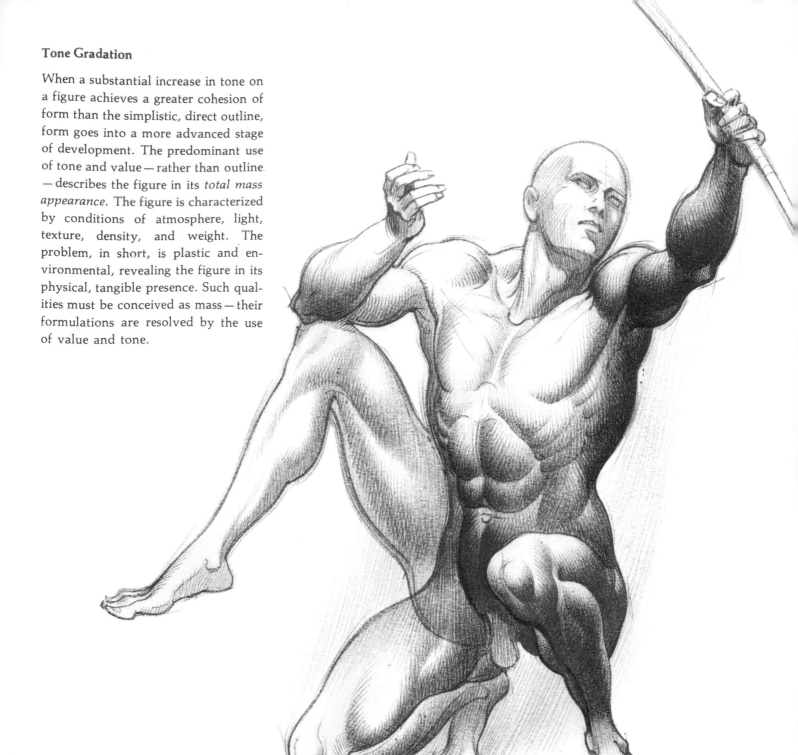

In this figure, outline is used as a supplemental feature. The left side of the figure shows an outline with some accented stress, supported by light tonal areas to show light orientation and form volume. The linear factor, however, tends to dominate. On the right side, the greater use of tone reduces the consciousness of line; the result is a closing down of forms and a massed, tonal effect.

In the treatment of these two down view action figures, line is used to define form — but the tones develop from top to bottom, giving light values to the nearest forms and darker values to the further forms, allowing both figures to be seen in tonal progression by mass. Their tonal gradations are seen as near-to-far form continuity in space. Check the result with your own eyes. Observe how simply your gaze sweeps the figures; how easily your eyes take in the rise and fall in space, moving from top to bottom on the gradated tones.

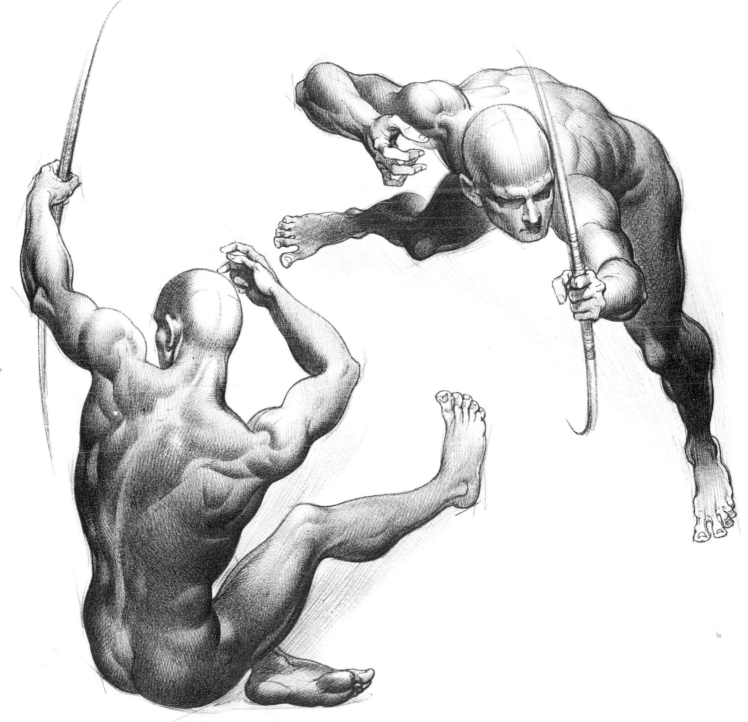

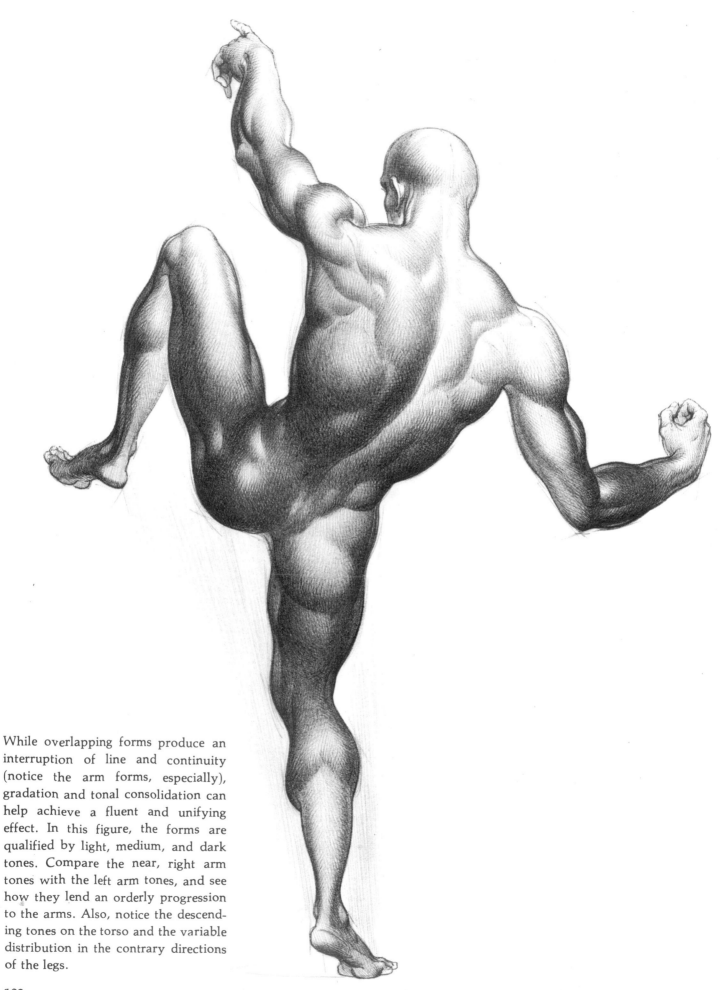

While overlapping forms produce an interruption of line and continuity (notice the arm forms, especially), gradation and tonal consolidation can help achieve a fluent and unifying effect. In this figure, the forms are qualified by light, medium, and dark tones. Compare the near, right arm tones with the left arm tones, and see how they lend an orderly progression to the arms. Also, notice the descending tones on the torso and the variable distribution in the contrary directions of the legs.

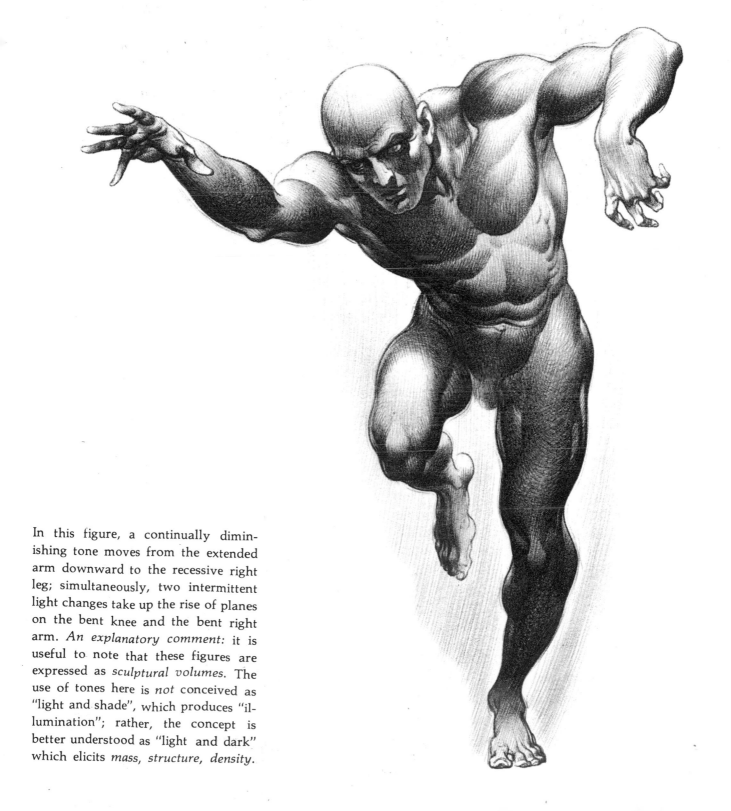

In this figure, a continually diminishing tone moves from the extended arm downward to the recessive right leg; simultaneously, two intermittent light changes take up the rise of planes on the bent knee and the bent right arm. *An explanatory comment:* it is useful to note that these figures are expressed as *sculptural volumes.* The use of tones here is *not* conceived as "light and shade", which produces "illumination"; rather, the concept is better understood as "light and dark" which elicits *mass, structure, density.*

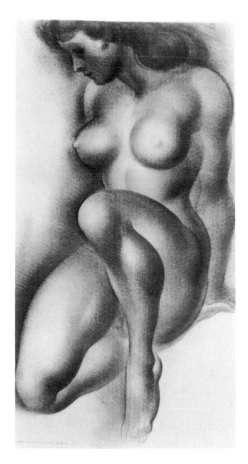

Here is a figure conceived with an indirect source of light. The function of tone as air is aimed at enclosing the figure in a region of dark values, so that forms may be seen as emerging from a diffused light, unified and complete. Line contour has virtually disappeared. Form is projected as an illuminated volume in spatial depth, not as outline.

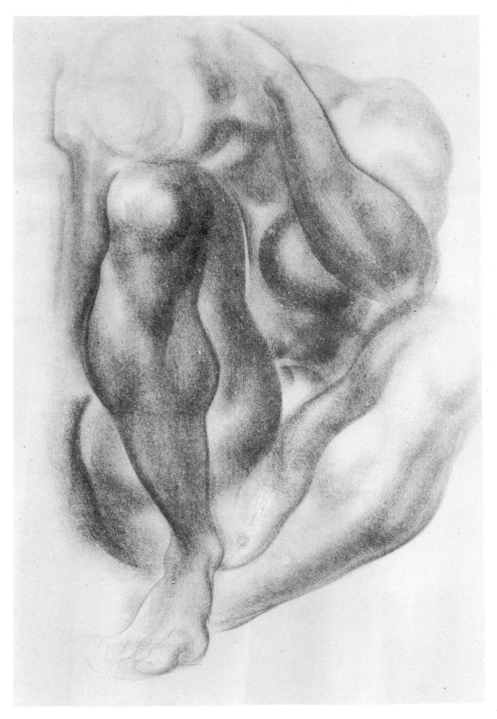

The accented stress of dark and light tones here is completely *compositional* and arbitrary. What appears to be *light* and *air* is an incident of *space*. Since there is no direct source of light, the figure — with its tonal interaction in space — is put in a context of motion; motion and space, scored together, are seen as design. An undulating, weaving, fading in and out effect organizes the flow of the figure and gives its forms a rhythmic pulse throughout. Note especially the plastic effect in this figure, which departs from any manifest consciousness of line.

4

Figure Invention: Controlling Size in Foreshortened Forms

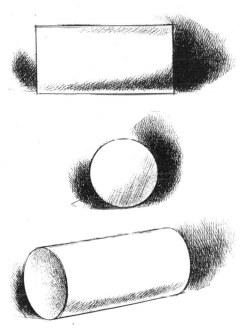

A cylinder, as everyone knows, shows two characteristics of geometric form: (1) from a direct *side view* position the cylinder has the appearance of a *rectangle*; (2) from a direct *straight-on* view into the top or base the cylinder has the shape of a *disc or circle*. Any change in the viewing angle from the above-mentioned positions will produce a third possibility — (3) in the *combination* of the rectangle and the circle, the *sides* of the cylinder are *straight*, but the *top and the base* show the curvature of the *circle at a tangent*. It is this combination of features which gives us the typical cylinder.

Until this point, the reader has been shown figure drawings that demonstrate structure, rhythm, shape-mass, form flow, figure notation, etc. It has been taken for granted that these figures form the basis of a problem to be studied, that they illustrate a premise; *how* they were devised is a question which has not yet arisen.

Now, however, that we have some primary knowledge of form, we can ask this question. *By what means* are figures originated and presented? How do figures come to exist in the first place?

So that the reader will have no doubt as to the origin of the figure illustrations in this book, let me assert firmly that they are not taken from any clip file or reference morgue, nor are they copied from posed models. These figures were drawn from the imagination, projected "off the cuff" with no visual reference except that of the inner vision of the inventive faculty alone. It would appear that this takes some doing, that it needs, as some would like to believe, some innate, special, personal talent. It needs nothing of the kind. Figure invention is a capability developed by work and by practice. To understand the nature of form in space — the uses of the controlled visual viewpoint, the comprehension and assertion of certain analytical devices — you need only apply yourself, and the pleasure of authentic figure originality can be yours. To this end, we shall probe the formal propositions of the figure in space.

It is almost unnecessary to say that the most stimulating figure is the figure in action; and the best of these are not side views but *in-depth* views. It is the in-depth figure that most students would like to be able to invent freely, without inhibition. But the complication, students find, is in making an up-ended, foreshortened form behave in relation to a partner form, or member, of *similar size and volume*, i.e., arms, legs, etc. The trouble with drawing advancing and receding members as if they were co-equal, non-foreshortened forms is that they tend to look distorted or exaggerated — too large, too small, too thick, too thin. And when any such exaggeration is perceived, hesitation quite naturally follows; and then perplexity, frustration, and failure. A typical reaction at this stage tends to be self-hatred, an ill-concealed rage which is projected onto the drawing and destroys it. In order to overcome this kind of problem, we must understand the difficulty piecemeal; we shall approach slowly, circumspectly; we shall study and practice.

Cylindrical and Barrel Forms

To invent in-depth, foreshortened figures (active or otherwise), let us assert that the forms which tip over most readily and present an up-ended view in most cases are, *primarily*, the cylindrical or column shaped forms and, *secondarily*, the ball or barrel shaped forms. These are, without a doubt, the most numeroud of the forms which make up the figure. They can be related to the columns of the upper and lower legs, all the rod and ball formations of the fingers and toes, the neck column, the chest barrel, the cranial ball — and if we include the half-cylinder facial mask, there is little left to discover in the way of forms in the human body except for a few minimally distributed wedge blocks.

The Cylinder as a Rational Form

For our purposes here, we shall deal with the forms we are discussing as *cylindrical*. The reason for this is the essential simplicity of the cylinder; it enables us to describe deep space foreshortening problems with a clear-cut, disciplined approach which the reader can understand with no confusion. Once the basic characteristics of the particular members are seen in their most simplistic forms, then their special qualities can be developed and refined.

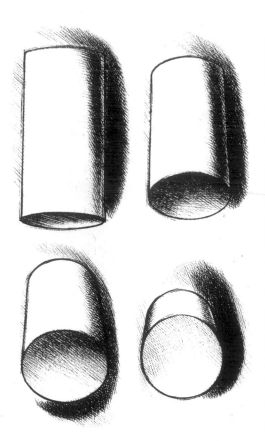

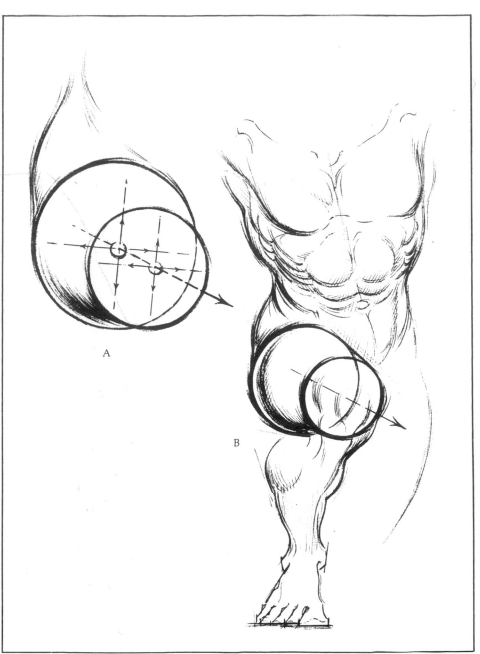

In any view where the straight/curved combination of the cylinder form exists, *foreshortening has already taken place.* As the view into the base or the top becomes more direct, the fuller curve of the circle becomes more obvious; the greater the curvature, the less we see the length of the sides. Observe the four stages of the cylinder illustrated in this example. If the curved aspect swells and becomes virtually a full circle, the length of the cylinder in depth is hardly seen at all. The overlapping top and bottom curves dominate the view. In the last-stage example, the extreme foreshortening gives the impression of a double curve, with scarcely any straight sides from front to back.

Treated as a cylinder, the drawing of a deep space, front view of the upper leg presents no great problem in working out the foreshortening. We take one exception, however, to the geometric cylinder shape—to accommodate the leg as an organic form (as we conceive *all* body forms), the upper leg is compressed to correspond to the tapered knee. Hence, in drawing the double curve, in-depth view of the thigh, the knee curve lies almost directly in front of the rear leg and hip region, and little, if any, length of leg is presented to the eye. In the schematic sketch (A), the circles with related arrows explain the forward directional thrust given in the leg sketch (B).

Finding Constant Factors

The foreshortening of a single member of the body is not a complex matter. The real problem lies in working with multiple figure forms that are required to move in a variety of spatial directions. When the entire figure must be expressed in the unequal form-lengths of action statements, how can form-to-form consistency be maintained? How can members be made to look proportionately equal and relatively similar in contrary positions and diverse views?

To most artists, solving the problem of depth tends to be beyond logic; it tends to be intuitive, depending on pure guesswork. Hence: *if constant factors can be found—norms of measurement to be applied to any change of a member in an in-depth view— then correct proportion of fore-shortened forms can be achieved by any student who is willing to apply this premise.*

Width of Form as a Constant Factor

Since we are using tapered cylinders or columns to interpret the majority of figure forms, one aspect of the cylinder may be used as a measuring device regardless of the way it is seen. This aspect is the *width* of the cylinder. Throughout its length, from top to bottom, the form of a cylinder is *circular*. Because the *circle* of the cylinder can be seen from any direction or change of view as an *ellipse*, we recognize that this ellipse (being a circle seen in perspective) is truly the original circle, provided that one factor is always present: *the width of the ellipse must be the same as the width of the original circle.* We call this width the *constant diameter* of the circular form. If the diameter is the *same* in a number of given ellipses, then these ellipses are all the *same circle* seen from different viewpoints in space.

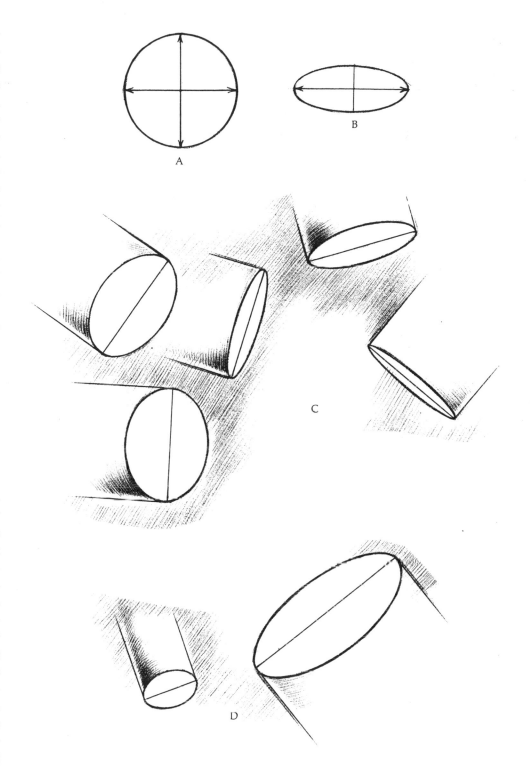

Here, the constant diameter circular form is given in a succession of sketches: (A) circle with a given diameter; (B) ellipse with the same diameter; (C) series of ellipses with constant diameters (note how all the ellipses which appear to be the same circle size develop into cylinders of equal dimension); (D) two ellipses of lesser and greater diameters (the circle sizes are different, and the dimensions of the cylinders are radically altered). Using these observations, a simple rule emerges: *in the foreshortening of cylindrical body forms, if the width of a member is held equal and unchanged, the length may vary, but the form itself will appear visually the same in all depth views.* The constant width (diameter of cylinder) produces form similarity regardless of differences in position or viewpoint. In sum: *similar widths produce similar forms.*

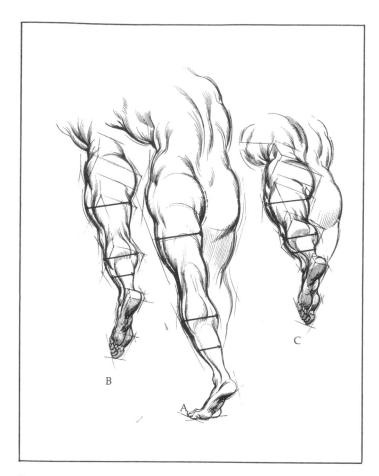

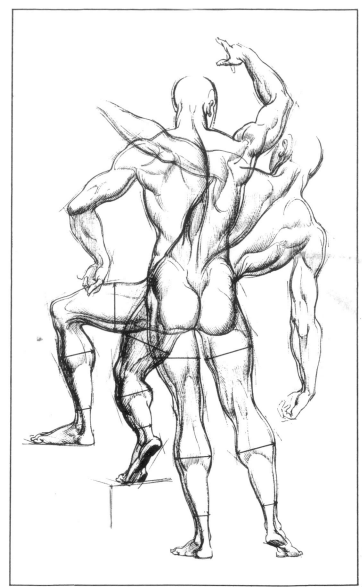

Let us test the preceding proposition by applying it to the figure. Suppose we look at a leg belonging to a figure seen from a three quarter back view. In this example, the leg moves progressively higher and more up-ended in relation to the viewpoint: (A) leg low, foot on ground, elongated view; (B) leg lifted, foot up, sole plane exposed, foreshortened view; (C) leg raised higher, more extreme form-to-form, in-depth view. If we check the related form measures given on the legs, member for member, we see that they belong to the *same body* in a sequential progression. Yet, member for member, while the widths are constant, the lengths are not the same. Clearly, as the rule shows, the size of forms in depth is governed by their widths.

An effective proof of the constant width factor can be seen in this multiple action drawing. Here, forms move from a conventional position to new positions in depth. The members shown in this way give us varied lengths; but if the widths are clearly the same, form identities appear correct. The accented arrow lines on the legs give the diameters of circles cross-cut through each form and defined as the *fixed width measure* at the thigh, calf, and ankle.

In this study, varying degrees of length of straight legs, seen in depth, do not inhibit the visual impression that these legs are the correct size.

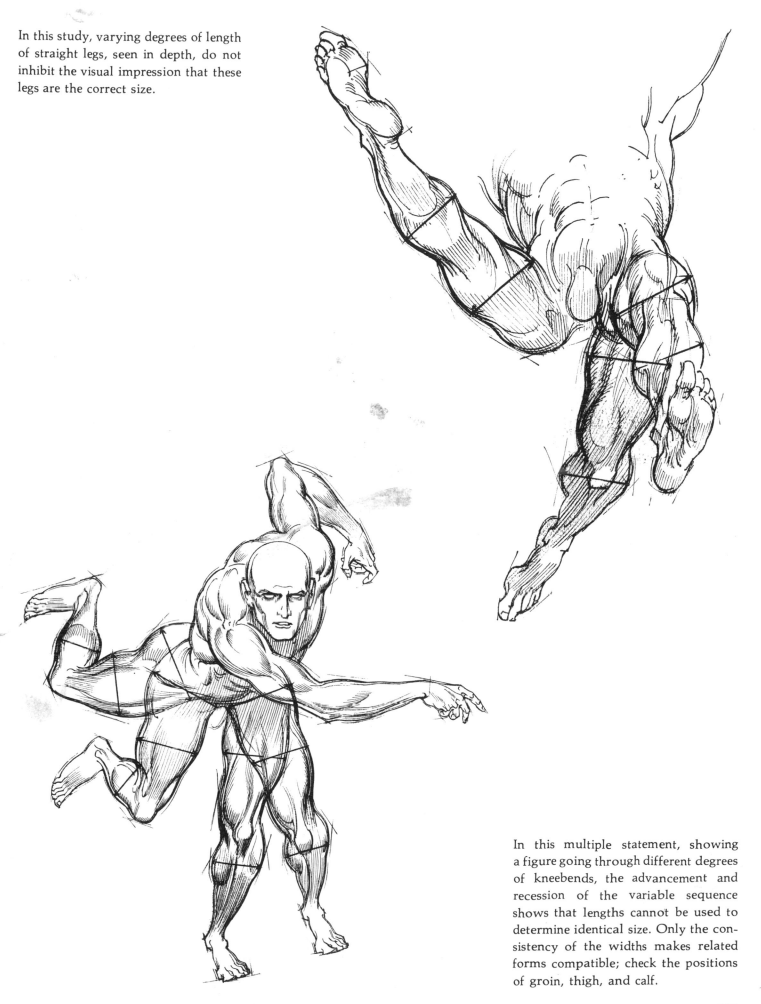

In this multiple statement, showing a figure going through different degrees of kneebends, the advancement and recession of the variable sequence shows that lengths cannot be used to determine identical size. Only the consistency of the widths makes related forms compatible; check the positions of groin, thigh, and calf.

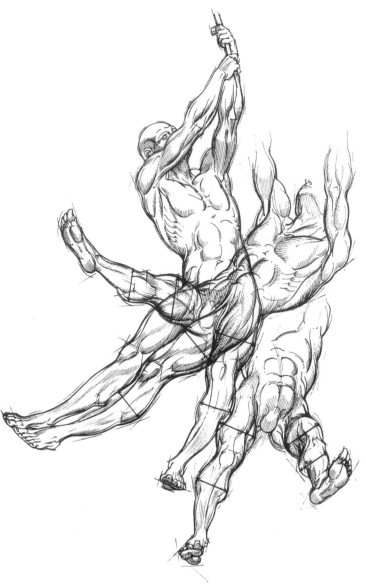

When forms are partially, or almost completely, hidden behind other forms — in leg bends, for instance, where one knee is upraised (right) and the other is down (left) — the interposition of members creates a problem of size identity, and it becomes difficult to get everything in proportion. In such cases, we shall depend on a principle of interpretation defined as *rational inference*. In effect, this means that we know the size of a relevant form (see left upper leg, the visible thigh), and carry it opposite to the related right leg (see expanded inner thigh bulge). The adduction of form size here begins with the *knee* as the organizing member of visual similarity. If the knee wedge is virtually *equal* in both legs, and the left (visible) thigh is in proportion to the knee, then the hidden right thigh will be correct. The extended left leg establishes a size norm. Note the similarities of calf, ankle, and foot forms.

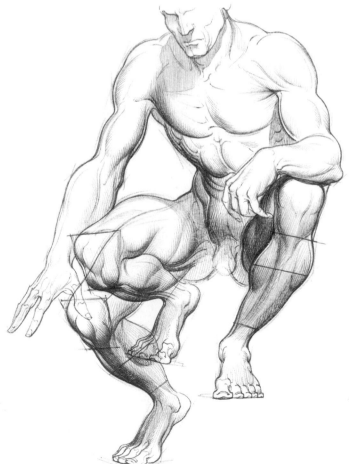

In the multiple leg sequence of this gymnast, from extended leg to extremely foreshortened leg, the thigh and the calf widths are repeated as the *rational measures* of form; as such, the legs assert themselves in consistent size no matter what view is presented. Each change gives a relevant appearance of the same form in motion.

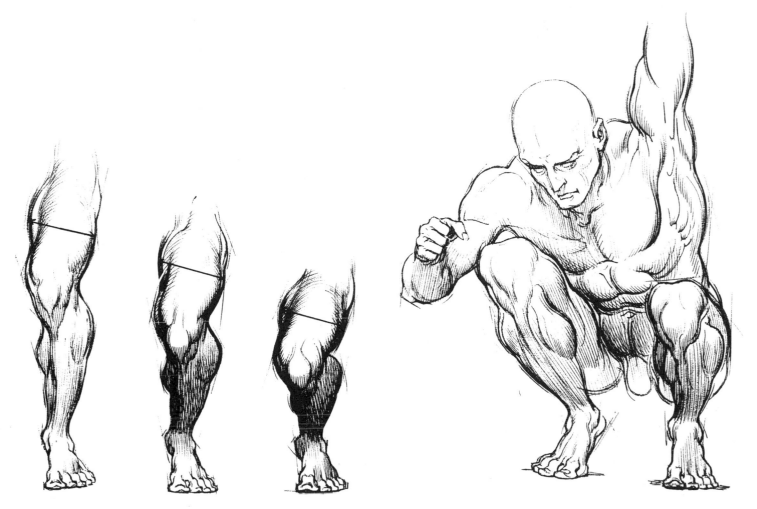

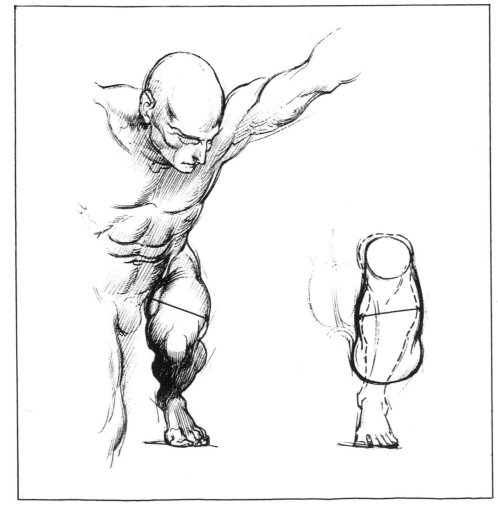

The problem of indicating the size of hidden members is seen in the above deep squatting position. The two lower legs can be seen completely; but the upper legs are obstructed, the right in virtual total overlap. Indicating size is not as difficult as it seems in cases like this. The clue lies in the sideward expansion of the wider thigh measure compared with lesser calf width. If the exposed thighs swell wider than the calf muscles do, the upper legs, obstructed as they are, will appear correct in size (again, note how your eye takes in the clue of knee relevance). The leg bend sequence above left shows how the thigh width is understood in its position behind the lesser calf muscle. As the leg closes, the width, as diameter, is constant; the leg lengths shorten as they tip in depth. The partial figure shown here puts both members in deep thrust—but the measures are maintained. The diagram to the right shows the complete overlap. The thigh is accented behind the lower leg in dotted line. Now see how this thinking is carried into the right leg of the upper, complete, figure.

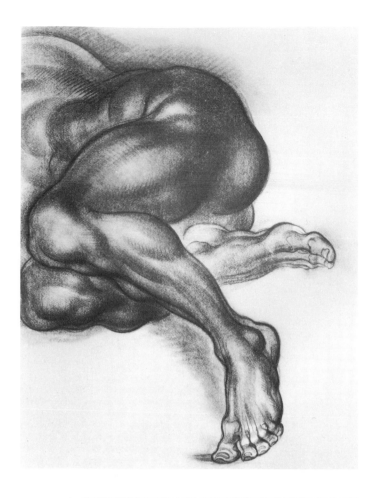

◁ Here is a closed, contracted leg whose members are almost blocked from view. The burden of size identification is on the visible knee and foot — these equate with the forms of the exposed, crossed leg — and the hidden member forms are inferred to be of equivalent size (left).

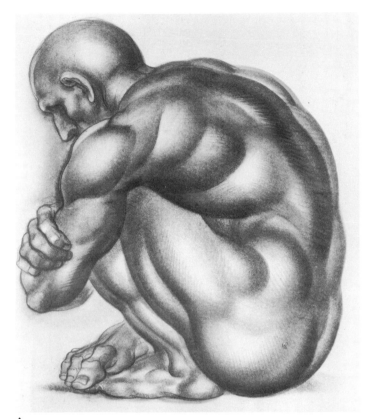

△
Extreme variations of hidden forms tend to occur in seated, closed, or hunched positions of the figure. An entire leg in this example is hidden by the body and simply cannot be shown. Yet, if the foot of the hidden leg is exposed and drawn in good size in relation to the visible leg, the total existence of the hidden leg is implied and comprehended (above).

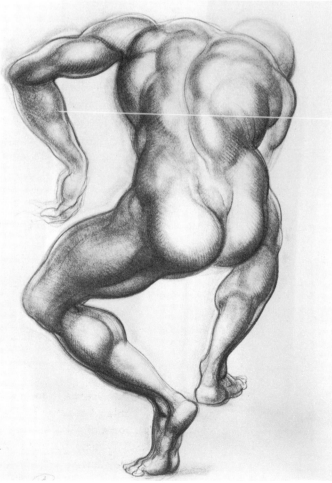

◁ This back view figure tends to present the most difficult problems with form obstruction. Size must be construed by working carefully with those parts which are visible. The obscured right upper leg in this figure takes the correctness of its size from the related lower legs and feet (left).

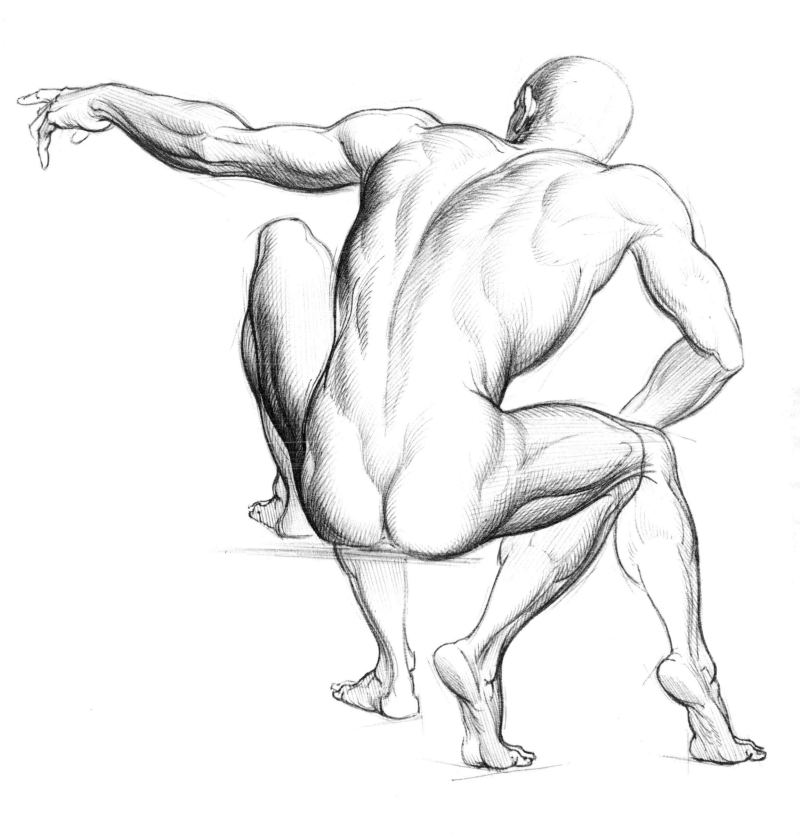

Here, a number of leg variations are expressed as similar because the feet are used as the norm of size. Note how the heels especially tend to make all the positions consistent as far as size is concerned.

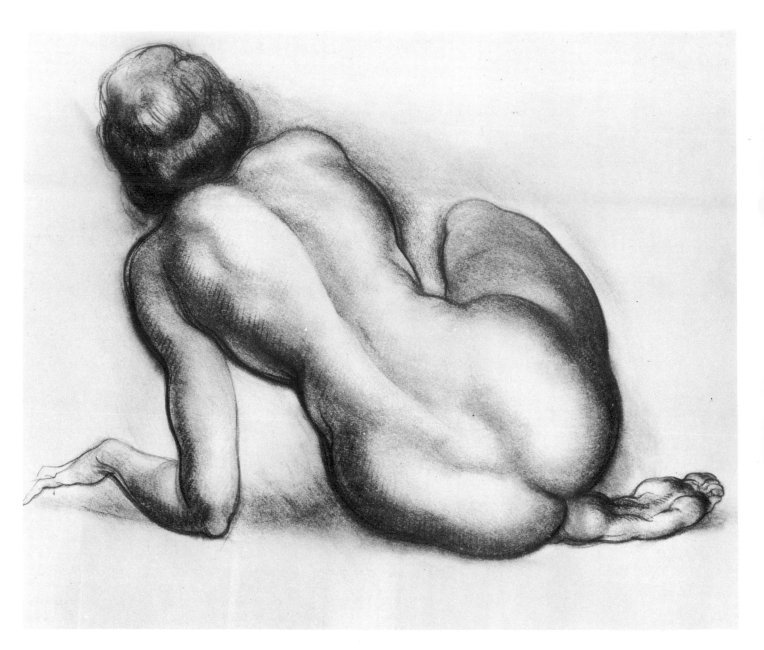

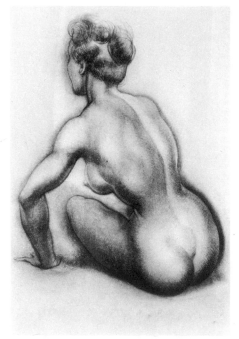

In back views in which most of the hidden leg members cannot be seen, how shall we judge their size? The problem can be solved very simply. In this figure, for example the right thigh is the only leg form which is visible. If the foot of the left leg (tucked underneath the body) agrees in size with (is in correct proportion to) the visible thigh, the missing forms will be understood to be relevant also. What shall we do about a figure such as the small one to the left, when the view gives us only the left thigh and leaves all the rest to imagination? What do we do about hidden forms in this case? Why, nothing at all! What is the point of trying to judge them if there is *no* relationship to any follow-up form? If the left thigh (which ends the leg problem of the thigh) is correct, relevant, and normal, it is sufficient.

The Arms

Problems in inventing arms in fore-shortened positions are directly analogous to those related to the legs. Because the arms are elongated and cylindrical, and similar to the legs in structure and movement, deep space solutions which apply to the legs may be carried over and applied to the arms with similar results.

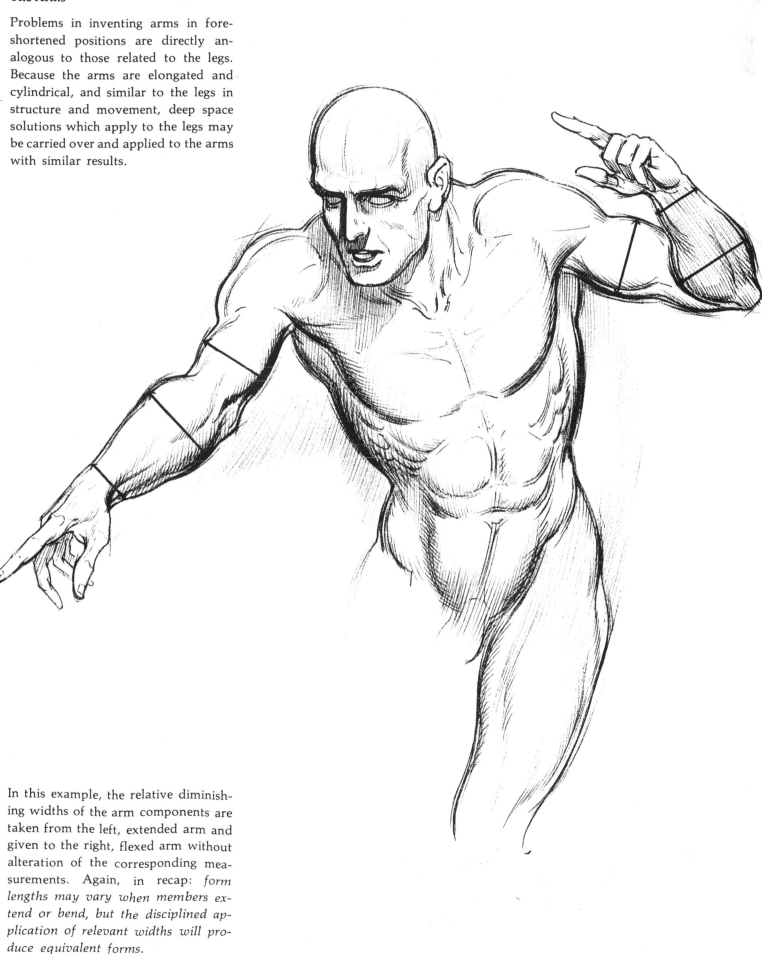

In this example, the relative diminishing widths of the arm components are taken from the left, extended arm and given to the right, flexed arm without alteration of the corresponding measurements. Again, in recap: *form lengths may vary when members extend or bend, but the disciplined application of relevant widths will produce equivalent forms.*

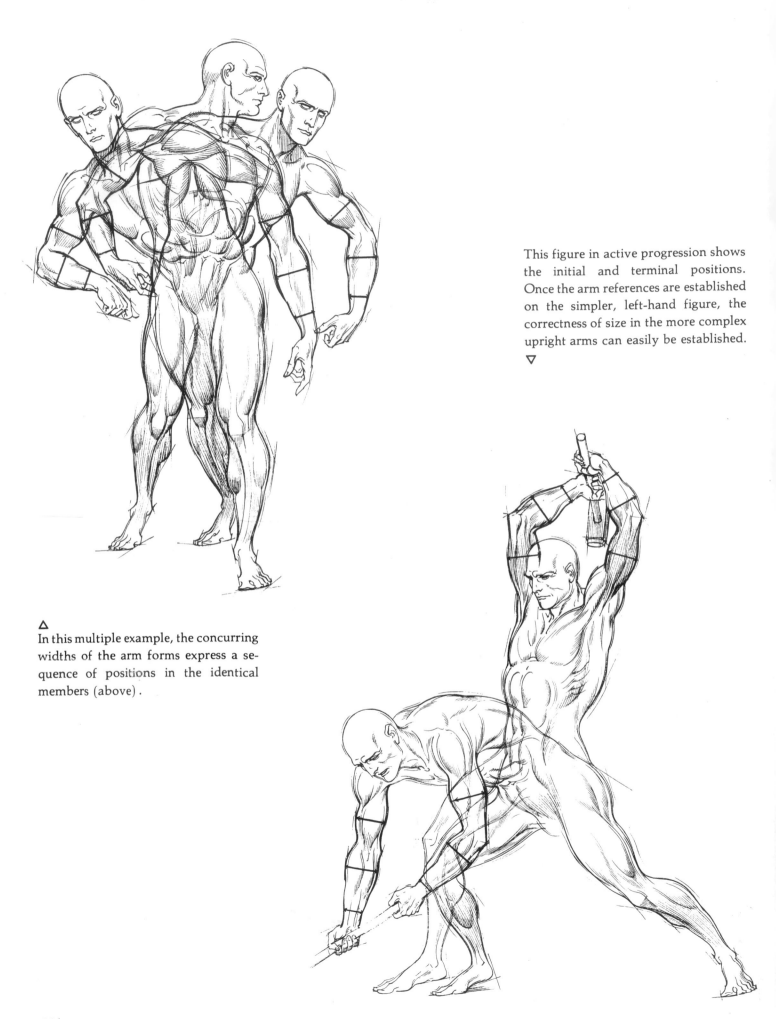

This figure in active progression shows the initial and terminal positions. Once the arm references are established on the simpler, left-hand figure, the correctness of size in the more complex upright arms can easily be established.
▽

△
In this multiple example, the concurring widths of the arm forms express a sequence of positions in the identical members (above).

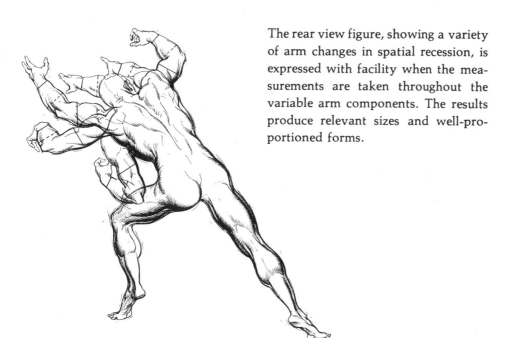

The rear view figure, showing a variety of arm changes in spatial recession, is expressed with facility when the measurements are taken throughout the variable arm components. The results produce relevant sizes and well-proportioned forms.

When we deal with a group of action figures in close relationship on a plane, the problem of arm-to-arm comparison is easily worked out with the use of arm norms taken commonly through each member.

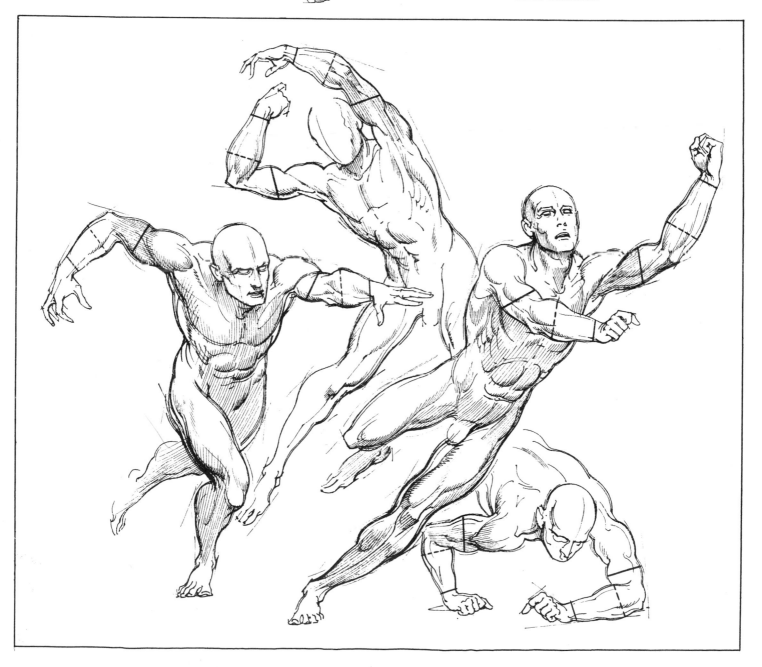

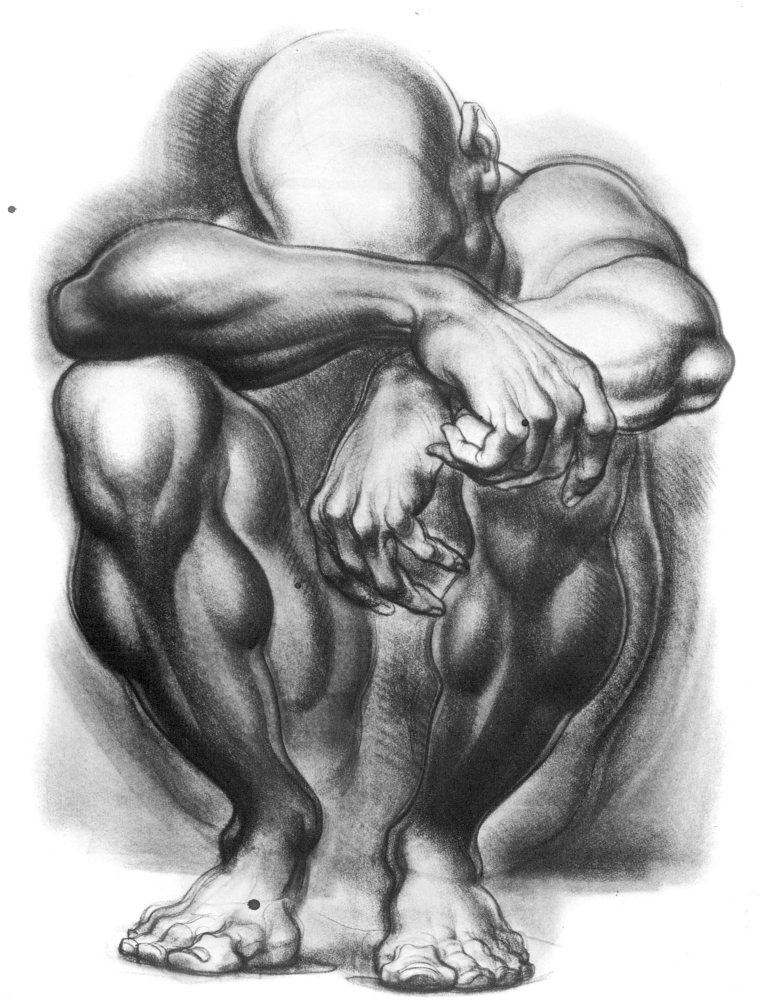

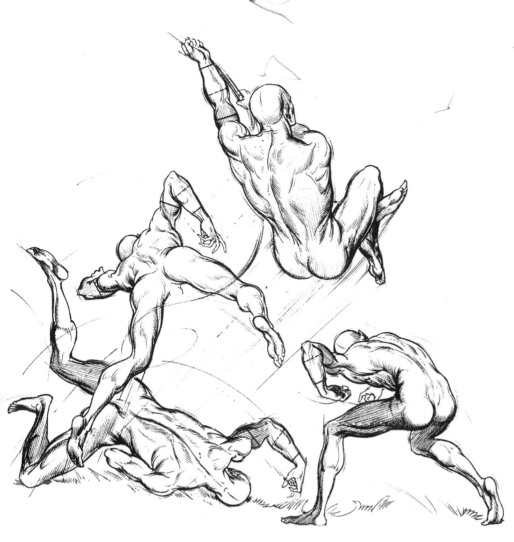

Again, here is a rear view projection of an action figure group. The diversity of arm movements in depth is carried through with the norm widths of the members. The blocked or hidden forms (illustrated earlier in the case of legs) are proved on the evidence of the visible arm forms (left).

In an involved action figure, where blocked forms are necessary, the relevant visible forms must be explicit enough to induce the viewer to infer the logical presence of the blocked or hidden members. Here, although the arms of the flying figure are obstructed, the support figure presents the viewer with references as to their size (note also the correlating upper arms). The crucial factors of form identity in both figures are the *gripped hands:* if these appear compatible, then the natural assumption follows that the hidden forms are similar and equal (below). ▽

◁ To comprehend the presence of blocked arm forms, it is necessary to show clearly the forms which are adjacent to the hidden member. These adjacent forms should be drawn in correct proportion, so that the hidden or blocked member is understood to exist. In this seated figure, the upper arms are virtually hidden or blocked from view; but the forearms and the hands, on both sides of the body, are convincing and plausible in their form and size in relationship to the rest of the body — hence, using the visible forms as our guide, the hidden upper arms are *conceded to be present as well*.

The Hands

Thus far, the rule of width expressing the roundness of cylindrical forms shows that we can draw deep views of the arms and legs; this rule may be relied upon to control *any* illusion of extended cylinder lengths in the depth plane, even though these are literally drawn quite short. Let us apply the rule to foreshortened drawings of the hand, with its diversified finger movements. For all its apparent complexity, it is not so troublesome a problem as we might suppose. First, because the widths of the fingers graduate from thick to thin, from the heavier thumb and forefinger to the little finger, we shall observe the origin of this change in size in the *changing thickness of the palm*, from the thumb to the little finger.

In the above sketch, the lessening thickness of the palm is shown in a view toward the knuckle base of the palm wedge. Here, we see the graduated widths of the fingers given in circles showing the finger origin; finger placement has been added in light, see-through sketch lines to illustrate the follow-up procedure. The sketch below shows us the graduated palm thickness shown in a transparent, reverse view. Once the relevant finger lengths have been established according to the view of the hand that you wish to draw, then each finger complex (phalanx) can be laid in as cylindrical rods, to which you can add the interlocking knuckle capsules.

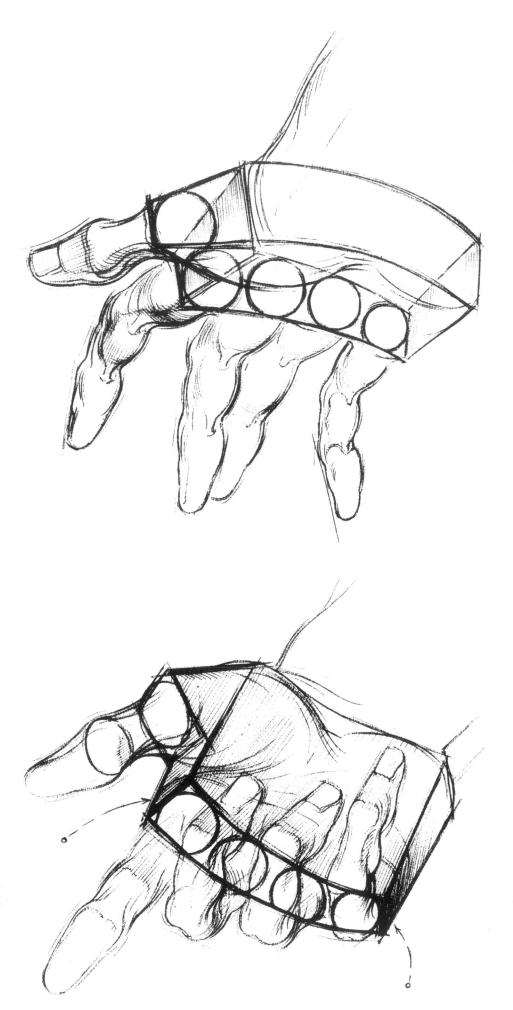

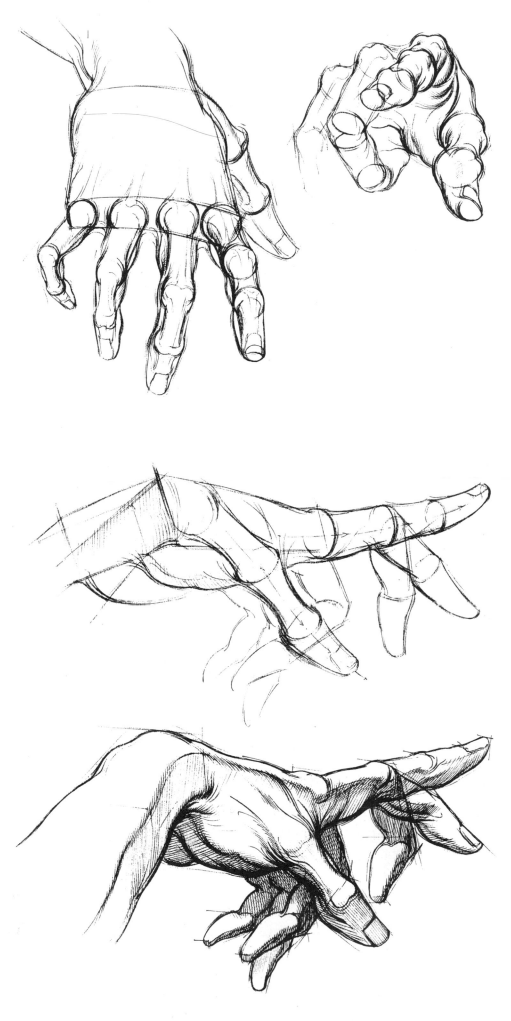

These partial sketches show extreme views with clearly overlapped forms seen on end. The short lengths of the thumb and the forefinger present no problem in visualizing these digital units as equivalent to the longer middle finger forms. The rotund circles of the first two fingers compare normally to the elliptical circles of the longer fingers. *The result:* all forms seem *visually* as long as forms on the hand should logically look. In the sketches below, we see a slight rear-to-side view of the hand, done in two stages to show the construction of the finger rods inserted into the palm wedge. Observe how the finger rods have an *extended* appearance, while the joints have concomitant *elliptical* curves. This proposition of variable circularity — rotund or elliptical — of the cylinder forms is critical for the correct interpretation of deep views in finger movement. It asserts: *the rounder the cylinder, the deeper, more frontal and foreshortened the view; the flatter (more elliptical) the cylinder, the more side and extended the view.*

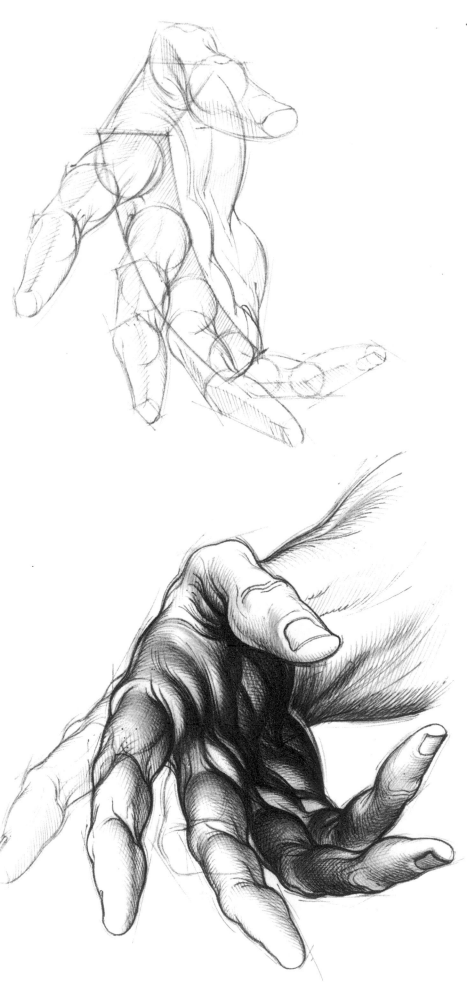

◁ Here is a deep, front palm projection done in two stages, from lay-in sketch to total finish. The foreshortened, in-depth finger views have a series of close-set, rotund curves at the knuckles where movement articulates and changes logically take place (left).

If your understanding of finger inven- ▷ tion is blocked or inhibited, doing some preliminary sketches might help overcome resistence: (A) *Start a tentative drawing,* a rough comp, a doodle with possible finger variables of approximate positions. The wedge palm view should be lightly introduced as an aid. Overlapping circles or spirals can casually indicate finger directions. (B) *Remember, nothing need be finished* during this probing process. Be free to make changes! If a special finger needs clarification, take it aside, test it, work it, block it, play with it; the approach is yours. There are no special rules for this search; keep the process open. (C) *If you feel that a small thumbnail sketch is in order, try one of the full hand.* Project arrows for finger directions, possibly palm curves and fingertip guide curves as well. Then continue without hesitation and complete the small sketch. Don't fuss. (D) *If you understand where your sketches are going, then lightly lay in a large comp.* Perhaps you'll wish to take a dimensional, structured approach, giving form planes and tonal shading for volume. As the sketch becomes clear, work in insertion lines and refine with an effective contour for general cohesion and unity (right).

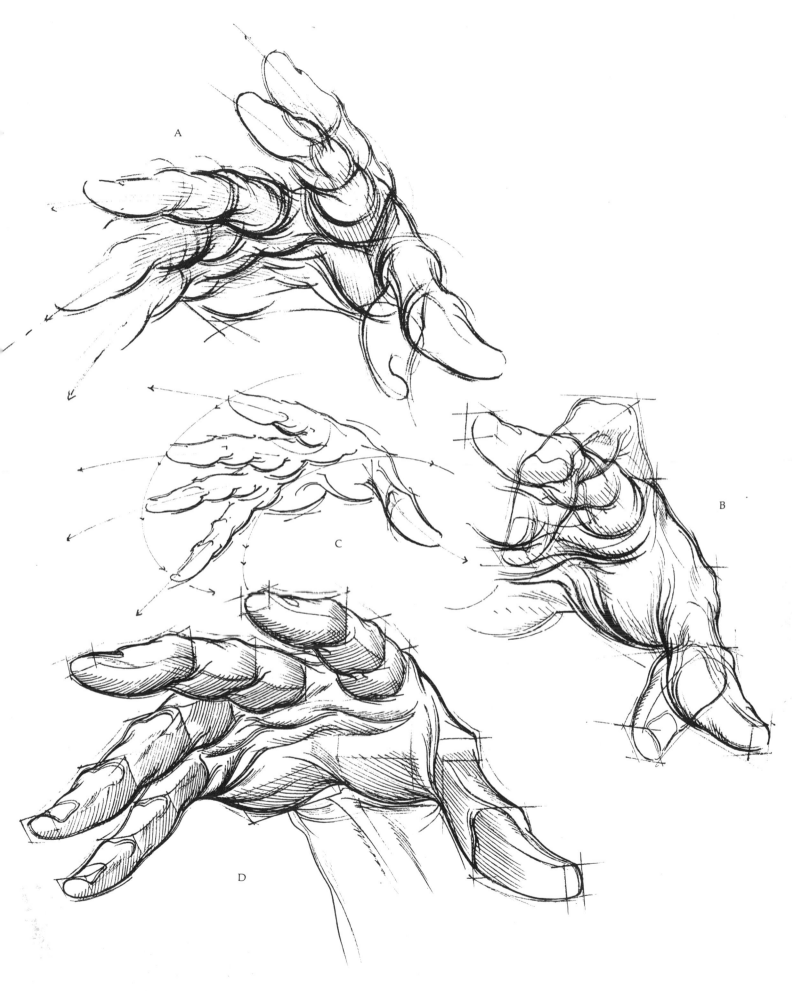

123

Returning to the system of inventing hand gestures and actions in deep space views with finger widths in proportional sequence, graduated from thick to thin, we now observe a follow-up drawing across the five fingers, which gives each finger a logical and visually acceptable variation. Because the finger widths are equivalent in each action change, the respective stage corresponds with and is analogous to the preceding; hence, it is recognizable and permissible (right). The illustration below shows the related finger widths of a pair of hands, right and left. The finger forms of both hands can perform special, dissimilar actions; but for them to look as if they are a pair, the sizes of the fingers, one for one, must be reciprocal and similar — not in their lengths — but in their *measured widths*. *Note:* the measures shown are taken only from the fisible forms; further, the widths are taken across the widest stable forms, the circular mid-shanks of the digits, not the knuckles.

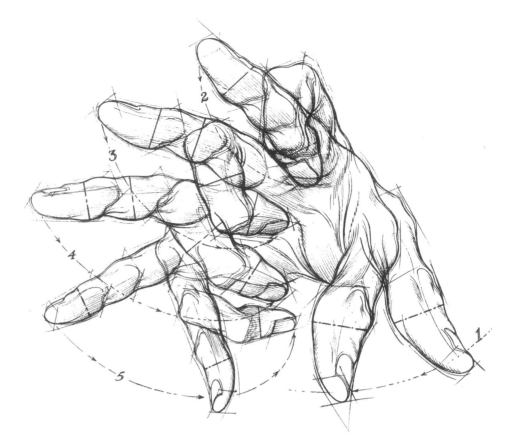

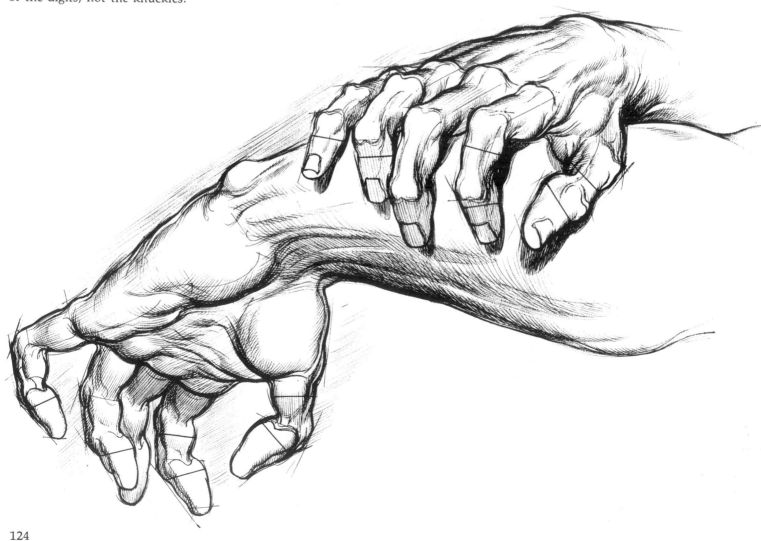

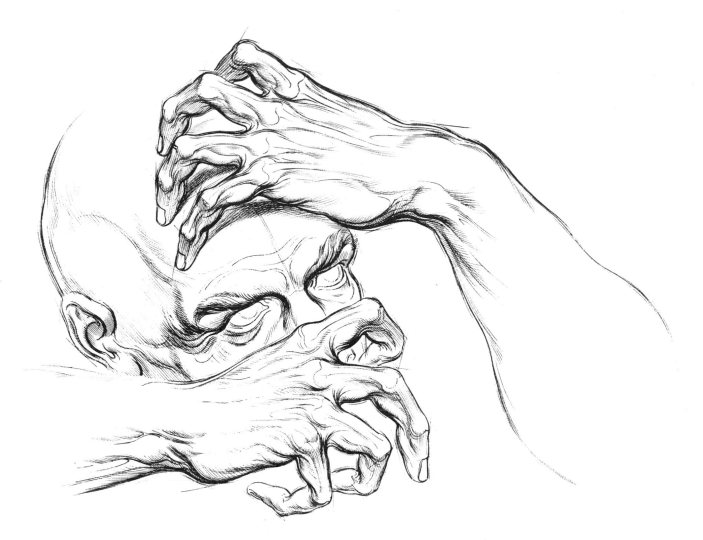

△
Here, again, is a drawing of a pair of hands, this time without the use of explicit measures, depending upon judgment alone. Part of the head is shown as a point of reference (above).

◁ When fingers close, as in a flexed hand, the necessity of judging size involves whatever fingers happen to be visible. In an inside view, the clenched thumb and forefinger alone are seen. Since all forms are foreshortened or blocked, no form can give us any information as to size. Our only means of definition is the comparative thickness of the exposed members. If these widths agree visually, the implicit result infers that all forms are present and correct. In an underview of a closed hand from an outside position, only the ends of the fingers are visible, and these are not fully exposed. Yet, of those given, the order of finger thickness, from little finger to thumb, produces a clear assumption that the hidden forms are of a corresponding size (left).

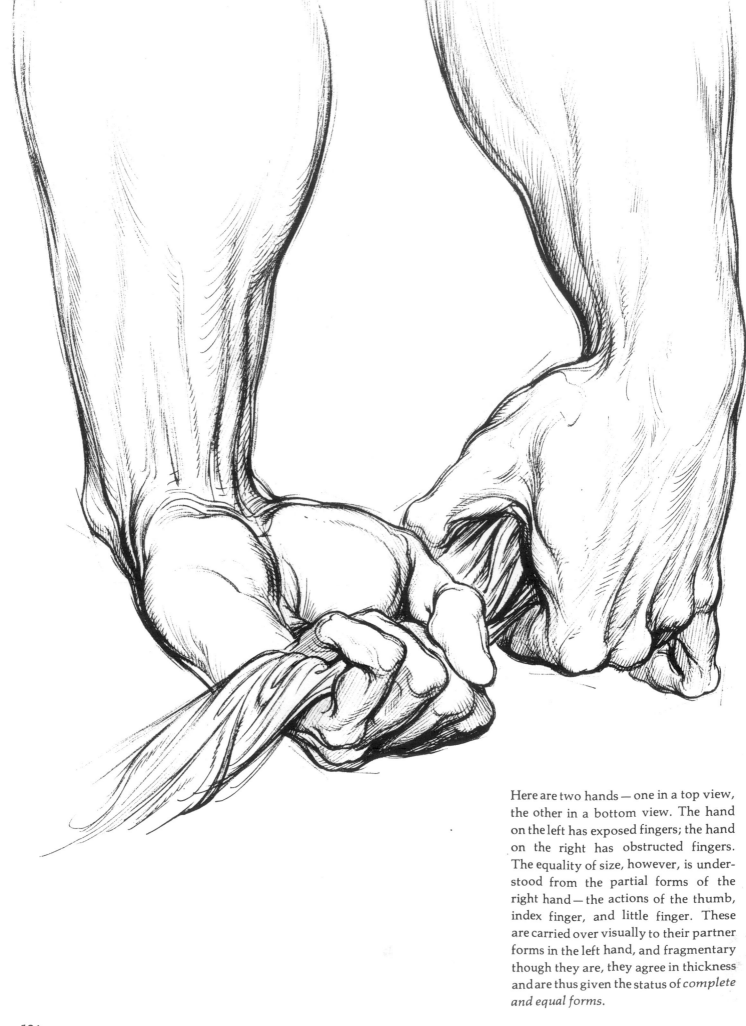

Here are two hands — one in a top view, the other in a bottom view. The hand on the left has exposed fingers; the hand on the right has obstructed fingers. The equality of size, however, is understood from the partial forms of the right hand — the actions of the thumb, index finger, and little finger. These are carried over visually to their partner forms in the left hand, and fragmentary though they are, they agree in thickness and are thus given the status of *complete and equal forms.*

The Joints

With this research of cylindrical forms in depth, we shall carry our probe to a new problem. (We shall put off discussing the neck column until later, although, clearly, it is a simple cylinder. The neck, however, is isolated between the large masses of the head and the torso; it lacks an independent function, and we shall be able to understand it better after we have examined the depth problems of the larger body masses.) The examples illustrating the means by which cylindrical forms are seen in depth—in legs, arms, fingers—can be multiplied endlessly. But in doing so, we are likely to overlook a subtle factor in drawing cylindrical members—the joint: *knee, knuckle,* and *elbow.*

The forms that we have been studying are *attached.* Not one of the members is an autonomous entity; it is conjoined to a partner member. Yet we have not yet concerned ourselves with the attaching mechanism, the joint, and its relationship to the contiguous forms, the cylinders. The problem, for our purposes, does not concern the way in which the joint works, but only the way it is seen in depth; or, more specifically, its *position of attachment* when two shank members bend, say, in an arm or a leg. The joint projection then must clearly express which of the shanks is the advancing member and which is the receding member. If the joint (as a mediator of direction in space) is attached in error, a violation of the spatial position of forms will develop and gross distortion will follow. Before we illustrate these statements, let us put the proposition clearly so that we can test its effectiveness: *when shank or cylindrical forms (in arms, legs, fingers) are seen to bend frontally, the joint or knuckle which lies between the two bent members must be interlocked with the forward, or advancing, member.*

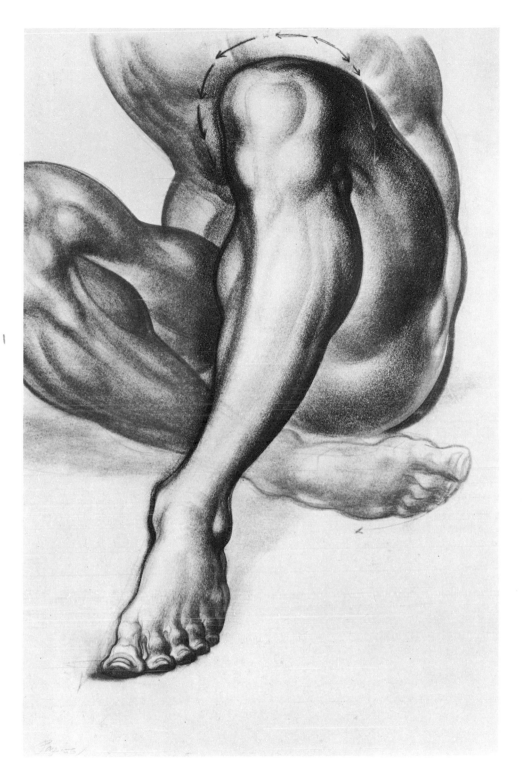

Let us look at a simple leg bend. The decisive position of the advancing form, in this case, is the *lower* leg. The extreme bend of the upper leg to the rear space leaves no doubt as to how the knee box must be joined; it must, absolutely, be locked in with the lower leg. Any other solution would be absurd. For the sake of clarity, the dotted line over the knee (as well as the reinforced outline) expresses the consolidation.

127

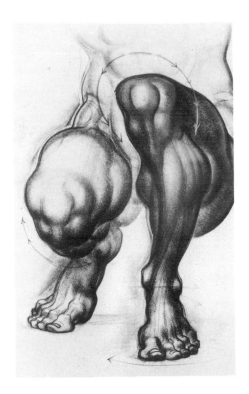

Here is another example of the knee interlock. This time, we see the knees of both legs, left and right. The *right* leg has the *lower leg advanced*, as in the previous example. Therefore, the knee is joined to the *lower* leg. The *left* leg has the lower leg reduced and the *upper leg advanced*. Hence, the knee is logically given to the *upper* member. (Note the arrows emphasizing this opposition.)

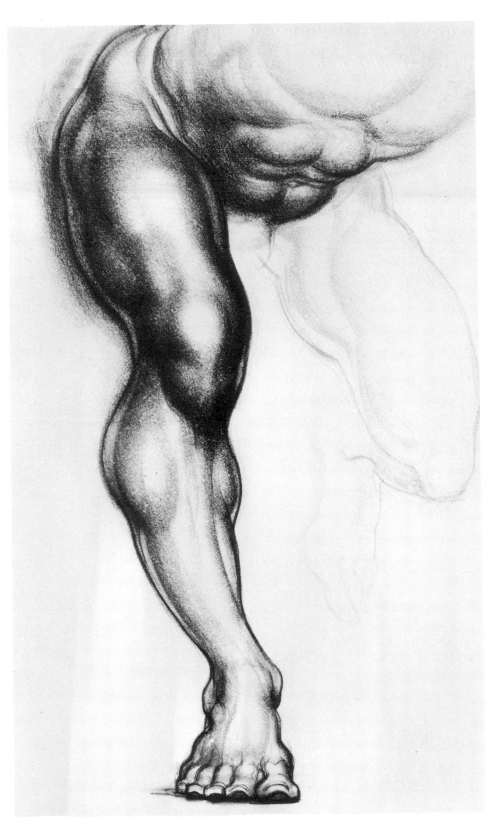

Let us test the proposition of the joint interlock by trying to *oppose* it. We will give the knee in this example *not* to the advancing member, but to the receding member. In this case, the receding member is the upper leg. We therefore circumscribe the knee with a heavy under accent and attempt to lock it in with the upper leg. Test the result visually. In a curious way, connecting the knee joint to the upper member results in a double error: the rear member tries to override the front (lower) member and come closer; even more startling, the near (lower) leg appears to have a swollen, distorted knee, while the override effect cracks the lower leg and separates the knee.

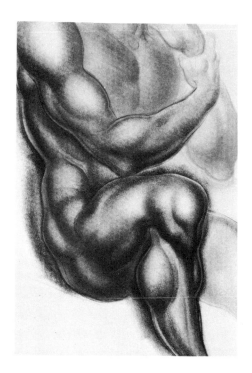

In another example opposing the joint interlock proposition, the same leg is in a flexed, bent position which shows the upper member in a decisively rear-ward space. See how incorrect the mis-joined knee appears. *Let us repeat:* the two foregoing examples are in *error*.

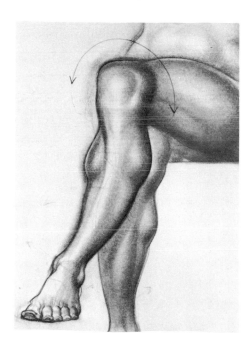

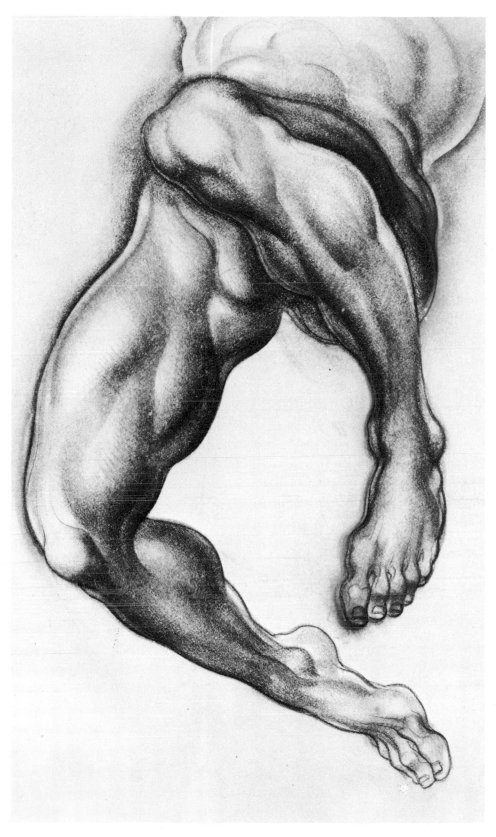

Once again, here is the formula for the *correct* treatment of the joint inter-lock: *when two flexed partner members are seen from the front, the joint between them always goes to the advancing member.*

Here is an action figure with legs given in a double direction. This time, there are no arrow clues. Let your eye decide how each advancing form takes the knee in two counterposed directions. Compare the validity of this example and the preceding one with the two contradictory ones which came before.

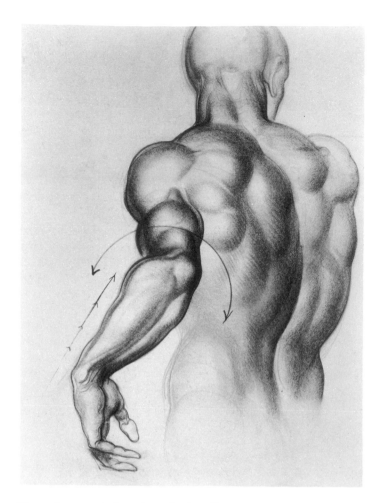

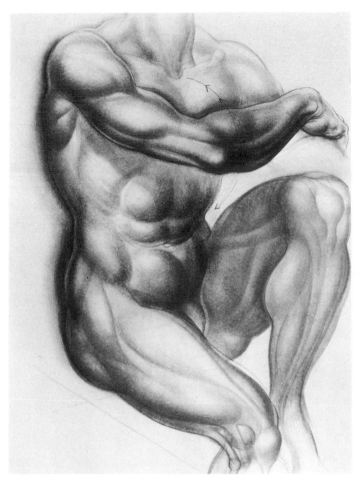

Here, the arm is flexed, with the elbow projecting toward the viewer. Observe how the *advancing* form (the forearm) takes possession of the elbow. Arrow curves, over and under, are given to show directional effect.

This example shows a front arm with the upper arm advanced. Compare this elbow effect with the preceding.

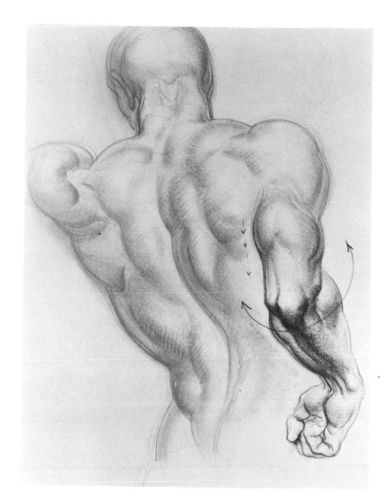

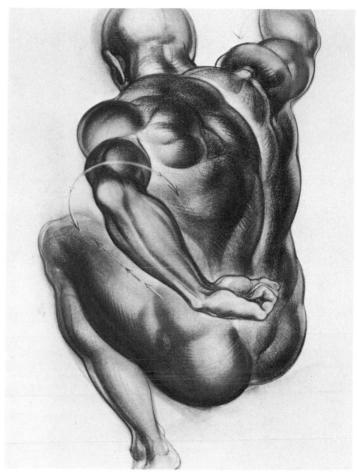

In this rear right arm, the elbow is given to the advancing upper member.

In this left arm, the lower member is advanced. Notice the elbow change between this example and the preceding one. Check the curve clues.

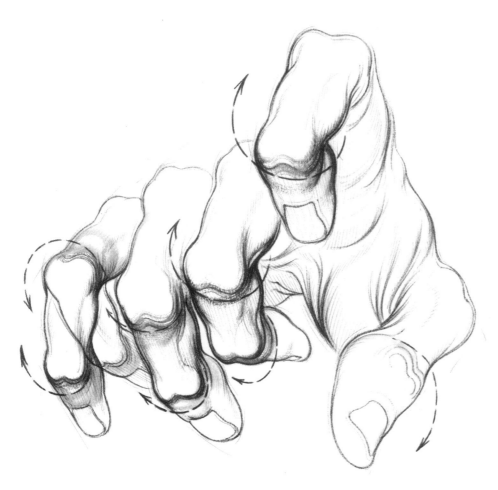

To summarize the premise of the joint interlock and its application, let us look at the use of the *knuckle* as a joint, seen in a sequence of fingers. The variety of possible finger movements can sometimes present a difficulty in drawing knuckles. But if we hold to the idea that *the advancing form gets the knuckle,* we are on safe ground. In the sketch above, observe the consolidation of (1) the thumb with the joint, (2) the central phalanx of the index finger (taking both knuckles, top and bottom), and (3) the long finger joined with the base knuckle. Arrow clues and tone are put in for visual comprehension. Below is an example giving the five fingers with their interlocked knuckles. Check the arrows, as well as the tonal accents turning over and under as the knuckles conjoin with each finger.

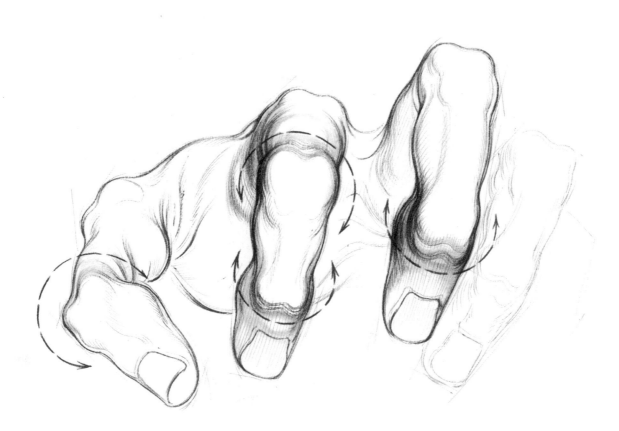

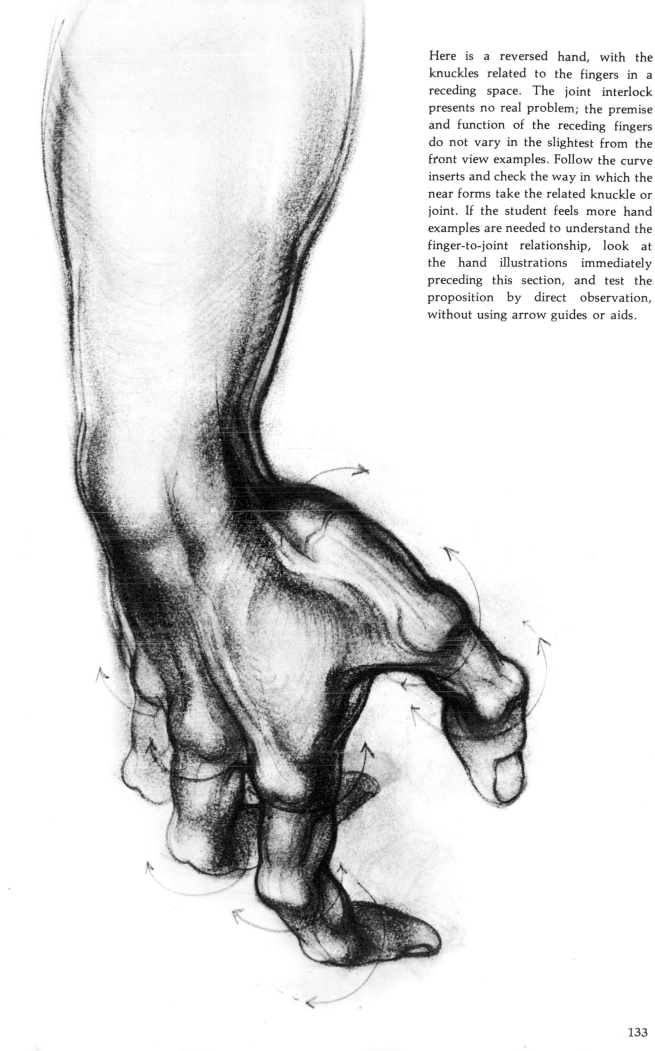

Here is a reversed hand, with the knuckles related to the fingers in a receding space. The joint interlock presents no real problem; the premise and function of the receding fingers do not vary in the slightest from the front view examples. Follow the curve inserts and check the way in which the near forms take the related knuckle or joint. If the student feels more hand examples are needed to understand the finger-to-joint relationship, look at the hand illustrations immediately preceding this section, and test the proposition by direct observation, without using arrow guides or aids.

Here are some ellipses, shown at greater or lesser oblique tangents: some are round, some are less round, but all have the appearance of circles in space.

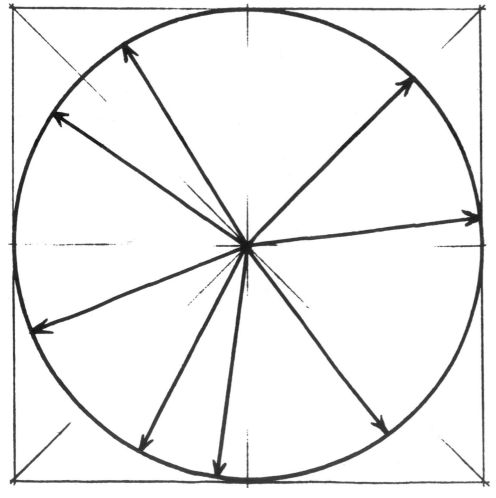

One of the rational factors of a circle is its radius, which, like the arm of a clock, is a constant length from the center no matter in which direction it points or moves. In this example, a circle in a square, the radii taken at random are all *equal in length*. Obviously, any new radius added in any direction from the pivotal centerpoint would be equally long.

5

Figure Invention: Controlling Length in Foreshortened Forms

In the previous chapter, we discussed the widths of foreshortened, cylindrical forms. Because these widths are constant in deep views, they can be relied upon to control the size and identity of forms. The length of a form, however, is inconstant and variable, and the decision to use a particular length according to a given view in depth is one of the most problematical aspects of foreshortening. As anyone familiar with figure drawing knows, deciding on the length of a form—an arm or a leg in deep space—is so open to intuitive interpretation (or blind guesswork) that good draughtsmen frequently feel that they are working with the irrational. Certainly, all of us have had, at one time or another, the frustrating problem of dealing with the excessive elongation of a member in depth, so that, in comparison with its opposite member, the form appeared so overdrawn as to be visually absurd and inadmissible.

Now, the problem of a foreshortened form tends to be difficult because a member may vary from its ultimate length, which is not foreshortened at all, to its absolute in-depth view, which has no length at all. Therefore, any length in between—and including—these limits would seem to offer an opportunity to develop an acceptable foreshortening solution. But this very simplicity is the most difficult problem—for if a deep view of an arm or a leg may vary in length, *which* of the lengths possible should be used?

The Circle in Space: the Ellipse

One device which may be used to control and measure form-lengths in depth is the development and use of the *circle in perspective.* We do not have to go to lengths to say that a circle in perspective, *any* circle seen in depth, has a tangent appearance according to an oblique view, and this oblique circle is seen as an *ellipse.* For the sake of economy and efficiency, we shall hereafter refer to this depth view of a circle as a perspective ellipse, or more simply, as an ellipse.

If the circle is seen in a perspective view (that is to say, if the circle is seen as an ellipse), any line of the radius—whether short or long from the pivotal center) would be construed to be equal in length. In the horizontal perspective circle, any radius line is equal to any other radius line; if a change of plane occurs, the ellipse can be shown standing vertically, tilted sideways, or seen from underneath. In any of these views, the rotations of the radii in each of the ellipses—since they are circles—are, by definition, equal.

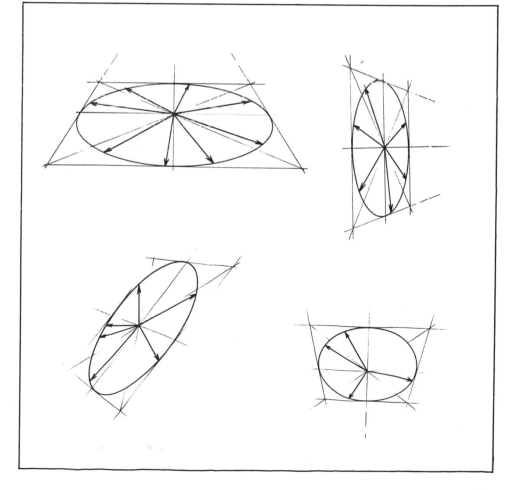

135

The Joint as a Pivot; the Member as a Radius

Let us point up the significance of the concept which emerges from the foregoing demonstrations. In the perspective circle, we see that the *variable lengths* of line are *identical and equal in different directions in depth*. This means that while these lengths appear to change — because they are put within the control of an ellipse — they are actually *unchanged in length*.

Should this proposition be applied to a pivoting member of the body — to an arm or a leg — then the over-all control of such members would be maximum, no matter what their direction in foreshortened space. Indeed, we should then have precise control of the irrational lengths of forms in space. Perhaps the following will serve to illustrate this concept to the reader.

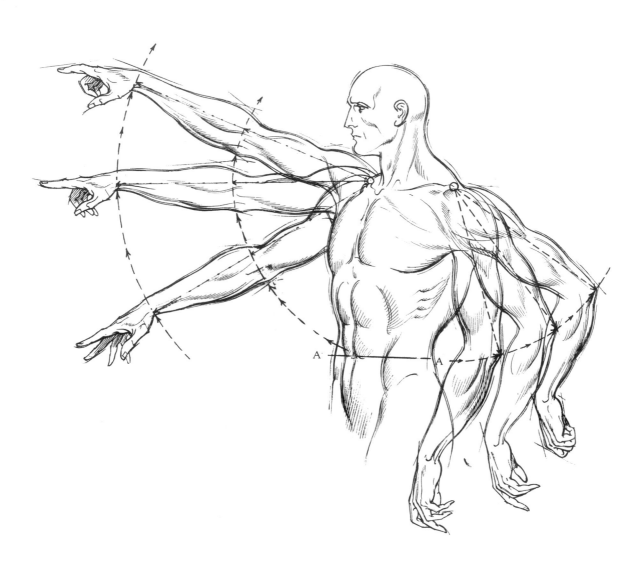

Suppose we look at a simple side view of the upper body and study the movement of the arm. First, the length of the upper arm (extended left arm) will be given the correct proportions by establishing the elbow, taken at the inner bony projection (condyle), on a line held equal to the position of the navel. This position occurs midway between the rib base and the pelvic crest, carried across the mid-axial waistline of

the body (A). Opposite, we see the right arm also taking this equivalent position at the elbow (A). Now, using the shoulder as a pivot, the extended arm swings up. The swing describes two arcs — a short radius, and a longer radius — held by the limits of the upper arm-to-elbow and the lower arm-to-wrist (see dotted curves). To the right, the elbow rises backward, describing an arc, using the shoulder as a pivot.

It is obvious that, in this multiple sequence of positions, if the arm length (on each side) is given to the arc of the circle, *any* position on the arc must be held correct as a radius. Hence, if the rotating elbow is drawn on such an arc, it, too, must be held correct at any position and can be developed fully as an arm, without distortion.

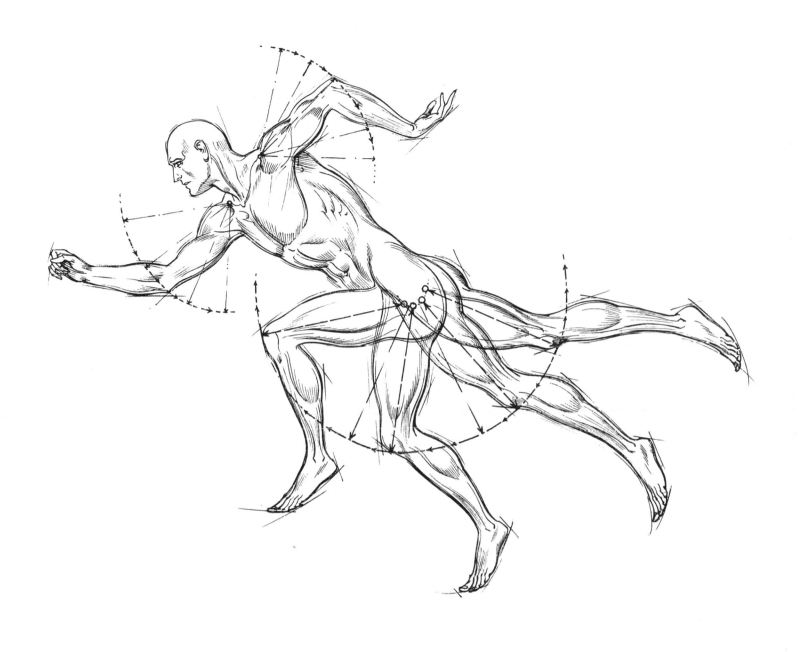

If we were to establish a side view of the leg in a circular path (as we did with the arm in the preceding example), the leg length from the pivot in the hip to the kneecap would describe a sequence of radii as possible positions in the arc. Here, we see a succession of equal lengths of the upper leg, given in extreme variations, from full forward thrust to full backward extension. A minor variant of this swing is reflected in the hip position of the great trochanter projection of the leg. This protrusion, emerging from the short neck of bone which joins the rotating head of the femur in the hip socket, effects a minute arc of movement in conformance with the extended swing of the knee. This observation, however, is a detail and need not affect the use of the pivot in foreshortening. Note, also, the arms with their possible arm positions as radii on circular paths of movement.

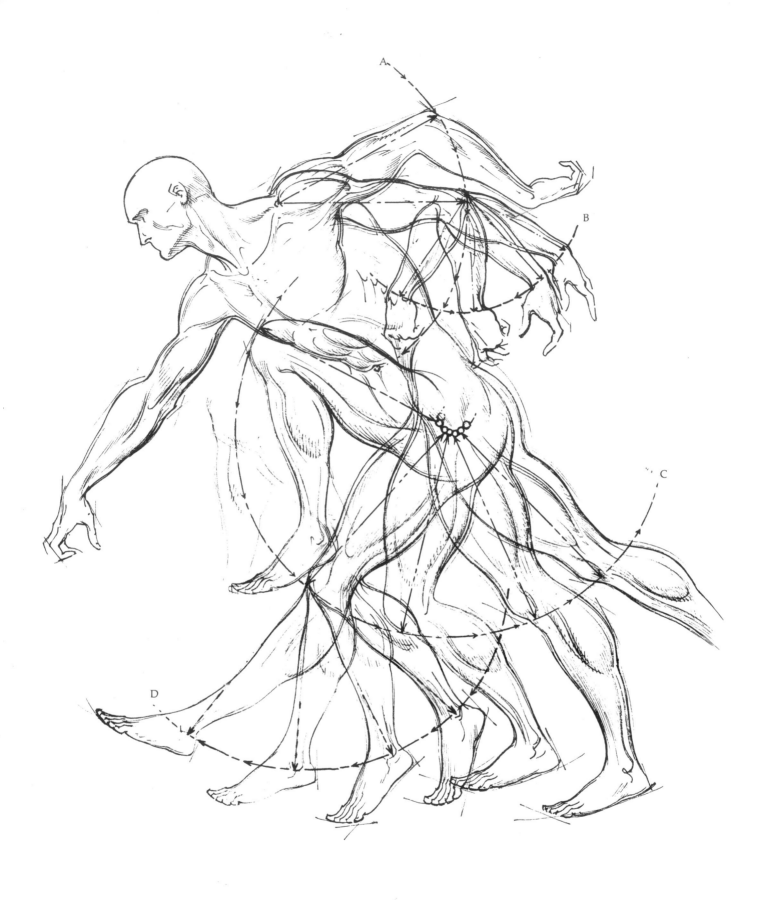

Once we understand the use of the arc—putting pivots at the shoulder, elbow, hip, or knee—a multiplicity of actions can be developed simply by taking the mobile member through a series of the radii in one of the circle patterns. Test your eye on the arcs imposed on this figure; check the changing positions: (A) shoulder, upper arm arc; (B) elbow, forearm arc, (C) arm arc; (B) elbow, forearm arc; (C) hip, upper leg arc; (D) knee, lower leg arc.

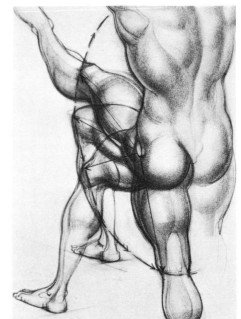

Here is another example of upper leg variations, taken from a high elevation. A tight arc holds the thigh view to an extreme foreshortening. The procedure is a simple one: the closed arc establishes a limit to the length of the form, which set up a control.

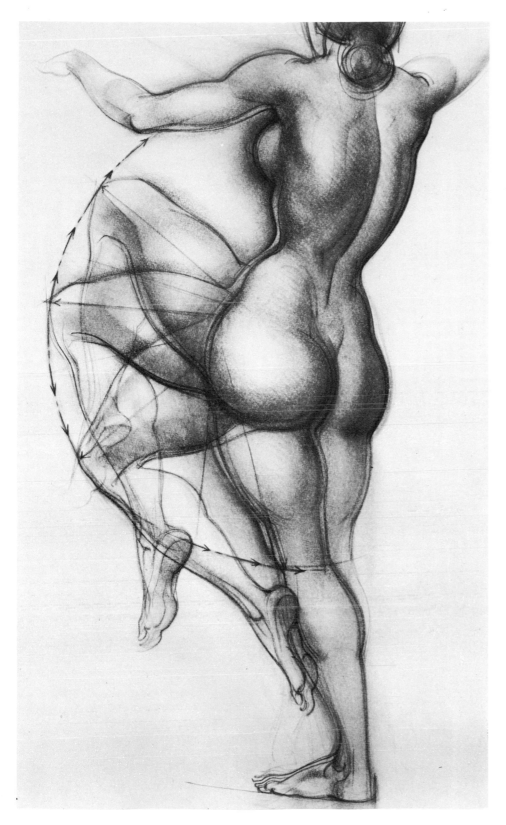

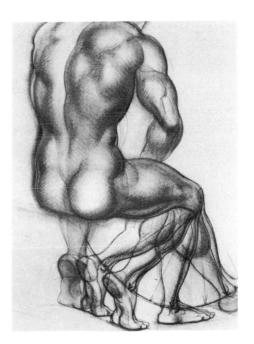

To use the arc and the pivot in foreshortening, let us apply the ellipse tracking device to a leg. Taking the hip as a pivot, this rear female figure gives us a set of upper leg variations in a fairly open arc. The four-stage positions are possible options for leg actions. See also the lower leg phase changes as the thigh moves through the arc.

Here is a reverse view, giving the pivot and arc of the lower leg. The lengths of the radii identify the *anklebone* positions on the arc. Not only does this idea give a precise position to the attachment of the foot, but it provides a basis for understanding a whole series of foot directions.

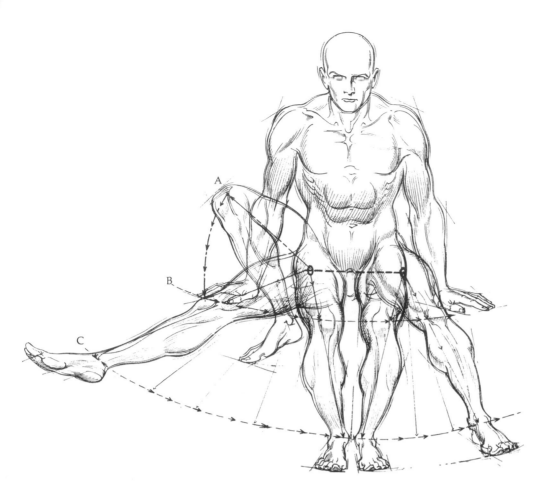

Let us look at a front view figure in order to carry the leg into a *front* foreshortening with the use of the ellipse arc. The raised, bent leg (A) at left cues the upper and lower members. Point A drops to the accented hip line (points O, left and right, drawn across the pubic arch line). The bent knee (A) drops to ellipse arc B; at the same time, the foot extends outward to ellipse arc C. These give us the beginning of the knee and ankle swings. The extended leg is now carried *inward* to a direct center foreshortening on the arc, holding the positions of the knee and ankle. The right, foreshortened leg is put in from the opposite hip, holding to the two arc lines. Now, the *right* leg is carried on the arcs *outward* to a new, oblique, foreshortened position.

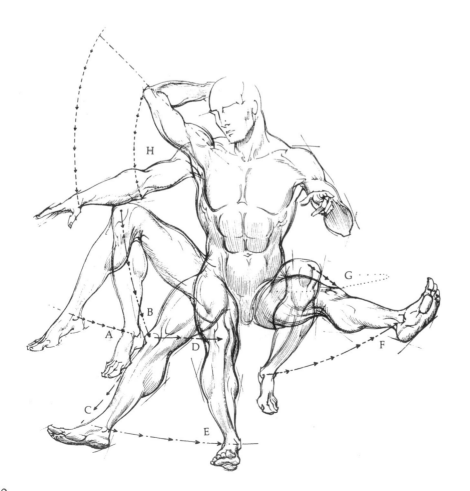

Here are a series of variable ellipse arcs expressing upper and lower leg changes. The lower leg, at the left, shifts inward on the ankle arc (A). The elevated left knee drops to a prone position (B); at the same time, the lower leg goes forward to full extension (C). The extended leg now swings inward on two curves—knee arc D and ankle arc E. Now the right bent leg straightens out; the ankle goes up to F; the knee drops off, forward, to G. Finally, higher, see how the arm at left pivots downward from the shoulder, straightens, and extends at H.

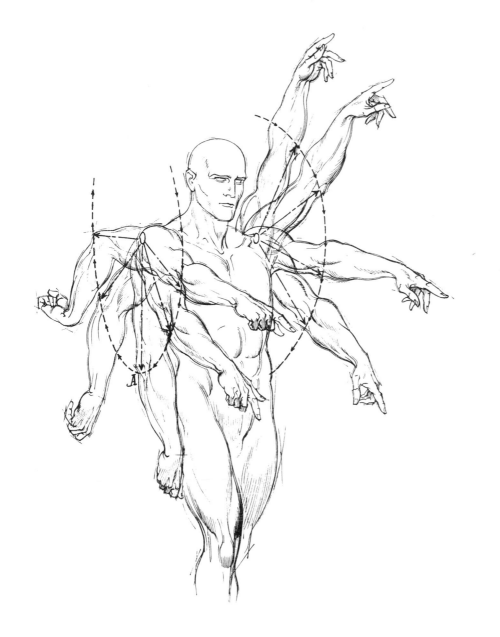

This drawing shows a direct correlation with the leg solutions illustrated in the preceding examples. To develop the arm in depth, the initial length is taken from the vertical arm at *left*, dropped to the side of the body (A). The shoulder pivot is moved to the outer side of the arm to relate to the outer elbow point. With this length as an absolute measure of the upper arm, a tight ellipse is put in. A number of straight lines, drawn from the pivot to the ellipse, produce a sequence of foreshortened views of the arm. For the *right* arm, a more open curve of the ellipse is shown. This produces a more open, extended arm series. A simple conclusion may be drawn from this example: the *tight* (compressed) ellipse produces an *extreme*, deep foreshortening; the *open* (rounder) ellipse produces a *less extreme* foreshortening. To put it as a rule, we would say: *the tightest ellipse curves make the deepest foreshortenings.*

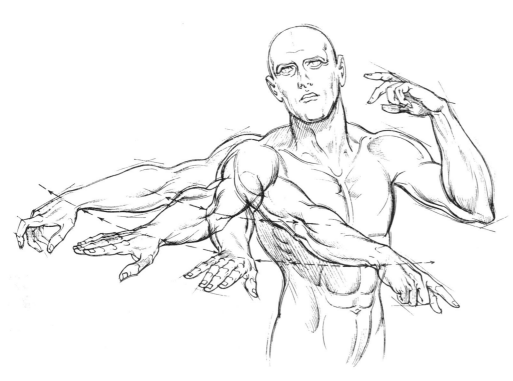

An example of the rule stated in the preceding example is seen here in its application to a lifted arm. Two tight ellipse curves are put in with the shoulder acting as pivot for both. The curves are concentric and express the control of the extended arm, taking the arcs through the elbow and wrist positions. As the radius lengths travel through the ellipse curves from the common pivot, see how the sequence of foreshortened arm views is projected.

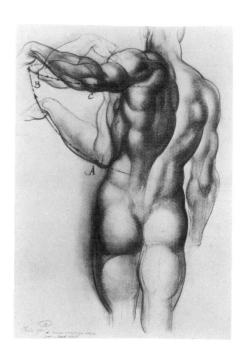

Here is an exercise using a tight ellipse, from a back view. The upper arm length from shoulder to elbow is at a vertical rest (A); the elbow rises to shoulder height and begins a retraction on a tight ellipse (B); the upper arm pulls back (C); the foreshortening becomes extreme.

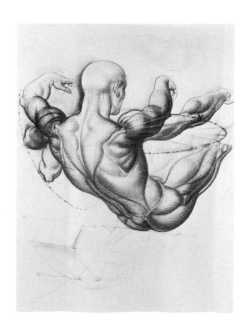

Here is another rear view figure, taken from a three quarter elevation over the shoulder. The left arm rises in three stages of foreshortened lengths: the tight arc holds the elbow positions firmly; the right arm swings at shoulder height on a compressed ellipse from a long to a brief, in-depth length.

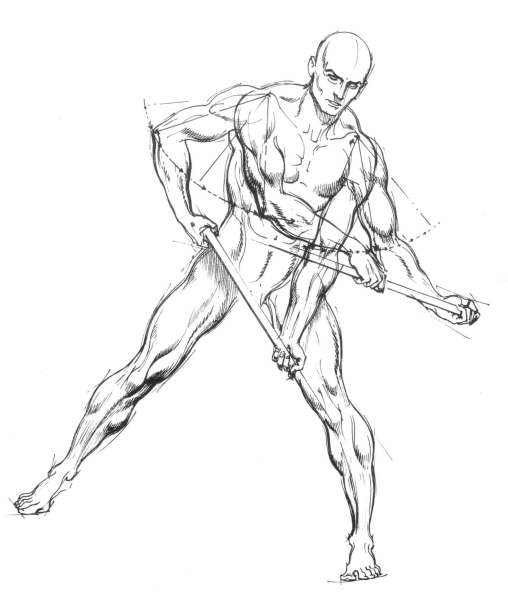

Once the information in this section has been assimilated, you should work out a series of exercises in direct, first-hand visualization. If, however, a foreshortening problem becomes difficult, a little coaxing with the perspective ellipse should help. This simple figure establishes a consistent figure action, with members related to a single, purposive motive. The arm action is tentatively worked out in two combinations and put in on ellipse guides; then the work-up to a final choice is conceived.

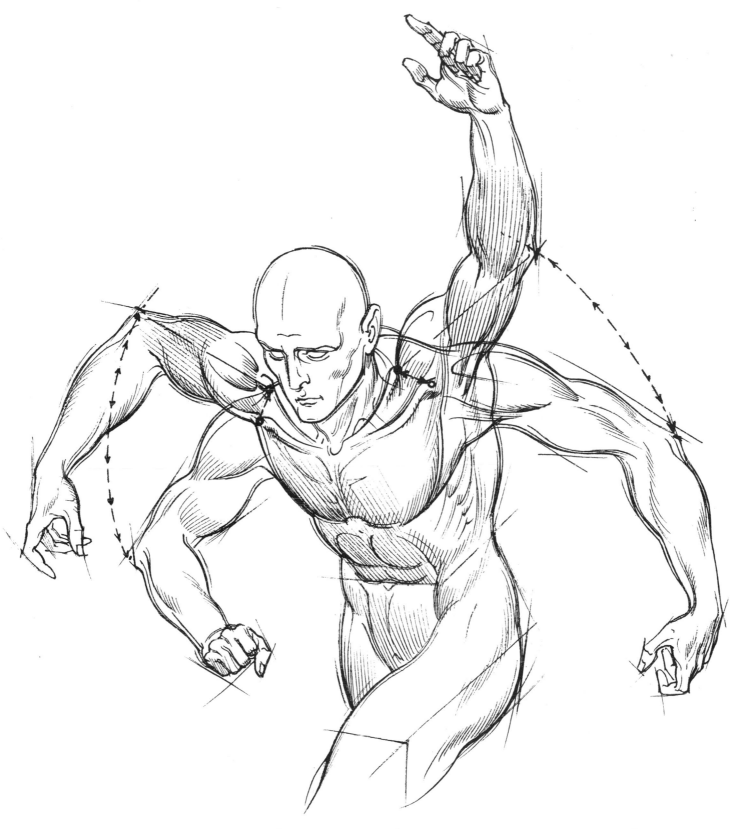

While the student works toward a flexible interpretation of the ellipse in tracking foreshortening, we should insert this summary point: the arms, in raising and lowering, tend to *shift* in the shoulder pivot as they move. Since the arms are attached to the collarbone, a *raising* of the arm swings the shoulder *upward* and *inward* toward the neck and head. A *drop* of the arm, conversely, shifts the shoulder *downward* and *outward*. Study the arm movements here. Both arms, higher and lower, move on ellipses at the elbows. The important observation in both actions is that the *shoulder pivot shifts and the collarbone lifts inward.*

The Isosceles Triangle Measuring Device

Measuring the length of foreshortened forms cannot always be done efficiently with a perspective ellipse. Frequently, in the stress of drawing, too much reliance on a technical factor which demands its own discipline inhibits the expression of the drawing itself. As we have seen, the ellipse usually measures a *single* member of a two-member form. Should the arm or the leg bend, clearly, not one, but two ellipses will be put to use. This can be cumbersome.

One means of simplifying the procedure is to introduce the principle of the isosceles triangle, producing a two-member form which can be resolved in deep space. Simply take the length of one foreshortened member, then give this length to its partner member. Within its limitations, this system works exceedingly well—although there are drawbacks, which we will discuss as we go along. The primary limitation of the isosceles triangle measuring device is that *it works only on legs.* The isosceles triangle has two sides which are exactly equal; the third side varies and may be any length at all. The reason that we can apply this system only to legs is that the upper and lower legs are of equal length, whereas the upper arm is longer than the forearm.

Here is a demonstration of the proposition of the isosceles triangle, used to develop the legs of a side view figure. First, here is a group of such triangles. The two equal sides are given in closed lines; the third, unequal, side is given in a dotted line. The isosceles triangle is then applied to the legs of two figures, one seated and the other moving. Observe the characteristic lines, closed and dotted. The equal sides of the triangles are fixed to relate hip to knee, knee to ankle. Note how the *apex* of the angle is *always* at the *knee.*

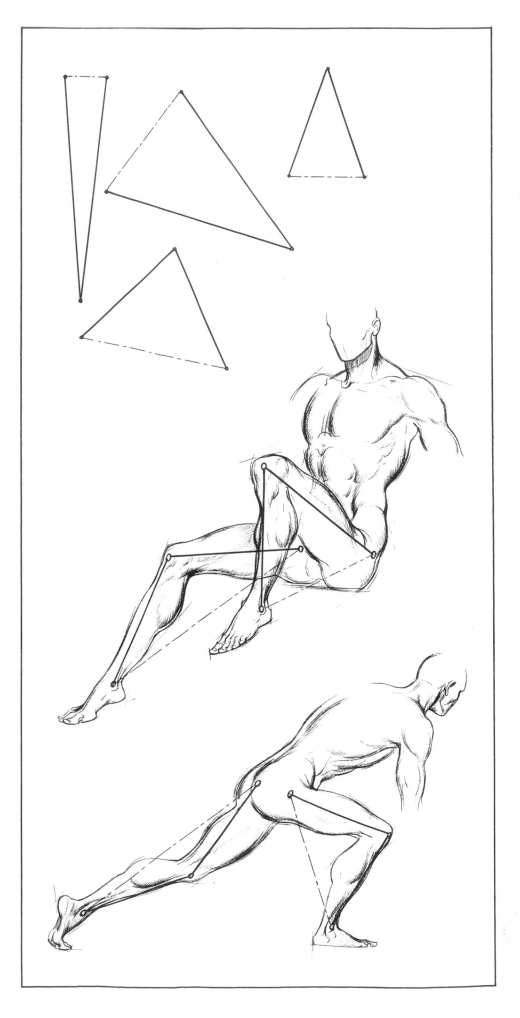

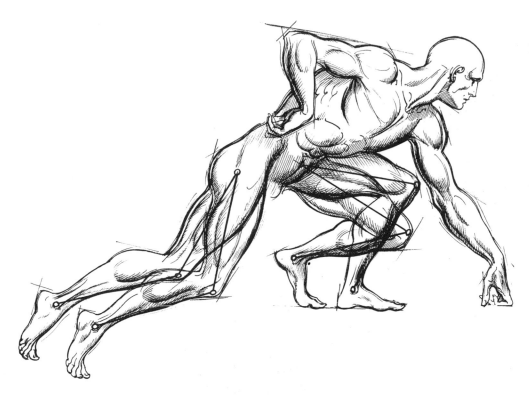

In this side view, we see a figure in progressive action. The dotted lines expressing the space of the triangle base have been left out. The proof of the isosceles triangle concept lies in the fact that the leg members are equal. Let us make an observation: *a narrow (acute) angle produces a bent or closed leg; a wide (obtuse) angle produces an extended or open leg.* See how this is borne out in this example.

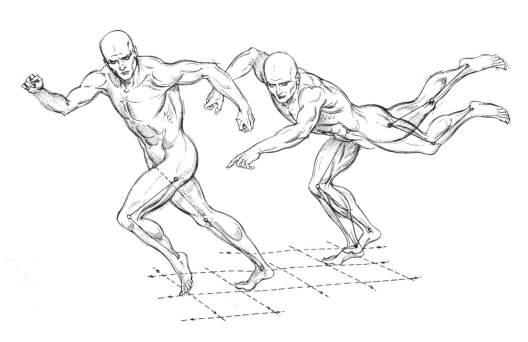

In foreshortening, the lengths of the upper legs are directly applied to the lengths of the respective lower legs. In the figure on the left, the bend of the knee is more open in the rear, thrusting leg. The open degree of the angle, as we have said, accommodates the extended action in the legs. In the figure to the right, a sequence phase of each leg shows how the similar lengths of the members take on a flexible interpretation of the depth problem simply by starting a shorter length in a new direction, then applying the equivalent measure to the lower leg. This solves the foreshortened measure of both members. See how the backward stretch of the right-hand figure's rear leg gives a depth view of the members which is pertinent and acceptable.

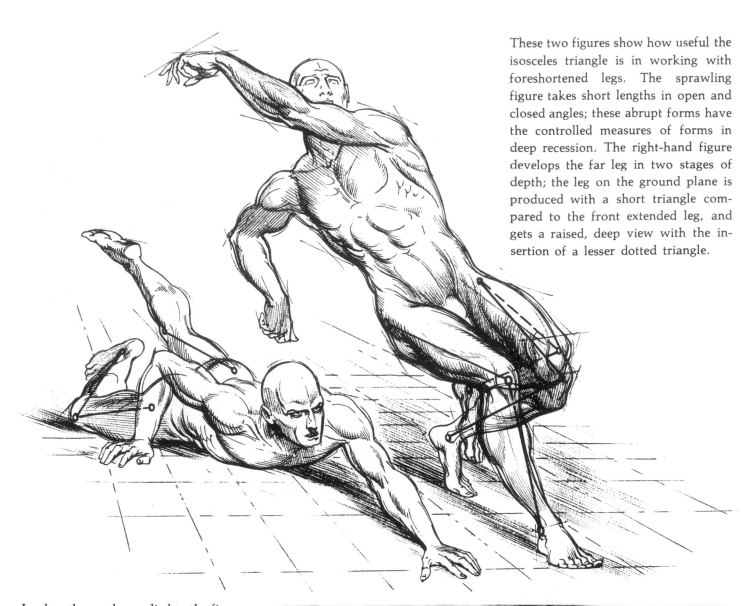

These two figures show how useful the isosceles triangle is in working with foreshortened legs. The sprawling figure takes short lengths in open and closed angles; these abrupt forms have the controlled measures of forms in deep recession. The right-hand figure develops the far leg in two stages of depth; the leg on the ground plane is produced with a short triangle compared to the front extended leg, and gets a raised, deep view with the insertion of a lesser dotted triangle.

Leg lengths can be applied to the figure as a whole and correlated to the adjacent body forms when drawing deep space actions. These correlations deal only incidentally with measurements; in a more direct sense, they are defined by certain *limits of function* in the legs and the torso. As a result, form lengths are visualized directly by using part-to-part *check positions* of foreshortened forms. Let us see how this works. When the leg bends to a deep squatting position, the *heel* of the foot presses against the *buttock*, and the extreme limit of the heel goes no further back than the rear contour of the buttock. Thus, the heel and the body line base appear to join (see rear dotted line). Furthermore, the trochanter protrusion of the leg bone in the hip appears directly over the outer anklebone of the foot (see inner dotted line).

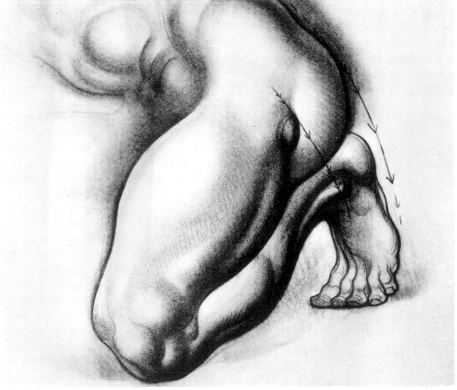

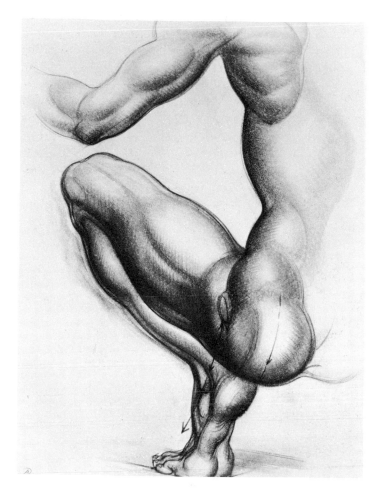

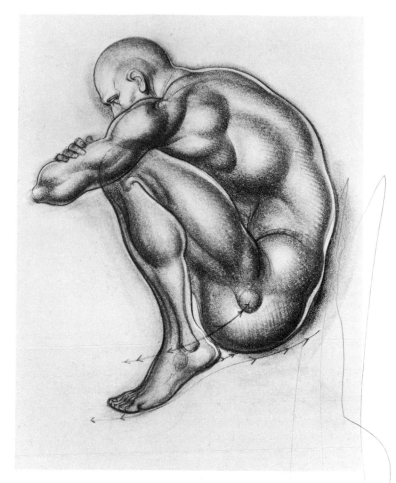

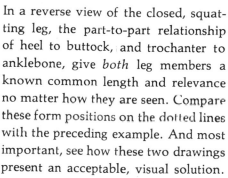

In a reverse view of the closed, squatting leg, the part-to-part relationship of heel to buttock, and trochanter to anklebone, give *both* leg members a known common length and relevance no matter how they are seen. Compare these form positions on the dotted lines with the preceding example. And most important, see how these two drawings present an acceptable, visual solution.

Beyond relating the lower leg to the lower torso, the squatting position relates the *entire folded leg* to the *entire torso*. Here, we see a hunched-over, squatting figure with the knee locked against the chest, rising just to the height of the armpit. The entire back line of the body bends in a consistent curve, giving the pelvic base and the buttock the same terminal point as the foot base. Note how the arm, topping the knee, is at a right angle to the leg.

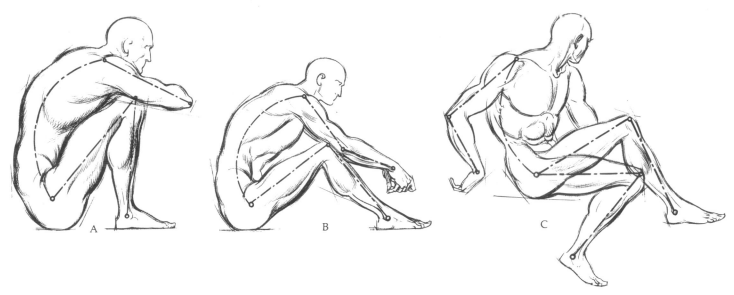

△
Here are three variations of the folded, hunched-over squatting position: (A) *a closed position*—tight, squat, knee at armpit; (B) *a loose position*—knee swinging forward, foot moving away from the buttock base, leg lengths holding to the primary isosceles triangle; (C) *an open position*—the figure at ease showing two isosceles triangles, the arm at the elbow corner projecting from a waist-middle-navel position.

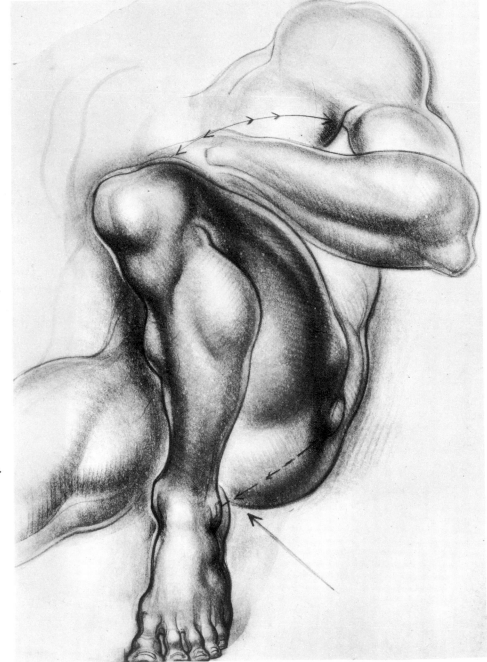

Quite a complex set of spatial varia-▷ tions can be worked with the body relationships discussed in the preceding illustrations. For example, the front leg bend is related to the torso and arm with the simple expedient of tracking in the *knee to the armpit* (top dotted line), and relating the *ankle to the trochanter projection* (bottom dotted line). Using no other information than this, the torso behind can be drawn in correct proportion.

148

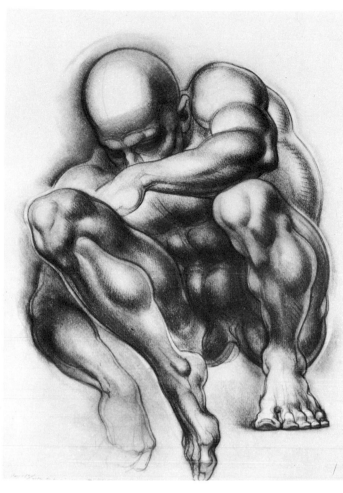

Carrying the observations made in the previous examples into exercises with the full figure, we shall see an amazing variety of actions develop through the sheer power of closing the knee to the body and pressing the heel back to the buttock base. In this male figure, the tipped shoulders and unequal disposition of the legs are validated if we see the forms in contrapositional interaction—left leg to right armpit, and right leg to left armpit (left).

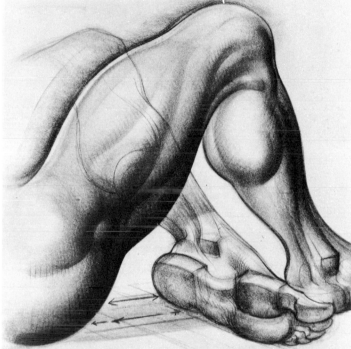

In this example involving a crossed leg, we see the uses of the heel-to-buttock base in which the heel can be made to confirm a spatial position. As the extended leg moves away from its buttock, the crossed foot passes under the open leg and relates its heel to the buttock of the extended leg. Note that no other references for this solution are required. Also, observe the isosceles triangle of the leg, and the simple, compact forms of the up-ended foot (above).

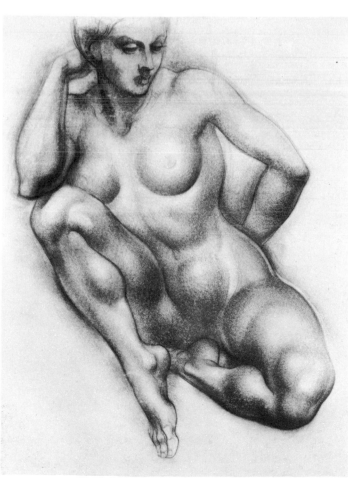

In this female figure, the complex, compressed forms are easily visualized and carried out without stress or confusion, using the system discussed in the preceding examples (left).

149

Here is a simple example of the scaling system. First, take a line, divided in half. Draw two parallel dotted lines across the paper, starting from the ends of the original line. Inside these parallel dotted lines put two other lines (fitted at an angle) of different lengths. Now, taking the original, short-length line at its half measure, add a dotted mid-division line, parallel to the outer tracks. *Note carefully:* as this mid-line cuts the two other slanted lines, they are partitioned *exactly in half* (check the accuracy of this with a ruler). This result implies that all lines having equal, corresponding divisions (at mid-length) are in proportion to one another. The result was obtained by projecting the parts of one line through the others.

6

Figure Projection in Deep Space

The solutions to the deep space problems we have thus far discussed have been limited to certain specific relationships of individual forms and combined relationships of grouped forms. But the more exacting problem of the general consistency of the total figure in deep space has not yet been entered into. Now, we shall introduce a system of planning the figure in which all the form-lengths in depth can be technically determined by rational means and precise methods. This is a system of *projection*, which is, in part, related to proportional scaling (a system of enlarging); but in our case, it is carried much further, into the depth plane of deep space recession. Let us see what this involves, and how it can become part of our toolbox of artistic disciplines.

In passing, however, one thing must definitely be said: I am not, in any way, in this book attempting to narrow the individual reflex to a set of purely formal practices. Systems of planning are not in themselves vehicles of creativity. They do not in themselves initiate or impel the artistic process. They are merely signposts or roadmarks which help guide the streams of artistic energy.

To begin with, the notion of projection means *enlarging* or *reducing* a form with the use of a geometric linear technique, so that every change in size relates *all* parts in an exact correspondence, or ratio, throughout. When this happens, each element is known to be in ratio (in proportion) to every other element. The technique used is called *scaling*, and the general result is *proportional projection*.

Suppose the first line in the preceding example was originally cut into *three equal parts*? Would not the parallel dotted projection also cut the longer lines into three equal parts? Of course. See how this is borne out—the line at the *left* is given in *thirds*, and the parallel projections cuts the *longer* line at the *right* into *equal, longer, proportionate thirds*. Is it not clear that if the parts and the lines relate correspondingly back and forth, part-to-part, the procedure of relating proportion could be started on the longer line first and scaled down to the shorter line? The results, whether scaling up or scaling down, would be unchanged; halves and thirds would develop in correct ratio no matter how we started. Now, if halves or thirds can be projected on another longer or shorter line at separate stages, could they not be projected all together at the same time? Clearly, they could. As a matter of fact, if measures were taken of *any* number of parts, equal or unequal, they could be projected—with no distortion of the essential proportional relationships—on any number of different lengths of line. The results would bear the effect of a constant ratio of similar, related measures on all the lines. The scaling method cannot fail to give precise results.

Parallel Projection of Solid Forms

Thus far, we have been enlarging or reducing parts of lines only. However —and note this well—the method of parallel projection can be used to augment or reduce the form-lengths of three dimensional solids in space as well. When this is done, we say that forms have been *foreshortened* in deep space. That is to say, if we apply this system not to lines, but to *rods* having thickness and dimensional solidity, then we find that the shorter rod is really a deep view, foreshortened version of the same rod (the longer one), seen from a lesser in-depth position.

In this example of lines changing into rods, see how the transition occurs. The reduced or augmented lengths are really phenomena of a changed viewpoint in space; that is, one sees forms from a side, to a deeper, to a very deep foreshortened position in receding space. It is this similarity of line and figure which allows the possibility of using the linear projection method to solve form correspondence of three dimensional figures from side views to in-depth spatial positions.

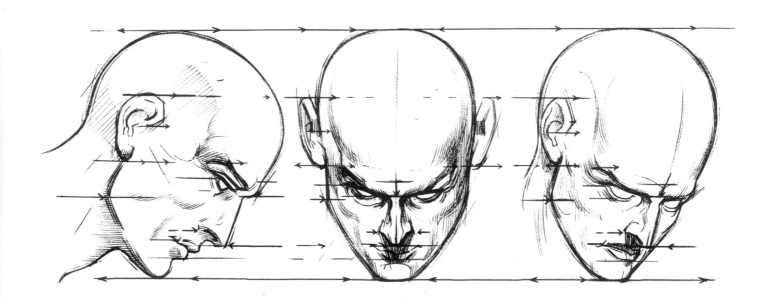

Let us see how the projection method is applied to the foreshortening of a head. As this illustration shows, a side view head is drawn (left) so that the details of all its forms and features can be clearly seen. Note that this profile head is not upright, but tipped down, forehead first, in order to advance the crown and forehead so that these will project ahead of the other forms, which will recede in a descending order. If the head is tipped the other way, with the chin forward, the eventual view will end up below the jaw, showing an up view of the head. Following the same precedure as we used with the linear example, we draw projection lines across the paper from the top and from the bottom of the profile head, as well as from the key forms and features in between. At the center and at the right, within the parallel tracks, two heads are sketched in contour mass—a front view head and a three quarter view head. When the projection form positions are carried into the sketched contours, then defined as features and tightened up, with more care to detail, two down views of the head develop. Each bears the characteristic deep space effect—a foreshortening from the top of the crown downward; but more remarkable, the discipline of the system produces a certain knowledge of form location and orientation in space. *Note:* if certain special interpretive effects are desired, the artist is not at all bound to the projection points—knowing where he is, he can work with a new freedom and take his forms to new, perhaps more expressive, ends.

In this two-figure study, it can be seen that a shorter line is really a tipped, deep space version of a longer line. Let us apply the system we used in the preceding example of the head to a full figure. The profile figure is drawn with feet toward the right, at an oblique angle within the parallel projection tracks. When this figure is foreshortened (right), the effect will be that of an up view, showing us the near underplane of the feet, then moving away in continuous recession to the head, which will be the furthest away in depth. In contradistinction to the head (preceding example), this view makes the underplane of the jaw and nose decisive. Note how all the figure positions of forms produce a sequence of *overcurves* which subtly engage the up view of the head, chest, and attached members.

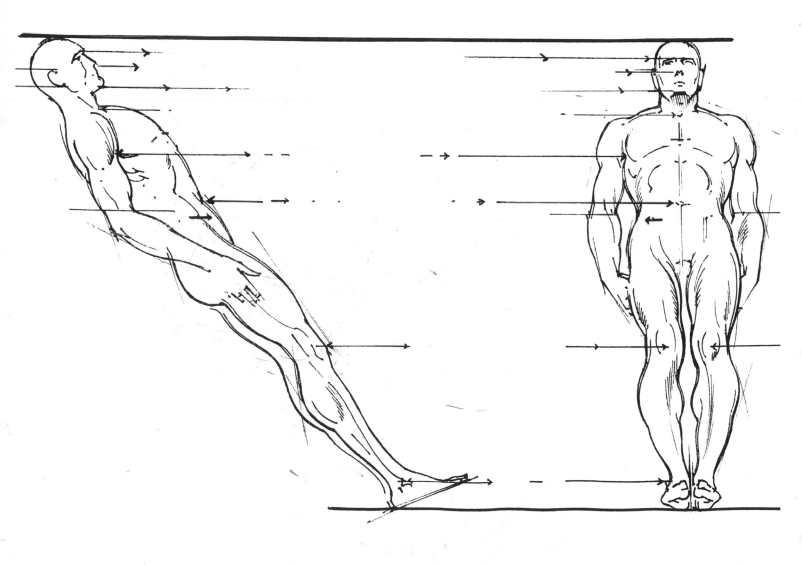

Deep Space Projection of the Figure in Action

What happens if you want to show a figure in an active phase of movement in a *foreshortened view*, and yet you are not able to visualize it readily? All that is required is a fairly clear knowledge of body masses and members, and the ability to draw a credible side view of the action desired. Then, if you work carefully with the projection method, you will be able to resolve many of the knotty problems involved in visualizing forms in space.

There is no doubt that this system involves a painstaking expenditure of effort to develop deep space figure

foreshortening—still, we must emphasize that this is a student's device. It is a means to encourage visualization on the drawing board, when no other means are available and where an artist's resources are tested to the utmost.

The figure which follows has been arbitrarily developed to show opposition of members, as well as extremes of form recession in depth. Also, this figure shows an extension of the head foreshortening illustrated previously, with a continuation of the tipped profile carried into deep foreshortening.

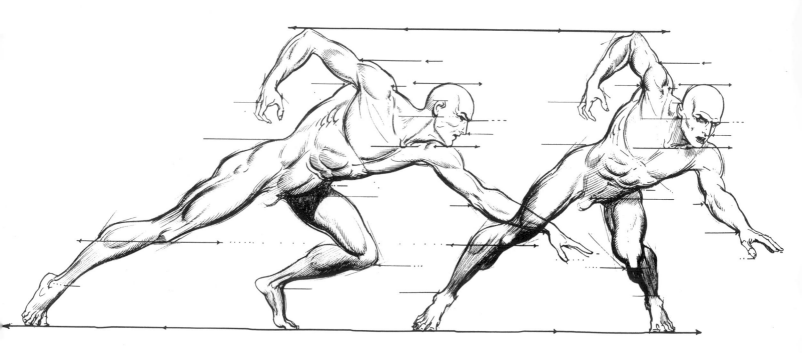

With the use of the projection method, the major limits of body forms are projected out from the side view figure. When the largest forms have been positioned within the parallel tracks, a deep view of the action can be attempted. This should be a tentative notation sketch, lightly laid in. The torso should come first, then the legs (for support), the arms, and the head (last). Throughout, the check positions

from the side view figure should be consulted. At this stage, you may be relying too much on this system of specific definition of forms and validation of the close relationships of members. However, when the essential features of the figure have been brought in and visually comprehended, the fluent translation of the figure can, and *should* begin. In the final workup, the side view figure can be dispensed

with and the front view action figure treated on its own terms. At this stage, the technical procedure should be internalized, held in the mind's eye, so to speak, so that the artist is not caught in a web of surface measurements. At this stage, the artist should dominate the system and make the drawing his own expression, the ultimate reflection of his authority.

This figure projection is included to reinforce the problem-solving factors of the side view projection method. In this jumping figure, we review a number of things that we have discussed previously: (1) the chest thrust toward the raised knee (left) relates both members taken from an arc at armpit height; (2) the heel of the far side flexed leg is set against the buttock and the rear body line; (3) the extended near leg is measured by the isosceles triangle system; (4) the raised rear arm pivots out on an arc taken from the mid-waist point (externus oblique at the side, lining up with the navel in the front). The fold-over effect of this figure, with the knee of one leg raised and the other leg bent under the body —together with the arms in extreme extension—shows how complex arrangements of forms can be carried into deep space recession with little difficulty. The form positions are checked in both figures, left and right, with part-to-part projection.

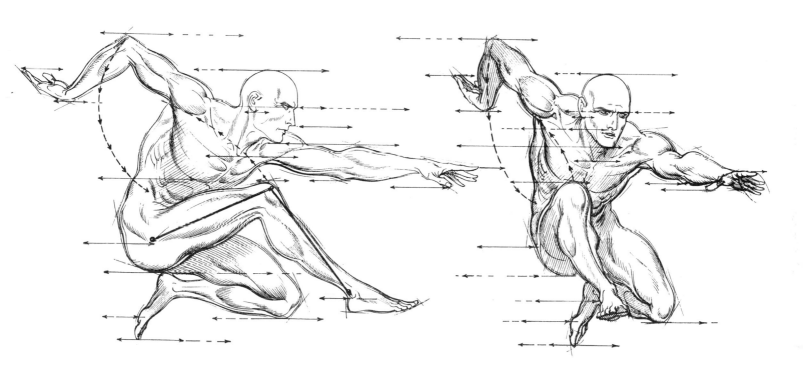

Figure Invention by Reversible Projection

A difficult and perplexing problem sometimes arises in drawing the back view action figure in deep space when parts of members are obscured or blocked from view. For example, if a figure seen from a back view is leaning *away* from the viewer, the figure's head will drop below the shoulder line and the neck and a good part of the head may be overlapped and hidden from view. And if these hidden forms are incorrectly assessed, form distortions will occur. If the neck is drawn too long, your figure will be ungainly; if it is drawn too short, the head will look as if it were depressed into the chest or, worse yet, it will look altogether amputated. In any case, where a back view figure raises the problem of the correct judgment of hidden forms in deep space, one solution is a method we call *reversible figure projection.*

First, we must consider the figure in terms of a silhouette. If we see the figure in contour, as a shape on a screen unidentified by any internal detail, then the resulting silhouette can be seen either as a *front view* or as a *back view.* That is to say, a form seen in outline, in silhouette, from a front view will produce the identical outline when seen from an equal, opposite viewpoint 180° away. This means that *any* position of the figure shown one way may be given an identical action and shown in a total reversal of the original position. To state the proposition simply: *a back view of any given figure has exactly the same outline as a completely reversed front view; if we can draw a front view correctly, we can transpose the shape pattern to a correct back view!*

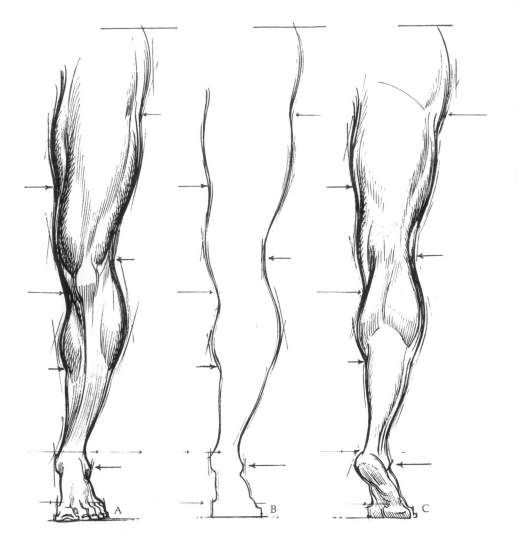

Here is an illustration of the proposition that we have been discussing. In example A, a leg is sketched in and defined in a direct, front view. The extreme bottom and top positions of the leg length are carried to the right of the key drawing with parallel projection lines. A series of form checkpoints are put in to control the contour of the developing right side projection. In example B, a silhouette leg in an equivalent contour is drawn with no internal detail, using the check positions of the forms in example A for correct placement. In example C, the silhouette used in B is repeated, and checkpoint related. Now however, the shape contour is used to create a total reversal of the front view to a *completely opposite rear view.* The critical thing here is that the contour outline, projected in this way, does not permit the rear forms to stray out of place. To finish the procedure, note how the back view is enhanced by overlapping insertion lines which help to articulate the backthrust of the leg. Also, note how the sole of the foot is found by sketching the heel upraised and taking the outer ridge base toward the little toe.

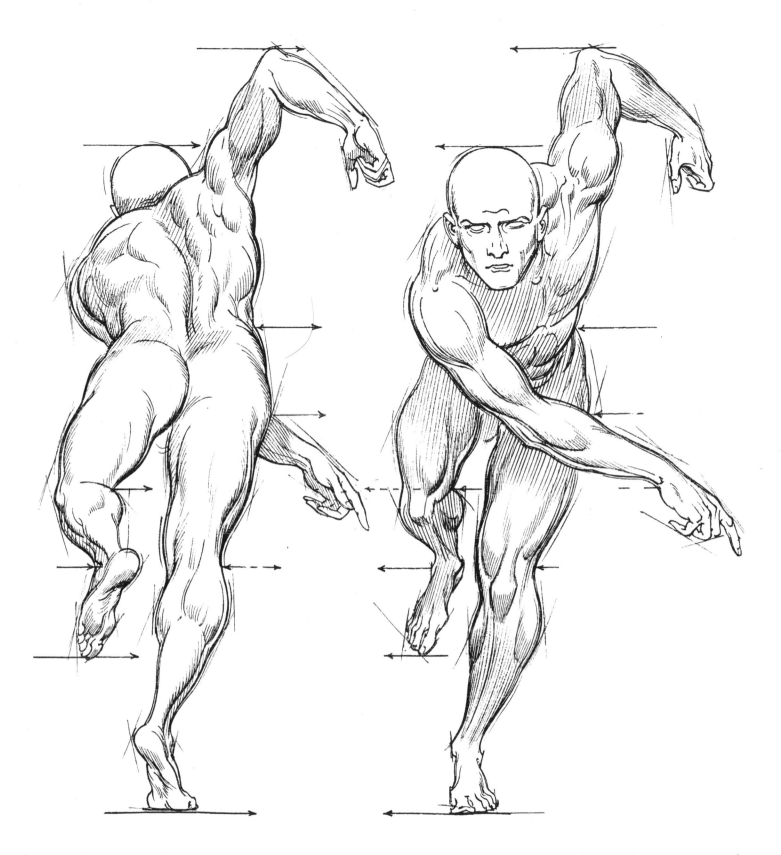

In cases where the shoulder overlap of head and neck poses a problem in drawing a back view torso, the silhouette projection in back-front reversal may offer a solution. Here, the back view figure is drawn first. When these back view figure forms begin to show incongruities, the front view forms are worked up in reciprocal correlation, front to back, right to left. This procedure helps to jog the imagination, keeping insight open and flexible; it keeps the mind from hardening into intractable and inauthentic misconceptions of form. If we find the correct head position in the back view figure by working out its correspondence with the front chest, neck, and collarbone in the front view figure, the rest of the back view torso can be handled with confidence. Not all forms have to be worked out in complete dual reference, of course. Where the certainty of forms can be visualized, there is no need to draw a complete reversal figure. Since this method is a convenience to produce results, shortcuts can, and should, be introduced.

157

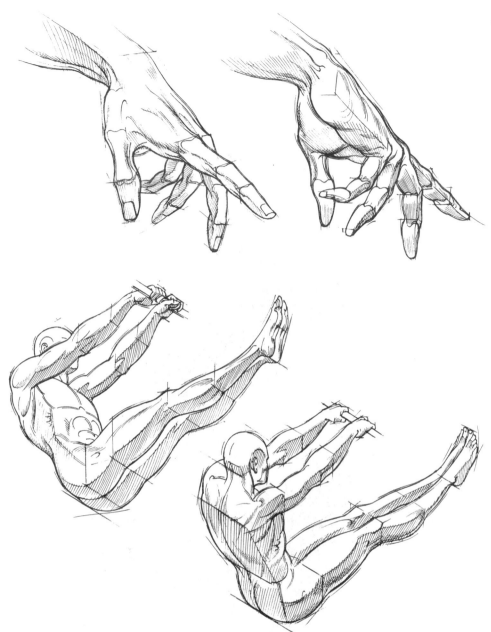

A striking feature of the figure reversal method is that it offers the artist a challenge to develop his latent powers of visualization. Some foreshortening problems are difficult, and this method can be used to help in finding a solution. As an example of the stimulation this method offers, the hand shown here takes the longer projection approach, then shortens it by eliminating the middle contour drawing step — if the artist is well advanced, the last step follows directly from the first one with no difficulty. Here is how this works. A hand (prototype at left) is sketched in. A *tracing* is made of the *contour only*. This contour is placed beside the original. Then the opposite view is worked into the contour, checking out each form in the part-to-part checkpoint system that we discussed earlier. In this case, the thumb offers the initial clue to the reverse view; then the heel of the palm is conjoined to the little finger, and the sequence of finger recession develops in spatial order. When the total reversed aspect is drawn, details are added. If adjustments are necessary to relate the tension of form thrust from forward to rearward, or diminution of form size in space, they are made at this stage.

Sometimes an exceptional view is needed in a drawing, one which cannot ordinarily be seen in everyday life because it is exotic, bizarre, or not common to the routine world. This trapeze figure is one such example. Approaching this problem without any references and getting a good result presents an intriguing problem in the form reversal method. The procedure here does not follow a step-by-step formula, but is done with a constant interaction of two correlated form probes. Try to visualize this, since you are seeing only the result of the process (really, this should be shown with film). The probe starts with the left underview figure, which is the way the drawing was originally envisioned. The lower body—hips and

legs—laid in first. Then the upper torso is set in, giving a clear overlap to the primary lower forms. In working out the interposed head, a tracing is done of the tentative sketch. This tracing is then cut in with decisive *perspective planes*, front and back, under and over (more will be said about this in the next section). The reason for this is to locate the placement of members in space and sustain the progress of the drawing. Working with a top view (right), the arms and head are easier to understand and visualize; the hip base and knees are clarified, as are the shoulders, wrists, and fingers. These two views develop simultaneously. With the tracing as a mediator, carrying the discipline of the common outline and

form checkpoints, the under and over figures emerge. One aspect of this procedure which cannot be shown here should be mentioned: throughout, the drawing of both phases is constantly *rotated* to check the validity of the figures, because the initial position shown is not necessarily the one which best expresses a credible flying figure. See for yourself: rotate the page slowly in a complete circle, to the left or to the right. See how, as the view shifts, there is a greater or a lesser visual impact than the original view seen on the use of the figure should not be made until all the possibilities have been explored and the most provocative and advantageous view adopted.

Perspective Projection of the Figure

Let us look briefly at three form concepts so that we may go on to a fourth in the comprehension of drawing the human figure in deep space. *First*, it is safe to presume that anyone who has ever attempted to give form to the figure already understands the importance of the *planes* of the body, and has worked with them in projecting structural volumes in space. *Second*, the first attempt to model light and shade (not only density and mass, but atmosphere and luminosity as well) will make the artist aware of *form edges*, opening up a whole environment of perceptual space. *third*, there are *form planes* which assert a particular viewing position or visual angle of the figure in space, i.e., oblique or three quarter up views or down views.

These three form concepts will be illustrated in the first three examples which follow, then we shall go on to illustrate the *fourth* form concept, *environmental gravitation*. When a controlled viewpoint of a figure in space (with integrated planes and edges) takes its position in such a way that it moves outward to engage the entire pictorial space surrounding it, the figure is taken out of itself and is made part of a total unity between figure, viewer, and viewpoint in space. Form volume and perspective space are combined to produce a figure which exists in complete relevance to, and cohesion with, other objects and structures in the space surrounding it.

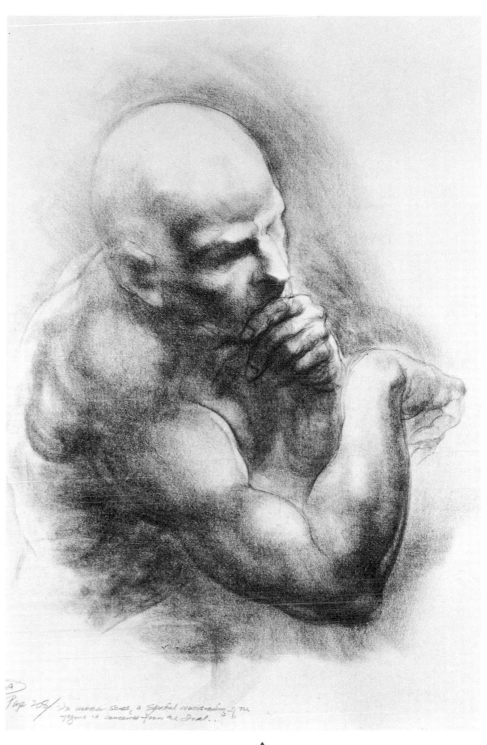

◁ In this example of the first form concept, we see the *integrated units of mass*, *volume*, and *structure*. The figure is seen as a three dimensional, close-knit, tightly packed sequence of forms with clarified edges in tactual, sculptural arrangements (left).

△
In this illustration of the second form concept, a spatial understanding of the figure is conceived from the dual phenomena of *light* and *air*. Different from the tactual, or "touch" approach where form planes are quite comprehensible, the effects of atmosphere and luminosity depend on the visual apprehension of brightness and dimness, clarity and lack of clarity. This example, with its ephemeral manifestations, presents a marked difference from the preceding example (above).

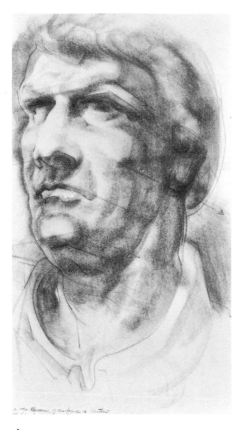

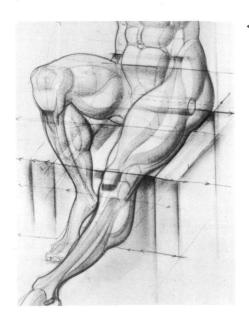

Where the approach to the figure is neither tactual nor visual, spatial orientation may depend on the *total positional stress* of the third form concept. That is to say, the *viewer* is given the task of interacting with the figure; it is a case where the viewing angle of the total figure form demands special notice. The above head is in an up view in which every underplane is exposed (they are reinforced with arrow edges to leave no doubt about the viewpoint).

◁ While numerous forms exist in the body, only a few of these can be developed from edge body planes into large scale pictorial projections. One such form is the hip and leg section. On a seated figure, the great hip mass—taken under the side of the buttock going toward the edge of the thigh—opens a projection path in space from back to front; the hip base, taken at the seat and carried across the body from right to left, takes care of the space in the opposite direction. These linear passages become a set of controls which can be structured into meaningful perspective space (left).

In this simple example illustrating the forth form concept, *environmental gravitation*, we take a head seen in a down view. Arrow form edges are carried from the head outward into the background area; these, by intersection, are made to form a *perspective grid* for structuring the external space. Vertical support lines are then cut in to create a framework for objects; when a consistent structural mass is created—a wall, a building, furniture, etc.—the construction *cannot* be incongruent or out of proportion, for its very existence is intelligible *only* in relation to the figure and *must* produce a unified pictorial environment (above)

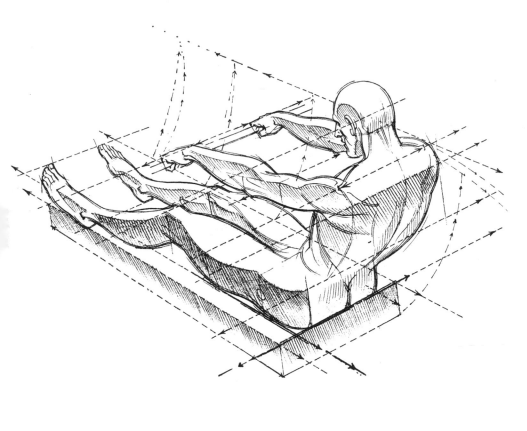

A second example of the hip base body lines developed into a set of controls can be seen in this back view sketch. The buttock block, back and side, extends outward to form a comprehensive perspective grid pattern. This sequence is continually referred to through all related body forms so that visual effect is expressed over-all. With this grid pattern, the figure is put into a structural space, an environment. Lest we forget the basis of the present discussion we will do well to remember that our premise is: *the body or figure forms come first!* The figure is drawn in first, then its position in space is introduced from the *front-to-side corner of the hip.*

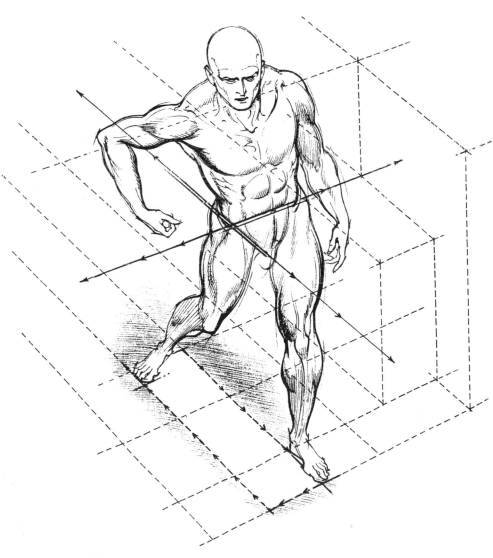

In this front, down view figure, the intersecting axes of the hip corner (solid lines) are the primary control lines from which all perspective tracks (dotted lines) are carried through. Simple vertical structure lines have been started to show how easily the grid controls permit the addition of new pictorial material. Note the way in which feet are positioned on the ground plane. The forward leg has two track lines: one holds the foot at front across the body; the other goes into the background depth area. A space separates the striding legs front and rear (seen on the ground in a rectangular dotted path). At a point to the rear, on the outer path, the backward leg is placed, foot first, then raised up to meet the base of the body.

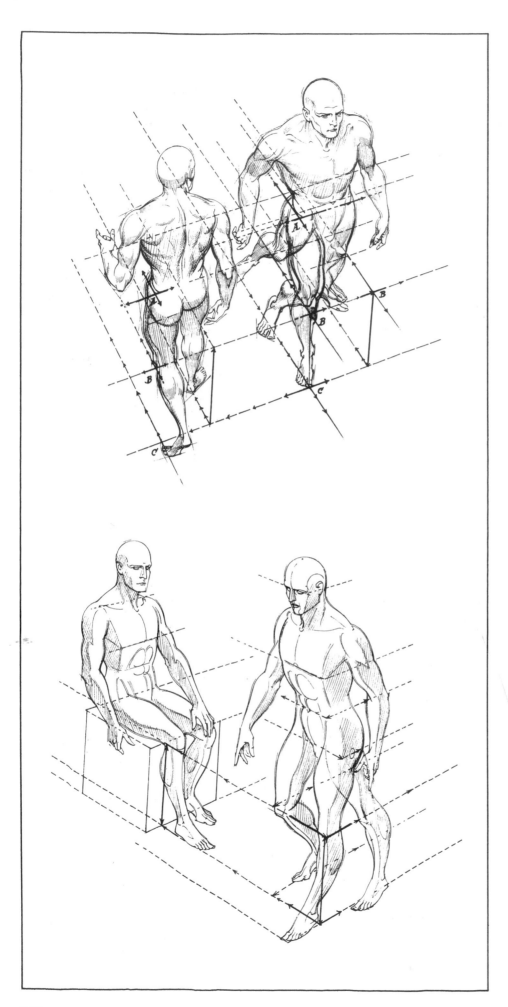

In this more advanced development, not only does the hip corner (A) produce the principal grid control, but two tracks (B and C) put the knee and foot base into a spatial passage which permits new foot and leg positions to be worked out. In addition, the lower leg length, carried through the grid, makes it possible to put a second figure in the plane, seen from the same vantage point and holding to a similar proportion.

Once a figure has the mobility of being able to move about in its own environment, then we can see additional figures emerging, as well as secondary structures which support the main pictorial content. Here, a spatial grid is developed from the figure to the right. This allows a companion figure, seated to the left, to emerge from its lower leg measure (projected rearward).

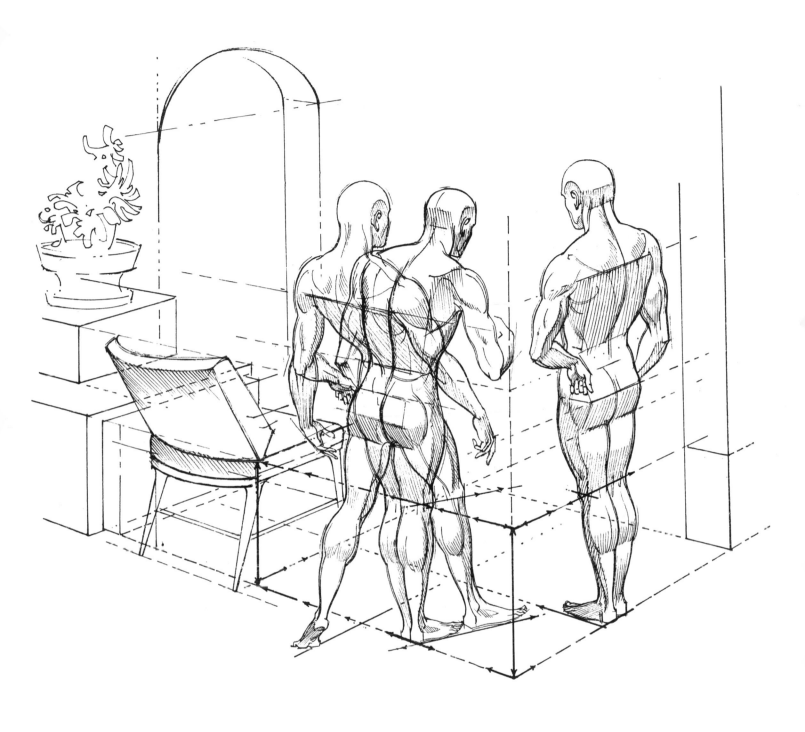

In this example, the body lines of the figure to the right, from thorax to foot base, are taken out into the depth grid from two directions of the form. The firm measure of the lower leg is carried around a corner device (center) and brought left to develop two figure phases of movement and gesture. From here, the grid controls may be used to draw in a room interior with furniture, objects, and walls in relevant proportion. But even more important, we are beginning to create the proportional interaction of *plural figures in space* through projection and the tracking of simple body lengths. And all of this derives from *one major form edge of the primary figure.*

163

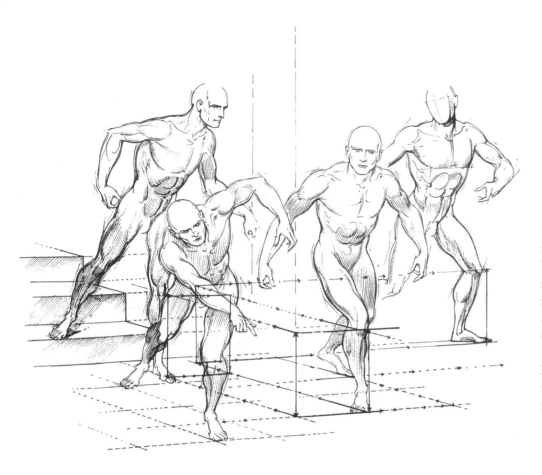

When it is necessary to work with more than one figure in space, the basic requirement is a good first figure with which to organize the mechanics of the grid system. Then, any number of actions may be freely devised throughout the depth plane. Here again, note how the lower leg length carries the projection norm into the spatial track for new figure insertions.

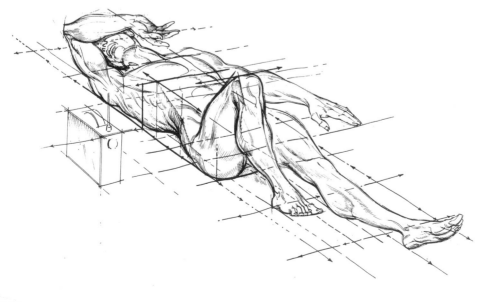

If the logic of the figure needs some action which is not upright (a reclining or supine figure like this one, for example), there is still a form plane from which to extrapolate a grid system and to advance a total environment in perspective space. Check this figure: scan the chest front for the cross-figure directions; note the back shoulders and rear pelvic-buttock edge which, linked in line, produce the support plane. These carry into the depth and grid plane. *Remember:* take your cue from the figure edges; think clearly and work carefully, and nothing can go wrong.

Phase-Sequence Projection: the Multiple Action Figure

Working with figure actions of a particular kind, which must fit some specific need—a figure to be cut into a stone block, a figure designed for a stained glass area or a mural, a figure required to meet a specified illustration shape, a vignette, medallion, or bas-relief figure, or any figure to be worked toward a conceptual purpose or to be given a certain evocative stress—may be so exacting as to thwart or suppress interpretation. In reality, the hazard is not in the figure, but in our lack of resilience and resourcefulness in overriding imposed conditions. *There is no figure action which cannot be solved.* But the search for a solution should not consist of struggling with the figure in an attempt to browbeat it and wrench it into place. The struggle should not be with the figure, but with yourself, with your own set of psychological roadblocks. What is required is a detour, a tactic of overcoming your own defenses and patterns of resistance by outflanking whatever constraining requirements there are.

One method which could prove useful is the *multiple action figure approach*, a searching device which leaves the figure aim open and uncommitted. For example, if a stubborn element in the initial drawing should stop our progress, rather than pursuing this particular figure, we should put it aside and not try for a final development at this time. Instead, we start another drawing, but simpler, less advanced, and more manageable. This figure is not the one we are ultimately striving for; it is a figure that we can use to experiment with and help to reorient our thinking. By exempting ourselves from the sanction of a predetermined figure action, we are free to explore body movement and form direction in space with a free vision. We move toward the final choice with fresh insight, and in becoming more fully aware of our creative powers, we have a heightened appreciation of the enjoyment, rather than the frustration, of drawing.

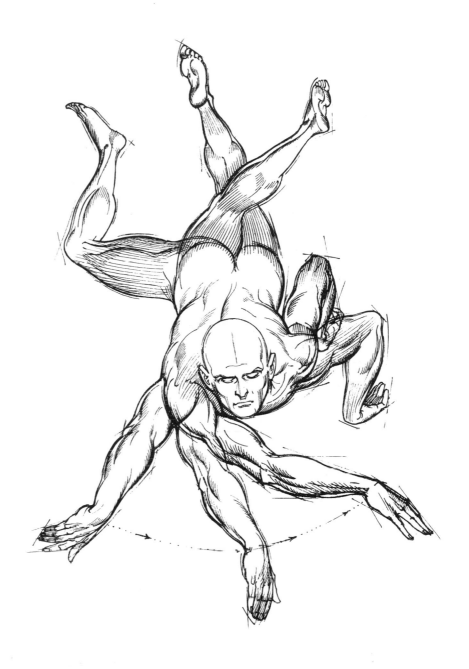

Here is a swimming figure with his front to the viewer. In the initial stage, a single torso is set in, using a form-over-form stacking arrangement which starts low from the pelvis and works upward to the chest. This torso is topped by the head oval. Then the left leg, a simple bend, is worked first; this is seen against the open right leg. The two legs, seen in unison, make a rather bland arrangement. Hence, to force interest, the left leg is brought right to effect a counterposed scissors overlap, giving a deeper impression. A similar start in the arms lets a wide gap occur between them. The successive swing of the left arm, with an answering further thrust of the rear arm bend, produces a provoking alternative by increasing tension and interest. Allow your eye to sweep over these progressive movements. Which combination do you think is most effective? If you think another action, not shown, would be even more feasible, cover the drawing with a sheet of tracing paper and make whatever changes you wish. Go ahead! There is nothing fixed in this open-ended procedure.

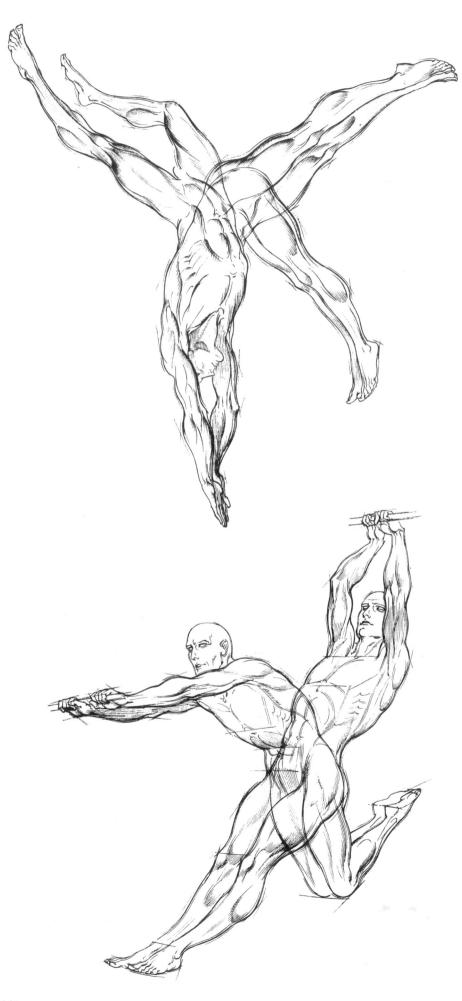

Here is a diving figure: again, it is a single torso with a series of leg variants. The leg positions here are not yet definitive and suggest further possibilities. Often, the oblique multiple figure method brings out ideas for figure action which might never occur otherwise. For instance, in this figure, a jackknife was the primary action that came to mind. But in following up the middle stretchout, an unexpected correlation intruded: in the final left leg swing, an awkward twist came through which caused an imbalance in the figure and forced a reappraisal of the possible aim of the figure in a whole new action context.

In this trapeze figure, a shift of the torso produces two body positions from which new actions may be taken. The primary interacting form is the pelvic wedge. The extended position of the upper body is put in first, and the extended leg line follows as a matter of course. Then the upper body is projected forward, the backward leg thrust comes in as a counterbalance to the frontal pitch, and an interesting compound result develops over-all. Let your eye sweep over the two figures. Look at each torso with each set of legs. Seen this way, there are really four phases in this sequence. Now, between these four sequences, can you see other torso variations, as well as new leg positions? If you can, place a sheet of tracing paper over the page and sketch in the actions that occur to you, one form at a time. Shift a member, follow with another — a torso, an arm, an upper leg, a lower leg, etc. — there is no rule, and you should feel free to explore and find new figure solutions for yourself. Finally, try rotating the page. Slowly. Then upside down. In each move, observe the potential effect of new figure solutions in this trapeze performer.

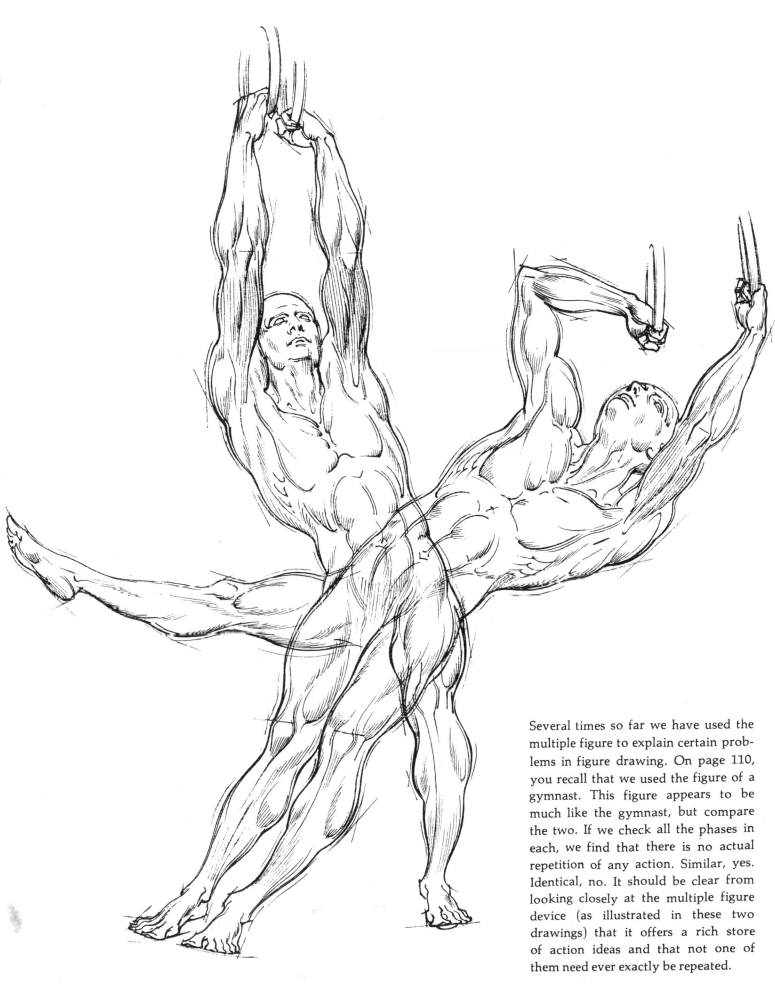

Several times so far we have used the multiple figure to explain certain problems in figure drawing. On page 110, you recall that we used the figure of a gymnast. This figure appears to be much like the gymnast, but compare the two. If we check all the phases in each, we find that there is no actual repetition of any action. Similar, yes. Identical, no. It should be clear from looking closely at the multiple figure device (as illustrated in these two drawings) that it offers a rich store of action ideas and that not one of them need ever exactly be repeated.

Chin Thrust Leads Body Action

At this time, we insert an observation which opens a new area of inquiry into drawing the action figure. Simply stated, the observation is this: *body action tends to follow the direction of the chin*. The study of any phase of body movement will generally confirm this statement. If the chin is drawn inward to the neck, the body will tend to go backward; if the chin is thrust out, the body will project forward. A twist in the chin direction left or right will produce a responsive twist in the torso. Arms, too, reflect the spiral rotation, and legs, knees, and feet carry out a similar tension.

A clue to any movement will first appear in the eyes of the figure. A nuance of eye direction subtly signals an impending change of action. Then, when the decisive moment of action change occurs, the impulse is governed by the controlling aspect of the chin. The multiple action sketches which follow show how the chin and the body movements are related.

Below are four head positions (from left to right). First, we see a raised head, with a lifted jaw exposing the underplane of the facial mass (A). Note the retracted shoulders and the subtle expanse of the chest. Then, we see a more erect head, the chin plane down, the chest barrel less arched (B). The next head has a chin that leads forward—the body takes the cue, tips front, and turns (C). And finally, we see a head and chin in greater frontal projection, with the body following this leaning (D). As the general tension of these four phases drifts rightward, follow the rightward tension in the body, as well as the concomitant veering of the arms. Finally, as the body tips forward, note the remarkable change in the angle of the collarbones.

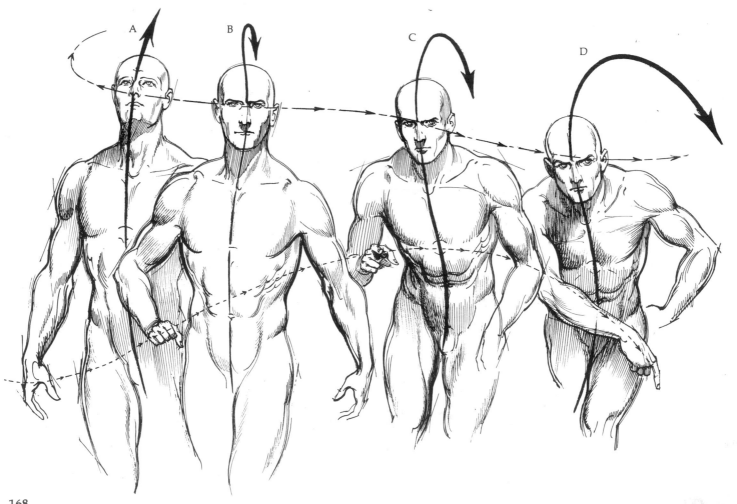

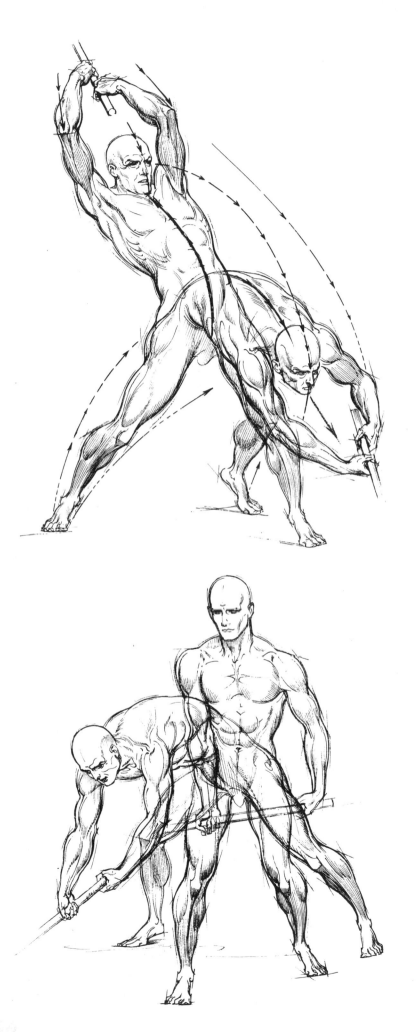

This full figure shows extremes of action, using the chin as a leader guide to the body. First, we see the body in an *upswing* state. Note the arched body curve upward (dotted arrow line). Against this erect body, the chin leads, compressing inward, giving a subtle movement-in-reverse direction to the torso. The arms, before the body reacts to this, tend to break the absolute tension with a contrary deflection Second, we see the body in a *downswing* state (continuing arrow line descent). The chin goes into a projected frontal thrust. The arms, arching ahead, plunge downward. The legs and torso, in fluent advance, provide full support and propulsion.

With this example, we return to the multiple action sequence and its uses. We have so far seen a two-stage process, as is illustrated here in this follow-up of the sledgehammer. We have seen the end phases of action sequences, the initial and the terminal, the stance and the thrust. This is the obvious approach.

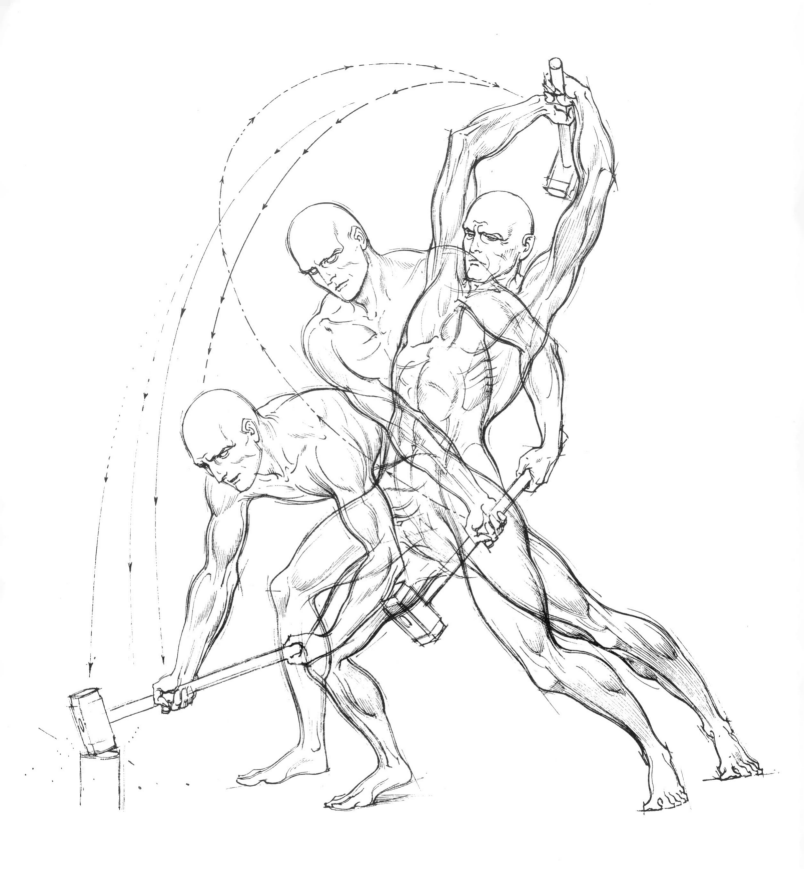

In this multiple action drawing, we become conscious of a new attitude to this method. Between the framing—beginning and ending—actions, a number of variations are possible. Indeed, a *filmic* concept evolves; a state of drawing approaching a cinematographic idiom. The drawing actually becomes a field of motion, open-ended and unlimited. This drawing, and the two which follow, show stance, poise, readiness, upswing, equilibrated tension, eversion, downswing, and thrust in a *filmic* sequence of action statements.

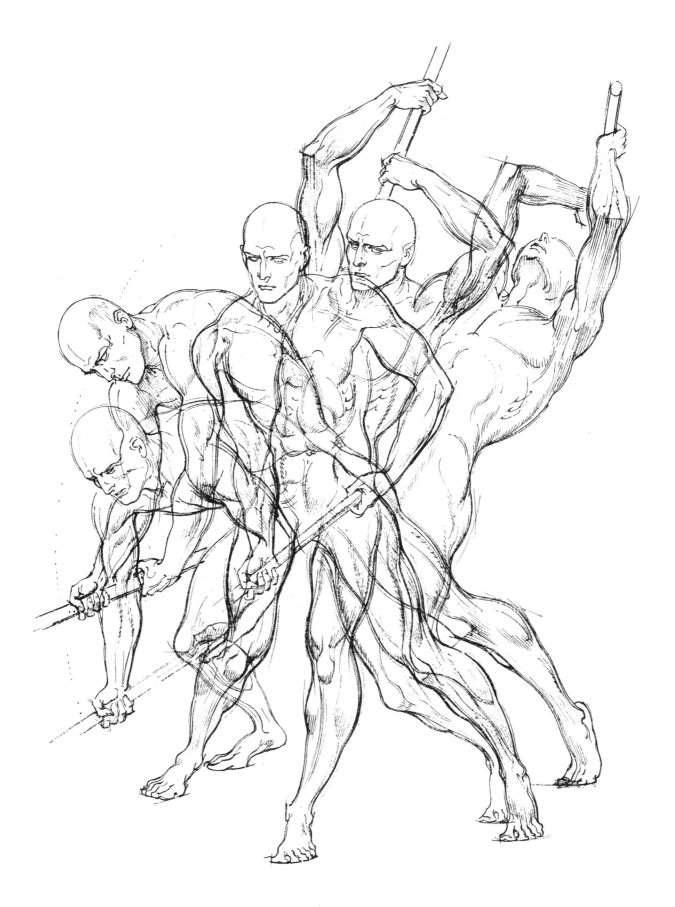

Here, there is a tendency to let the figures dissolve into moments of time. The sketches become progressive variations. No two figures are alike. Even secondary details — hand actions, feet, facial aspects — tend to become experimental segments, detached, yet fluid and interacting. Try seeing each variation as a possible solution to a single figure problem. While it is intriguing to see this as a charted relationship in drawing, it is more important to think of it as a means to stimulate the imagination; it conjures up new figures where none had been contemplated before. None of these figures is copied from reference sources.

In this illustration, a darting figure begins a succession of phases from a running start forward, into a twist, a wheel, and a quick leap upward. The figure moves in progressive sequence, but the action forces the feeling that the figure is accelerating. It conveys not only motion, but a kinesthetic projection of velocity. Certainly the action changes, but more than that, the speed changes also.

172

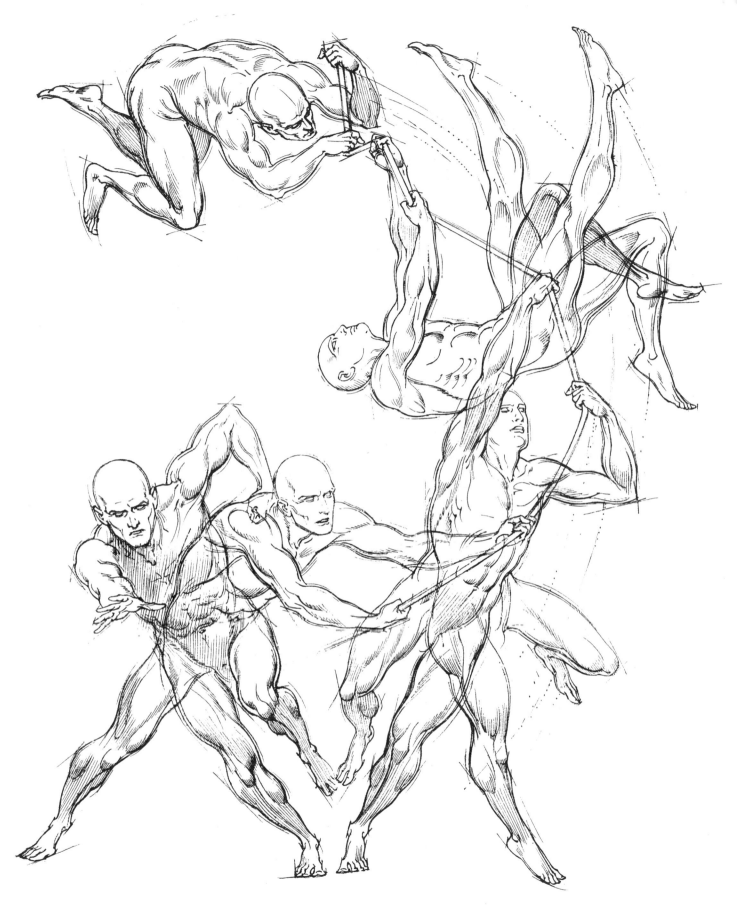

Here, the figure runs, wheels (note the double, four-phase start); we try the legs (*separately* with each body); now a leap (study the double-phase legs in the upward bound); the figure goes higher in a spring and a stretch (which choice — one, the other, or both?); the action speeds up, mobilizes energy, goes through an arching vault, a whirl — and descent. In each case, arm and leg action is carried progressively in phase-sequence coordination; at the same time, the chin reinforces and informs us of the direction. More than all else, however, this exercise helps illuminate and focus and creative dynamics of the student's imagination, and develops the means to sustain it.

The Hand in Phase-Sequence Projection

The study of the multiple action figure would be incomplete if we did not at least mention its experimental possibilities in foreshortening the hand. In Chapter 4, we studied certain deep space ideas relating to the hand, some of which discussed form probes in multiple phase-sequence. Rather than repeat this material, we will append this token illustration of the system as it applies to the hand, with the understanding that the reader will refer to the earlier hand examples for further information on the structure of the hand.

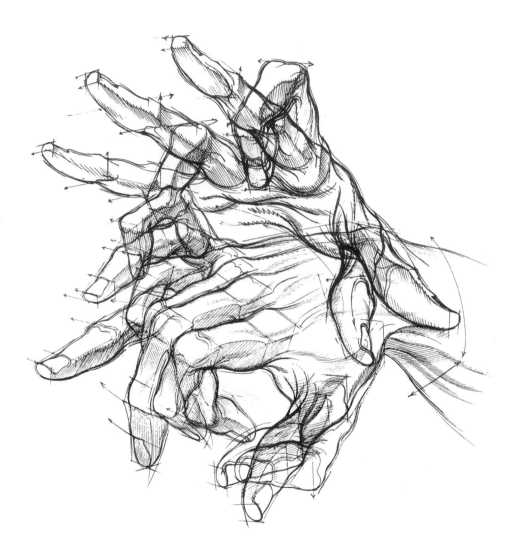

Conclusion

For the present, this ends our investigation of deep space form and the foreshortening of the figure in motion. The experimental approaches outlined in this book represent an attempt to present an advance in figure visualization which may add to the student's natural creative powers. If the exercises are used, no foreshortening problem in the figure, no position, view, or attitude need be troublesome. If the student is tenacious enough, barriers and problems will dissolve; forms hitherto not seen or conceived will move freely and easily within the infinite spatial realm of the picture plane.

The original drawing for the example shown here is of a simple, undistinguished down view hand. The drawing begins with the fingers slightly bent, the thumb extended. Playfully, the thumb is flexed in stages. This flexion is carried over to the index finger. Then the little finger is extended, and this extension is carried over to the fourth finger. But suppose we were to see this thumb flexion, finger extension, and finger fanning and flexion, from a different view — from *underneath* the palm? The drawing that results from following this idea through is the product of a piecemeal stage-on-stage process and looks very complicated indeed. Yet in its evolution, how easy it is!

Index